Nikon®
D600™
Digital Field Guide

Nikon®
D600™
Digital Field Guide

J. Dennis Thomas

WILEY

John Wiley & Sons, Inc.

Nikon® D600™ Digital Field Guide

Published by
John Wiley & Sons, Inc.
10475 Crosspoint Boulevard
Indianapolis, IN 46256
www.wiley.com

ISBN: 978-1-118-50930-2

Manufactured in the United States of America

10 9 8 7 6 5 4 3 2 1

WILEY

About the Author

J. Dennis Thomas is a freelance photographer and author based out of Austin, Texas. He has nearly 25 years of experience behind the lenses of Nikon cameras. His work has been published in many regional and national publications, including *Rolling Stone*, *SPIN*, *Elle*, *EBONY*, *W*, *Country Weekly*, *Us Weekly*, and *Thrasher*. He has written more than a dozen highly successful Nikon *Digital Field Guides*, a comprehensive book about concert and live music photography, and a book about urban and rural decay photography. Thomas also writes articles about photography for *Digital Photo* magazine and www.masteringphoto.com, and maintains a blog called *The Nikon Digital Field Guide Companion* (www.deadsailorproductions.blogspot.com).

Credits

Acquisitions Editor
Carol Kessel

Project Editor
Kristin Vorce

Technical Editor
George Maginnis

Copy Editor
Marylouise Wiack

Editorial Director
Robyn Siesky

Business Manager
Amy Knies

Senior Marketing Manager
Sandy Smith

Vice President and Executive Group Publisher
Richard Swadley

Vice President and Executive Publisher
Barry Pruett

Project Coordinator
Sheree Montgomery

Graphics and Production Specialists
Andrea Hornberger

Quality Control Technician
Jessica Kramer

Proofreading and Indexing
Joni Heredia
Ty Koontz

As always, to my girls Henrietta and Maddie.

Acknowledgments

I'd like to thank everyone at Wiley who works so hard to get these books out, especially my favorite woman at Wiley, Courtney Allen, for always lending an ear and an objective opinion, and generally being an all-around great gal. I'd also like to thank Kristin Vorce and Carol Kessel for all the hard work that they do behind the scenes, Kathleen Jeffers for getting out all the paperwork, Robyn Siesky for crackin' the whip on the production team, and Barry Pruett for giving the go-ahead and signing the checks!

I'd also like to thank the folks at Precision Camera and Video in Austin, Texas, Jack and Monica Puryear at Puryear Photography, Cricket Krengel, and everyone else who lent a helping hand along the way.

Contents at a Glance

Contents

CHAPTER 3
Setting up the Nikon D600 75

CHAPTER 4
Selecting and Using Lenses
with the Nikon D600 147

CHAPTER 5
Controlling Exposure 173

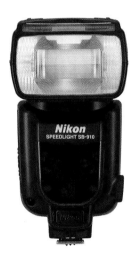

CHAPTER 6
Working with Light 193

Introduction

There had been rumors circulating for quite a while that Nikon was planning to release an affordable full-frame camera, so when the D600 was announced, it wasn't a complete surprise. The world was expecting a full-frame sensor in a D7000 and that's what they got. What was surprising, however, was that the D600 wasn't just a full-frame D7000; it inherited quite a bit of technology from its bigger brother, the D800.

While the D800 turned the world of digital photography on its head, the D600 arrived a little later and set the world on fire. With a 24MP sensor (which puts it on par with one of Nikon's flagship cameras, the D3X), the brand-new EXPEED 3 image processor, the updated Multi-CAM 4800FX 39-point autofocusing system, and the 2016-pixel Color Matrix Metering II metering system, the D600 borders on being a professional camera.

Although the D600 isn't necessarily a professional-grade camera, it does have a lot of professional features, including a magnesium alloy top and bottom for durability, weather sealing for protection against the elements, and easily accessible buttons to make quick changes during shooting. The D600 has everything an advanced photographer needs, but Nikon also hasn't forgotten about newer photographers. The D600 offers a plethora of scene modes to allow you to open up your creativity and capture great images in any shooting situation, no matter how much photography experience you have. The D600 also allows in-camera editing so you don't necessarily need to be computer savvy to add great effects to your images. It even allows you to edit RAW files.

The D600 will appeal to videographers as well. It matches the D800 in almost every way in terms of video capabilities, including the ability to record uncompressed video through the HDMI port. Other features that will appeal to videographers — in addition to the lower price point — include the stereo microphone input, the stereo headphone

output, the ability to control ISO, shutter speed, and aperture, and the number of fast lenses Nikon offers to achieve the shallow depth of field that is the hallmark of high-quality video production.

To sum it all up, Nikon has created an amazing, full-featured, full-frame camera that isn't out of reach of regular folks.

About the Digital Field Guide

The *Digital Field Guide* book series is intended to act as an adjunct to the manual that comes with your camera. While the manual gives you a great overview of the camera, a photographer didn't write it. The *Nikon D600 Digital Field Guide* gives you all of the information you need about the camera from a working photographer's perspective.

The goal of this guide is to help photographers — from novices to advanced amateurs — grasp all of the features of their new camera. It includes tips learned from working with the camera in the field, as well as some basic information to help new photographers quickly get up to speed.

This guide walks you through setting up your camera and offers insight into which settings to use, as well as why each setting is useful in a particular situation. It includes full-color images that demonstrate different photography concepts and show you some of the things that the D600 is able to accomplish under different circumstances.

The *Nikon D600 Digital Field Guide* will help you quickly become familiar with your camera so that you can navigate and handle it better, and more easily reach your photographic goals and visions.

Exploring the Nikon D600

This chapter covers the key components of the D600, including the buttons, switches, dials, and knobs. These are the features you most need to master because you will use them all the time as you modify settings to adapt to changing shooting conditions.

The D600 is very similar to its DX sibling the D7000 and, indeed, was designed with this camera in mind. If you're upgrading to FX from the D7000, you will feel instantly at home. If you're stepping up from a D5100 or a D3200, the number of controls may surprise you. If you are accustomed to using one of Nikon's compact pro bodies such as the D300s, D700, or D800, you will definitely notice the difference in the control layout.

Getting to know all your camera's menus, buttons, and dials allows you to capture your images just as you envision them.

Key Components of the D600

The exterior controls of the D600 are used to access features that are most commonly changed. The D600 is a more advanced model than the D3200 and D5100 series, so it has a lot more buttons and dials to allow you to change your settings more quickly, which is a good thing. On the other hand, the D600 has much fewer buttons than the higher-end cameras, so a lot of the buttons perform double or even triple duty, depending on what mode the camera is in.

The good news is that a number of buttons can be customized so that you can control the settings that you need to access the most.

Top of the camera

Most of the important buttons are on the top of the D600. This makes it easier to find them, especially when you have your eye to the viewfinder. This is where you find the dials to change the shooting modes as well as the all-important shutter-release button and the relatively new Movie record button.

▶ **Shutter-release button.** In my opinion, this is the most important button on the camera. Pressing this button halfway activates the camera's autofocus and light meter. Fully depressing this button releases the shutter and takes a photograph. When the camera has been idle, and has "gone to sleep," lightly pressing the shutter-release button wakes it up. When the image review is on, lightly pressing the shutter-release button turns off the LCD and prepares the camera for another shot.

▶ **On/off switch.** This switch, located concentric to the shutter-release button, is used to turn the camera on and off. Push the switch all the way to the left to turn the camera off; pull the switch to the right to turn the camera on. The on/off switch also has a spring-loaded momentary switch, which, when pulled to the far right, turns on the control panel backlight.

▶ **Movie record button.** When the camera is in Live View movie mode (🎥), pressing this button (which has a simple red dot on it) causes the camera to start recording video. Pressing it a second time stops the video recording. In Live View still photography mode (📷) and standard shooting mode or scene modes, this button has no function at all.

▶ **Metering mode button (▦).** Pressing this button and rotating the Main Command dial allows you to change the metering mode among Matrix (▦), Center-weighted (◙), and Spot metering (⊡). This is also one of the buttons

for the two-button formatting option used to format the active memory card. Press and hold this button in conjunction with the Delete button (🗑) until FOR blinks on the LCD control panel, and then press the buttons in conjunction a second time to complete formatting. This second button press is required as a fail-safe against accidental formatting.

▶ **Exposure Compensation button (⧄).** Pressing this button while spinning the Main Command dial allows you to modify the exposure that is set by the D600's light meter when it is set to Programmed auto (**P**), Shutter-priority auto (**S**), or Aperture-priority auto mode (**A**). Turning the Main Command dial to the right increases exposure while turning the dial to the left decreases the exposure. You may also notice a green dot next to this button. Pressing and holding this button in conjunction with the Zoom out/Thumbnail/ISO button (⧄/ISO) resets the camera to the default settings.

> **NOTE** The ⧄ button serves no function when shooting in automatic or scene modes.

▶ **Mode dial lock release button.** Press this button to unlock the Mode dial so that you can rotate the dial to change the settings.

▶ **Mode dial.** This is an important dial. Pressing the Mode dial lock release button and rotating the Mode dial allows you to quickly change your shooting mode. You can choose the scene mode, one of the semiautomatic modes, or Manual exposure mode (**M**), which lets you pick the exposure settings.

> **CROSS REF** For a detailed description of all the exposure modes, see Chapter 2.

▶ **Focal plane mark.** The focal plane mark shows you where the plane of the image sensor is inside the camera. The sensor is directly behind the shutter. When measuring distance for calculating flash output, you measure the subject-to-focal-plane distance.

▶ **Hot shoe.** This is where you attach an accessory flash to the camera body. The hot shoe has an electronic contact that tells the flash to fire when the shutter is released. A number of other electronic contacts allow the camera to communicate with the flash, enabling the automated features of a dedicated flash unit such as the SB-700.

▶ **Control panel.** This LCD panel displays numerous controls and settings. The control panel is covered in depth later in the chapter.

3

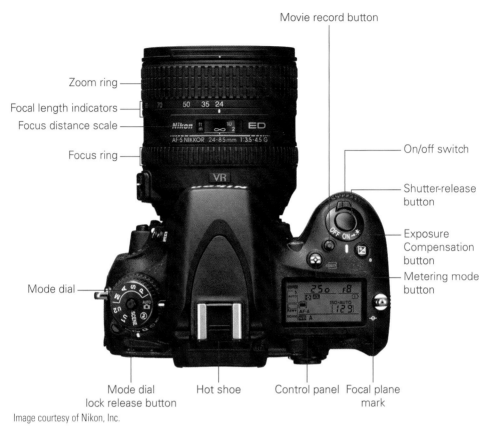

Movie record button

Zoom ring

Focal length indicators

Focus distance scale

Focus ring

On/off switch

Shutter-release button

Exposure Compensation button

Metering mode button

Mode dial

Mode dial lock release button Hot shoe Control panel Focal plane mark

Image courtesy of Nikon, Inc.

1.1 Top-of-the-camera controls

On the kit lens, you find four key features:

▶ **Focus ring.** Rotating the focus ring allows you to focus the lens manually. The location of the focus ring varies by lens. With old AF (non AF-S) lenses, and even older manual-focus lenses, you turn the ring to focus the lens. Newer AF-S lenses, such as the kit lens, have a switch labeled A and M. Select M before attempting to manually focus. If you don't switch it over first, you can damage the lens. Some higher-end AF-S lenses have a switch labeled A/M and M. With these lenses set to the A/M position, you can manually override the autofocus at any time without damaging the lens.

▶ **Focus distance scale.** This window displays the approximate focus distance in both metric and imperial measurements.

CROSS REF For more information on lenses and compatibility, see Chapter 4.

▶ **Zoom ring.** Rotating the zoom ring allows you to change the focal length of the lens. Prime lenses do not have a zoom ring.

▶ **Focal length indicators.** These numbers indicate which focal length in millimeters your lens is zoomed to.

Back of the camera

The back of the camera is where you find the buttons that mainly control playback and menu options, although a few buttons control some of the shooting functions. Most of the buttons have more than one function — a lot of them are used in conjunction with the Main Command dial or the multi-selector. On the back of the camera, you also find several key features, including the all-important LCD and viewfinder.

▶ **Release mode dial.** Although technically the Release mode dial is located on the top of the camera, on recent Nikon cameras the release modes are easier to view from the rear of the camera. The release mode controls how the shutter is released when you press the shutter-release button. Press the Release mode dial lock release and rotate the Release mode dial to change the settings. There are seven modes:

• **Single frame (S).** This mode allows you take a single photograph with each press of the shutter-release button. The camera does not fire multiple frames when the button is held down.

• **Continuous low speed (CL).** When you're using this release mode, pressing and holding the shutter-release button allows the camera to shoot multiple frames at low speed. You can set the frame rate for this release mode in Custom Settings menu d5 (✔ d5). You can select from 1 to 5 fps.

• **Continuous high speed (CH).** When you use this release mode, pressing and holding the shutter-release button allows the camera to shoot multiple frames at high speed. The camera shoots at the maximum frame rate of 5.5 fps.

NOTE The actual maximum frame rate depends on the shutter speed, buffer, and memory card speed.

• **Quiet shutter-release (Q).** This mode allows you to control the release of the reflex mirror. When you press the shutter-release button, the reflex mirror

stays up until you release the button. This allows you to take pictures more quietly by moving to a different area or covering up the camera before you release the shutter-release button, allowing the mirror to reset.

- **Self-timer (↻).** This mode activates the self-timer that allows a delay between the time you press the shutter-release button and the shutter is released. You can set the timer in the Remote control mode (■⚬)))) in the Shooting menu (📷).

- **Remote control (■⚬)))).** This mode allows you to use the optional ML-L3 wireless remote to release the shutter. You can change the settings in the Remote control mode in the 📷 menu.

- **Mirror up (Mᴜᴘ).** This mode raises the reflex mirror with one press of the shutter-release button and releases the shutter and resets the mirror with a second press of the button. You can use this mode to minimize camera shake from mirror movement when shooting long exposures on a tripod or when using a long telephoto lens.

▶ **LCD monitor.** This is the most prominent feature on the back of the camera. This 3-inch, 921,000-dot liquid crystal display (LCD) is a very bright, high-resolution screen. The LCD is where you view all your current camera settings and review your images after shooting, and it displays the video feed for Live View and video recording.

▶ **Viewfinder.** This is what you look through to compose your photographs. Light coming through the lens is channeled through a five-sided reflective prism (called a *pentaprism*), enabling you to see exactly what you're shooting. The rubber eyepiece around the viewfinder gives you a softer place to rest your eye and blocks any extra light from entering the viewfinder as you compose and shoot your images.

▶ **Diopter adjustment control.** Just to the right of the viewfinder (hidden behind the eyecup) is the diopter adjustment control. Use this control to adjust the viewfinder lens to suit your individual vision strength (not everyone's eyesight is the same). To adjust this control, look through the viewfinder, and press the shutter-release button halfway to focus on something. If what you see in the viewfinder isn't quite sharp, slide the diopter adjustment control up or down until everything appears in focus. The manual warns you not to put your finger or fingernail in your eye. I agree that this might not be a good idea.

▶ **AE-L/AF-L button (ᴬᴱ⁻ᴸ/ᴬꜰ⁻ᴸ).** The Autoexposure/Autofocus Lock button is used to lock the Autoexposure (AE) and Autofocus (AF). You can customize this button in the Custom Settings menu (✔ f5) to provide AE/AF Lock, AE Lock only, AE Lock (hold), AF Lock only, or AF-ON. AE Lock (hold) locks the exposure with one

press of the shutter-release button; the exposure is locked until you press the button again. AF-ON engages the AF in the same way that half-pressing the shutter-release button does, but it disengages the shutter-release button from any AF functions. You can also set the button to FV Lock when using the built-in flash or an accessory Speedlight.

▶ **Main Command dial.** You use this dial to change a variety of settings, depending on which button you are using with it. By default, it is used to change the shutter speed when the camera is in **S**, **P**, and Manual exposure mode (**M**). It is also used to adjust exposure compensation and change the flash mode.

▶ **Multi-selector.** The multi-selector is another button that serves a few different purposes. In Playback mode, you use it to scroll through the photographs you've taken, and you can also use it to view image information such as histograms and shooting settings. When the D600 is in Single-point AF ([⚬]) or Dynamic-area AF mode ([⚬⚬]), you can use the multi-selector to change the active focus point. And you can use the multi-selector to navigate through the menu options.

▶ **OK button** (⊛). When the D600 is in the Menu mode (**MENU**), you press the ⊛ button to select the menu item that is highlighted. In Playback mode (▶), pressing ⊛ brings up the Retouch menu (🖉) options. In shooting mode, you can set ⊛ to a couple of different functions using ✐ f1, Select center focus point, Highlight active focus point, or you can disable ⊛ by selecting Not used.

▶ **Focus selector lock.** This switch, located concentric to the multi-selector, locks the focus point so that it cannot be moved with the multi-selector.

▶ **Ambient light sensor.** This sensor detects the luminosity of the ambient light so that the monitor brightness can be automatically adjusted.

▶ **Live View button/Live View selector.** With the introduction of the D800, Nikon added this switch, which makes it much more convenient to use the Live View settings. Simply pressing the Live View button (Lv) activates the Live View option, and flipping the switch allows you to choose between shooting stills (📷) or video (🎥).

▶ **Memory card access lamp.** This light blinks when the memory card is in use. Under no circumstances should you remove the card when this light is on or blinking. You could damage your card or camera and lose any information in the camera's buffer. If the buffer is full when you switch the camera off, the camera will stay powered on and this lamp will continue blinking until the data finishes transferring from the buffer to the memory card.

▶ **Info button** (ℹ). Pressing this button displays the shooting information on the monitor. Press this button twice to adjust settings in the ℹ menu.

▶ **Speaker.** This small speaker enables you to hear the audio recorded with the video you have shot. I must admit that the fidelity of the speaker isn't that great, and it's quite hard to get an accurate representation of what the sound is going to be like when it is played back through your TV or computer speakers.

▶ **Rear infrared sensor.** This picks up the infrared signal from the optional wireless remote, the ML-L3.

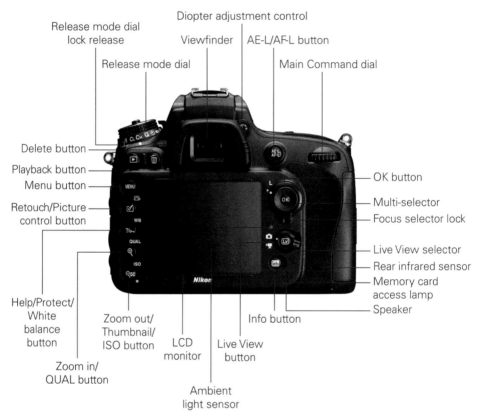

Image courtesy of Nikon, Inc.

1.2 Back-of-the-camera controls

▶ **Playback button (▶).** Pressing this button activates Playback mode and by default displays the most recently taken photograph. You can also view other pictures by pressing the multi-selector left and right.

▶ **Delete button (🗑).** If you are reviewing your pictures and find some that you don't want to keep, you can delete them by pressing this button. To prevent you from accidentally deleting images, the camera displays a dialog box asking

you to confirm that you want to erase the picture. Press 🗑 a second time to permanently erase the image. This is also one of the buttons for the two-button formatting option used to format the active memory card. Press and hold this button in conjunction with the 🖾 button until FOR blinks on the LCD control panel, and then press the buttons in conjunction a second time to complete formatting. As mentioned previously, this second button press is required as a failsafe against accidental formatting.

▶ **Menu button (MENU).** Press this button to access the D600 menu options. There are a number of different menus, including Playback (▶), Shooting (📷), Custom Settings (✐), and Retouch (🖾). Use the multi-selector to choose the menu you want to view and press ⊛ to enter the specific menu screen.

▶ **Retouch/Picture Control button (🖾/⊡).** Pressing this button in Shooting mode allows you to select and adjust the Picture Controls (⊞). When the camera is in Playback mode, pressing this button brings up the Retouch menu (🖾) options or the Movie editing options if a video is selected during playback.

▶ **Help/Protect/White balance button (?/ₒ̴/WB).** Pressing this button and rotating the Main Command dial allows you to change the white balance (WB) settings when in Shooting mode. Rotating the Sub-command dial allows you to fine-tune the selected WB setting by adding blue or amber to make the image cooler or warmer, respectively. You can add blue (b1–b6) by rotating the dial to the right and amber (a1–a6) by rotating to the left. When you're viewing the Information display and a question mark appears or when you're scrolling through the menu options and a question mark appears in the lower-left corner, you can press this button to get more information. When the D600 is in Playback mode, press this button to protect (lock) the image from accidentally being deleted. Press it again to unlock it.

▶ **Zoom in/QUAL button (⊕/QUAL).** When the D600 is in Shooting mode, pressing this button and rotating the command dials allows you to quickly change the image quality and size settings. Rotating the Main Command dial allows you to choose a format (RAW, JPEG, or RAW+JPEG) as well as the JPEG compression (Basic, Normal, Fine). Rotating the Sub-command dial allows you to choose the JPEG size but has no effect when the quality is set to RAW. When reviewing your images or using the Lv option, you can press the ⊕/QUAL button to get a closer look at the details of your image. This is a handy feature for checking the sharpness and focus of your shot. When you are zoomed in, use the multi-selector to navigate around within the image. To view your other images at the same zoom ratio, you can rotate the Main Command dial. To return to full-frame playback, press the Zoom out button (⊝/ISO). You may have to press ⊝/ISO multiple times, depending on how much you have zoomed in.

▶ **Zoom out/Thumbnail/ISO button (🔍/ISO).** In Shooting mode, pressing this button and rotating the Main Command dial allows you to change the ISO settings. In Playback mode, pressing this button allows you to go from full-frame playback (or viewing the whole image) to viewing thumbnails. The thumbnails can be displayed as 4, 9, or 72 images on a page. You can also view images by calendar date. When you're viewing the menu options, pressing this button displays a help screen that explains the functions of that particular menu option. This button also allows you to zoom out after you have zoomed in on a particular image. Pressing and holding this button in conjunction with the 🔲 button resets the camera to the default settings.

Front of the camera

The front of the D600 (with the lens facing you) is where you find the buttons to quickly adjust the flash settings as well as some camera-focusing options, and with certain lenses, you will also find some buttons that control focusing and Vibration Reduction (VR).

▶ **Sub-command dial.** The Sub-command dial is used to adjust a number of different things, but by default, it's used to change the aperture setting in **A**, **M**, and **P** exposure modes. It also changes various settings when used with other buttons.

▶ **AF-assist illuminator.** This is an LED that shines on the subject to help the camera focus when the lighting is dim. The AF-assist illuminator only lights up when in Single-servo AF mode (**AF-S**) or Full-time-servo mode (**AF-F**) and the center AF point is selected. This LED also lights up when you set the camera to Red-Eye Reduction mode (**⚡◉**) using the camera's built-in flash.

▶ **Built-in flash.** This handy feature allows you to take sharp pictures in low-light situations. Although not as versatile as one of the external Nikon Speedlights, such as the SB-600 or SB-400, the built-in flash can be used very effectively and is great for snapshots. I highly recommend getting a pop-up flash diffuser if you plan on using it often. You can also use it to control off-camera Speedlights, which is a great option that isn't included on some of Nikon's lower-end models.

▶ **Preview button.** By default, this button stops down the aperture to the current setting (the lens aperture stays wide open until the shutter is released) so that you can see in real time what the depth of field will look like. It's a customizable button that you can change to a number of different settings. You can set the button to quickly change the image quality, ISO sensitivity, white balance, or Active D-Lighting settings via the Info display. Pressing the Preview button and rotating the Command dial changes the settings. You can change the setting options in ✏ f3.

▶ **Function button (Fn).** You can set the **Fn** button to a number of different settings so that you can access them quickly, rather than searching through the menu options manually. You can set the button to change the image quality, ISO sensitivity, white balance, or Active D-Lighting settings via the Info display. Pressing one of the command dials changes the settings, depending on which option is selected. You can change the setting options in the Setup menu (**Y**) in ✎ f2 under the Buttons option.

CROSS REF For a complete list of options for the Preview and **Fn** buttons, see Chapter 3.

▶ **Front infrared sensor.** This receiver picks up the infrared signal from the optional wireless remote, the ML-L3.

▶ **Built-in microphone.** This microphone can record sound while you're recording HD video. For best sound quality, I recommend using an external microphone.

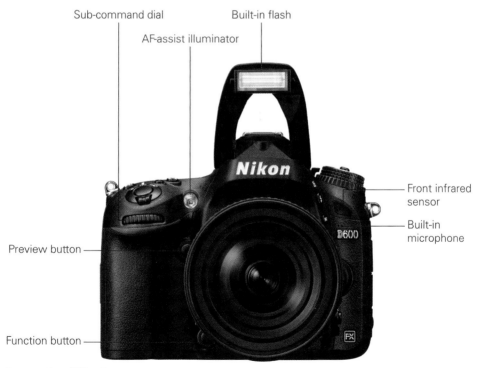

Image courtesy of Nikon, Inc.
1.3 Front of the Nikon D600

Right side of the camera

On the right side of the camera (with the lens facing you) are the output terminals on the D600. These terminals are used to connect your camera to a computer or to an external source for viewing your images directly from the camera. They are hidden under a rubber cover that helps keep out dust and moisture.

▶ **Flash pop-up/Flash mode/Flash Exposure Compensation button (⚡/🔲).** When you're using *P*, *S*, *A*, or *M* exposure mode, press this button to open and activate the built-in Speedlight. Pressing this button and rotating the Main Command dial on the rear of the camera allows you to choose a flash mode. Depending on the shooting mode, you can choose from Front-Curtain Sync (default) (⚡), Red-Eye Reduction (⚡⊙), Red-Eye Reduction with Slow Sync (🔲), Slow Sync (⚡ slow), Rear-Curtain Sync (⚡ rear), or Rear-Curtain Slow Sync (⚡ slow rear). Once the flash pops up, pressing this button and rotating the Main Command dial allows you to adjust the Flash Compensation (🔲). This enables you to adjust the flash output to make the flash brighter or dimmer depending on your needs. When you're shooting in Auto or scene modes, the flash is automatically activated and some Flash sync modes aren't available depending on the scene mode.

- **Auto (🅰), Portrait (🄿), Child (🄲), Close-up (🌷).** When using these modes, you can select Auto-flash (⚡ auto), Auto with Red-Eye Reduction (⚡⊙auto), or Off.

- **Night portrait.** With this mode, you can select Auto with Slow Sync and Red-Eye Reduction (🔲), Auto with Slow Sync (⚡ slow), or Off (🚫).

- *P*, *A*. With these modes, you can select ⚡⊙, 🔲, ⚡ slow, or ⚡ slow rear.

- *S*, *M*. These modes allow you to use ⚡⊙, or ⚡ rear.

▶ **Auto-bracketing button (BKT).** You use this button to activate the Auto-bracketing feature. Pressing the button and rotating the Main Command dial allows you to choose from a three-frame bracket (normal, under, over), or a two-frame bracket (normal, over, or normal, under). Rotating the Sub-command dial lets you choose the bracketing increments; by default you can choose 0.3, 0.7, 1, 2, or 3 EV. When ✎ b2 is set to 1/2 step, the choices are 0.5, 1, 2, or 3.

▶ **Lens mounting mark.** Most lenses have a white or red mark on them to help you to line up your lens bayonet so that it can be rotated and locked into place. Use this mark to line up with the mounting mark on the lens.

▶ **Lens release button.** This button disengages the locking mechanism of the lens, allowing the lens to be rotated and removed from the lens mount.

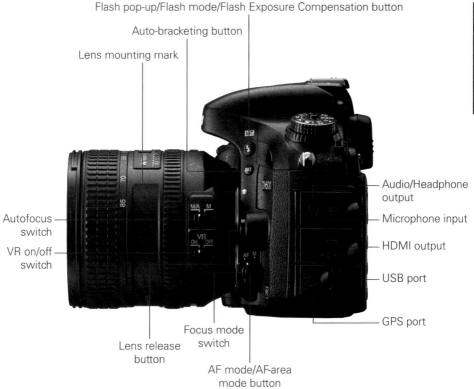

Flash pop-up/Flash mode/Flash Exposure Compensation button

Auto-bracketing button

Lens mounting mark

Autofocus switch

VR on/off switch

Audio/Headphone output

Microphone input

HDMI output

USB port

GPS port

Lens release button

Focus mode switch

AF mode/AF-area mode button

Image courtesy of Nikon, Inc.

1.4 The right side of the D600

▶ **AF mode/AF-area mode button/Focus mode switch.** Flipping the switch allows you to choose between autofocus and manual focus. Pressing the button and rotating the Main Command dial allows you to select the AF mode; you can choose Auto-area AF (AF-A), Single-servo AF (AF-S), or Continuous servo AF (AF-C). Rotating the Sub-command dial allows you to select the AF-area mode. In AF-S, you can choose Single-point AF ([□]) or Auto (■). In AF-A or AF-C, you can select from Single-point AF ([□], Dynamic-area AF ([⊡]) (9, 21, or 39 points), 3D-tracking ([3D]), or ■.

▶ **Microphone input.** You can use this port to connect an external microphone, which records sound for your videos at a better quality that you can get from the built-in microphone.

▶ **USB port.** This is where you plug in the USB cable, attaching the camera to your computer to transfer images straight from the camera to the computer. You can also use the USB cable to connect the camera to the computer when using Nikon's optional Camera Control Pro 2 software.

▶ **HDMI output.** This terminal is for connecting your camera to an HDTV or HD moni- tor. It requires a type C mini-pin HDMI cable that's available at any electronics store.

▶ **GPS port.** This is an accessory port that allows you to connect the optional Nikon GP-1 or a third-party GPS accessory for geo-tagging your images. You can also use this port for connecting the WT-T10 transceiver.

If you purchased the camera with a kit lens, there are a few switches on the lens as well. If you're using a different Nikon lens or a third-party lens, there may be different switches or no switches at all, depending on the lens and the features that it offers.

▶ **Autofocus switch.** This switch is used to choose between using the lens in Auto or Manual focus.

▶ **VR on/off switch.** This switch enables you to turn the Vibration Reduction (VR) on or off. When you're shooting in normal or bright light, it's best to turn the VR off to reduce battery consumption.

Left side of the camera

On the left side of the camera (with the lens facing you) is the memory card slot cover. Sliding this door toward the back of the camera opens it so you can insert or remove your memory cards.

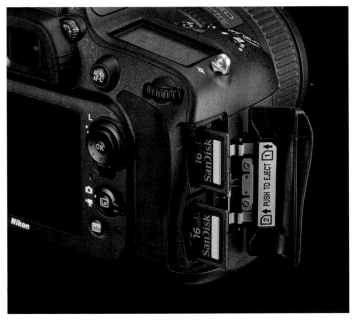

Image courtesy of Nikon, Inc.
1.5 Memory card slot cover

Viewfinder Display

The viewfinder display is kind of like the heads-up display in a jet plane. It allows you to see all the useful information about the settings of the camera. This aids you in setting up the shot without having to take your eye away from the viewfinder to check your settings. Most of the information also appears in the Information display, but it is less handy when you are looking through the viewfinder composing a shot. Here is a complete list of all the information you get from the viewfinder display:

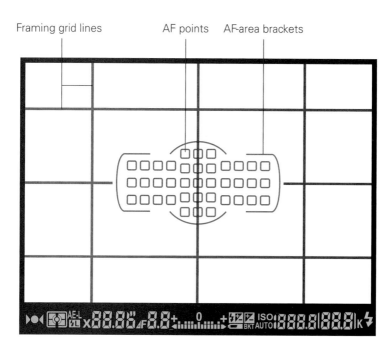

Framing grid lines · AF points · AF-area brackets

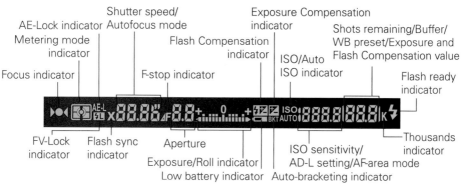

Shutter speed/
AE-Lock indicator Autofocus mode
Metering mode
indicator
Focus indicator · F-stop indicator

Exposure Compensation
indicator
Flash Compensation
indicator · ISO/Auto
ISO indicator

Shots remaining/Buffer/
WB preset/Exposure and
Flash Compensation value

Flash ready
indicator

FV-Lock · Flash sync
indicator · indicator · Aperture
Exposure/Roll indicator
Low battery indicator · Auto-bracketing indicator
ISO sensitivity/
AD-L setting/AF-area mode

Thousands
indicator

1.6 Viewfinder display

▶ **Framing grid.** When this option is turned on in the ✐ d2 menu, you will see a grid displayed in the viewing area. Use the grid to line up elements of your composition to ensure they are straight.

▶ **AF points.** The first thing you are likely to notice when looking through the viewfinder is a small rectangle near the center of the frame. This is your active focus point. Note that only the active focus point is shown full-time when you're using the [⊡], [⊞], or [3D] AF setting. When you set the camera to Auto-area AF (■), no focus point is shown until the shutter-release button is half-pressed and focus is achieved. When you use AF-S, the AF point lights up momentarily and disappears. When you use AF-C, the AF point lights up and remains lit, although the point may change if the focus point shifts due to camera or subject movement.

▶ **AF-area brackets.** These brackets are used to indicate where the boundaries of the AF points are. The AF system does not recognize anything that lies outside the brackets. In the middle of the AF-area brackets on the top and bottom there is a semi-circle, which is the 12mm center-weighted metering circle.

▶ **Focus indicator.** This green dot lets you know whether the camera detects that the scene is in focus. When focus is achieved, the green dot lights up; if the camera is not in focus, no dot is displayed. On either side of a dot is an arrow. When the left arrow lights up, the focus is in between the camera and the subject; when the right arrow lights up, the focus is falling behind the subject. Both arrows blinking indicates that the camera is unable to achieve focus.

▶ **Metering mode indicator (▨).** This indicator shows you which metering mode is active: Matrix metering (▨), Center-weighted metering (◉), or Spot metering (⊡).

▶ **AE-Lock indicator (AE-L).** When this indicator lights up, you know that the Autoexposure has been locked.

▶ **FV-Lock indicator (⚡L).** When this indicator lights up, it means you have locked in the flash exposure value. The flash value (FV) can only be locked when the **Fn** button (or Preview button) has been set to do this.

▶ **Flash sync indicator (▨).** This indicator is displayed as a small X. It comes on when you set your camera to the sync speed in ✐ e1. This setting is only available in **S** mode or **M** mode. To set the camera to the preset sync speed, dial the shutter speed down one setting past the longest shutter time, which is 30 seconds in **S** mode and Bulb in **M** mode.

▶ **Shutter speed/Autofocus mode.** This indicator shows how long your shutter is set to stay open, from 30 seconds (30") up to 1/4000 (4000) second. When you press the AF mode button, this shows your AF mode setting (AF-A, AF-C, or AF-S).

▶ **F-stop indicator.** This indicator appears when a non-CPU lens is attached that hasn't had non-CPU lens data entered. The camera displays the aperture steps in numbers. When wide open, the indicator reads F0, and each stop you click down is another full number; for example, stop down to f/5.6 when using an f/2.8 lens and the indicator reads F2. Stop down to f/22 and it reads F6, which is 6 stops away from f/2.8.

▶ **Aperture.** This indicator shows your current aperture setting. The words *aperture* and *f-stop* are used interchangeably. Your aperture setting indicates how wide your lens opening is. The aperture setting appears as numbers (1.4, 2, 2.8, 4, 5.6, and so on).

▶ **Exposure indicator/Exposure Compensation indicator/Roll indicator.** When the bars are in the center, you are at the proper settings to get a good exposure; when the bars are to the left, you are underexposed, and when the bars are to the right, you are overexposing your image at those settings (you can reverse this in ✐ f8). This option only appears when in ⅄ mode and when ⊞ is applied. This display also doubles as a roll indicator for the Virtual horizon feature that allows you to ensure your camera is level, which is great when shooting landscapes. When the camera is tilted to the right, the bars appear on the left. When the camera is tilted to the left, the bars appear on the right. When the camera is level, a single bar appears directly under the zero. To use this feature, you must assign the Virtual viewfinder horizon to either the **Fn** button or Preview button.

▶ **Flash Compensation indicator (⊞).** When this indicator appears, Flash Exposure Compensation is on. You adjust FEC by pressing the Flash mode button (✦) and rotating the Sub-command dial.

▶ **Low battery indicator (▭).** This indicator appears when the battery is low. When the battery is completely exhausted, this icon blinks and the shutter-release is disabled.

▶ **Auto-bracketing indicator (BKT).** This indicator appears when Auto-bracketing is engaged.

▶ **ISO indicator (ISO).** When you press the **ISO** button, this indicator shows up next to the ISO sensitivity setting, letting you know that the numbers you are seeing are the ISO numbers.

▶ **Auto ISO indicator (ISO-A).** This indicator appears when the Auto ISO setting is activated to let you know that the camera is controlling the ISO settings. You can turn on Auto ISO in the ISO sensitivity settings, located in the Shooting menu (◉), or by pressing ◎/ISO and rotating the Sub-command dial.

▶ **ISO sensitivity/AD-L setting/AF-area mode.** By default this readout displays the ISO sensitivity setting number. If Active D-Lighting is assigned to the Preview button or **Fn** button, then when you press the button the AD-L amount is displayed here. Pressing the button and rotating the Main Command dial changes the setting. When you press the AF-area mode button, the AF-area mode is displayed.

▶ **Shots remaining/Buffer/WB preset/Exposure and Flash Compensation value.** By default, this set of numbers lets you know how many more exposures can fit on the memory card. The actual number of exposures may vary according to file information and compression. When you half-press the shutter-release button, the display changes to show how many exposures can fit in the camera's buffer before the buffer is full and the frame rate slows down. The buffer is in-camera RAM that stores your image data while the data is being written to the memory card. This also shows the WB preset recording indicator (PRE), as well as ⊞ values and ⊞⊞ values.

▶ **Thousands indicator (⊠).** This indicator lets you know that there are more than 1,000 exposures remaining on your memory card.

▶ **Flash ready indicator (⚡).** When this indicator appears, the flash, whether it is the built-in flash or an external Speedlight attached to the hot shoe, is fully charged and ready to fire at full power.

Control Panel

The control panel on the top of the camera gives you a quick way to reference some of the most important settings on your D600.

▶ **Kelvin color temperature indicator (K).** This indicator displays to alert you that the numbers you are seeing represent the color temperature in the Kelvin scale. It only appears when you have set the camera to Kelvin WB and you press the **WB** button.

▶ **Shutter speed.** By default, this set of numbers shows you the shutter speed setting. These numbers also show a myriad of other settings depending on which buttons you are pressing and what modes are activated. Here's a list:

 • **Exposure compensation value.** When you press the ⊞ button and rotate the Sub-command dial, the exposure value (EV) compensation number appears.

 • **FEC value.** Pressing the ⚡ button and rotating the Sub-command dial displays the FEC value.

Shutter speed/Exposure compensation value/FEC value/WB fine-tuning/
Color temperature/WB preset number/Bracketing sequence/
Interval timer number/Focal length (non-CPU lenses)

Kelvin color temperature indicator

Flash sync indicator Aperture indicator

MB-D14 battery
indicator

Battery indicator

F-stop/Aperture (number
of stops)/Auto-bracketing
compensation
increments/Number of
shots per interval/
Maximum aperture
(non-CPU lenses)/PC
mode

Flash modes

Autofocus mode
JPEG image size

Memory card indicators
(slot 1, slot 2)

Image quality
and compression

ISO/Auto ISO indicator
Interval timer/Time
lapse indicator

WB fine-tuning indicator WB setting indicator

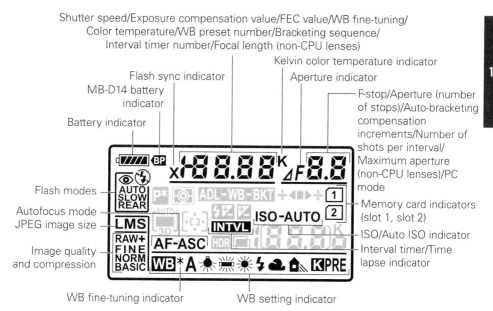

Metering mode indicator

Flexible program indicator Auto-bracketing indicator

Bracketing progress
indicator

Exposure
Compensation indicator

Auto-area AF/3D-
tracking indicator

Flash Compensation
indicator

AF-area mode
indicator

Thousands indicator

HDR mode indicator

Remaining exposures/Buffer/Capture
mode indicator/ISO sensitivity/Preset
white balance recording indicator/
Active D-Lighting amount/Non-CPU
lens number/HDMI-CEC indicator

Multiple exposure indicator

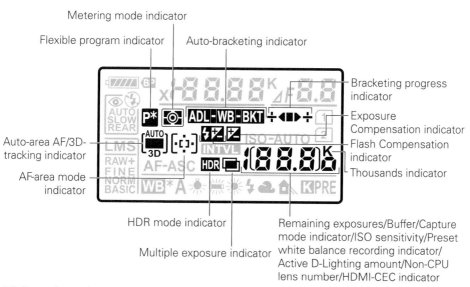

1.7 Control panel

19

- **WB fine-tuning.** Pressing the **WB** button and rotating the Sub-command dial fine-tunes the white balance setting. A is warmer and B is cooler.

- **Color temperature.** When you set the WB to K, the panel displays the color temperature in the Kelvin scale when you press the **WB** button.

- **WB preset number.** When you set the WB to one of the preset numbers, pressing the **WB** button displays the preset number currently being used.

- **Bracketing sequence.** When the D600 Auto-bracketing feature is activated, pressing the **BKT** button displays the number of shots left in the bracketing sequence. This includes WB, exposure, and flash bracketing.

- **Interval timer number.** When you set the camera to use the interval timer for time-lapse photography, this displays the number of shots remaining in the current interval.

- **Focal length (non-CPU lenses).** When the camera's **Fn** button is set to choose a non-CPU lens number when you press the **Fn** button, the focal length of the non-CPU lens appears. You must enter the lens data in the ⚒ menu.

▶ **MB-D14 battery indicator.** When the MB-D14 battery grip is attached and the camera is using the battery installed in the grip, this icon appears.

▶ **Battery indicator.** This display shows the charge remaining on the active battery. When this indicator is blinking, the battery is dead and the shutter is disabled.

▶ **Flash modes.** These icons denote which flash mode you are using. The flash modes include Red-Eye Reduction (🔆⊚), Red-Eye Reduction with Slow Sync (🖼️), Slow Sync (🔆 ꜱʟᴏᴡ), and Rear-Curtain Sync (🔆 ꜱʟᴏᴡ ʀᴇᴀʀ). To change the Flash sync mode, press the 🔆 button and rotate the Main Command dial.

▶ **Autofocus mode.** This indicator lets you know which focus mode is being used: AF-A, AF-C, or AF-S.

▶ **JPEG image size.** When you're shooting JPEG or RAW + JPEG files, this indicator tells you whether you are recording Large, Medium, or Small files. This display is turned off when shooting RAW files.

▶ **Image quality and compression.** This indicator displays the type of file format you are recording. You can shoot RAW or JPEG. When you're shooting JPEG or RAW + JPEG, it displays the compression quality: FINE, NORM, or BASIC.

▶ **WB fine-tuning indicator.** When the white balance fine-tuning feature is activated, this asterisk appears. You can fine-tune WB by pressing the WB button and rotating the Sub-command dial.

▶ **WB setting indicator.** This indicator shows you which white balance setting is currently selected.

▶ **Aperture indicator.** This icon appears when a non-CPU lens is attached without the non-CPU lens data being entered. This indicates that the numbers next to it are not aperture settings, but aperture stops starting from F0, which is wide open.

▶ **F-stop.** At the default settings, this indicator displays the aperture at which the camera is set. It also displays other settings as follows:

 • **Aperture (number of stops).** This shows the number of stops for a non-CPU lens with no data entered into the camera.

 • **Auto-bracketing compensation increments.** You can adjust the exposure bracketing to over- and underexpose in 1/3-stop increments. When you set the **Fn** button to Auto-bracketing, the number of EV stops appears here. The choices are 0.3, 0.7, or 1.0 EV. You can also adjust the WB Auto-bracketing; the settings are 1, 2, or 3.

 • **Number of shots per interval.** When you set the D600 to Interval Timer shooting, this indicator displays the number of frames shot in the interval.

 • **Maximum aperture (non-CPU lenses).** When a non-CPU lens is attached and the non-CPU lens data has been entered, this indicator displays the aperture setting of the specified lens.

 • **PC mode.** This indicator appears as PC when you connect the D600 to a computer via a USB cable.

▶ **Memory card indicators (slot 1, slot 2).** This indicator appears when a memory card is inserted into a slot. If a number appears in the icon, the slot contains the active card and the images are being recorded to it. Both slots can be active when you're using slot 2 as a backup or recording RAW to slot 1 and JPEG to slot 2.

▶ **ISO/Auto ISO indicator.** ISO indicates that the numbers below are the ISO sensitivity settings. ɪsᴏ-ᴀ appears when the Automatic ISO setting is activated to let you know that the camera is controlling the ISO settings.

▶ **Interval timer/Time lapse indicator (INTVL).** When you turn on the camera's Interval timer or Time lapse option, this indicator appears in the control panel.

▶ **Metering mode indicator.** This indicator displays the metering mode setting (⊞, ⊙, ⊡).

▶ **Flash sync indicator (◙).** This indicator appears as a small X when you set your camera to the sync speed in ✎ e1. This is only available in **S** mode or **M** mode. To set the camera to the preset sync speed, dial the shutter speed down one setting past the longest shutter time, which is 30 seconds in **S** mode and Bulb in **M** mode.

▶ **Flexible program indicator (P*).** When using **P** exposure mode, this indicator appears when the settings have been changed from their default to an equivalent exposure.

▶ **Auto-area AF mode/3D-tracking indicator.** This indicator lets you know if the Auto-area AF mode (▣) or 3D-tracking (▣) is selected and in use.

▶ **HDR mode indicator (▣).** This indicator appears when the camera is set to shoot High Dynamic Range images. You can set this option in the ▣ menu. Note that this can only be enabled when shooting JPEG only.

▶ **Multiple exposure indicator.** This icon informs you that the camera is set to record multiple exposures. You set multiple exposures in the ▣ menu.

▶ **Auto-bracketing indicator.** When the D600 is in the Autoexposure or flash bracketing setting, this indicator appears on the control panel; when it is using WB bracketing, a WB icon (**WB**) also appears. When using Active D-Lighting bracketing, the ADL indicator (▣) appears. You set Auto-bracketing in ✎ e6.

▶ **Bracketing progress indicator.** This indicator shows you your place in the bracketing sequence when Auto-bracketing is turned on.

▶ **Exposure Compensation indicator.** When this icon appears in the control panel, your camera has exposure compensation activated. This affects your exposure. Adjust the exposure compensation by pressing the ▣ button and rotating the Main Command dial.

▶ **Thousands indicator (◙).** This icon lets you know that there are more than 1,000 exposures remaining on your memory card.

▶ **Remaining exposures.** By default, this indicator displays the number of remaining exposures. It also displays a few other things, depending on the mode and what buttons are being pressed, as follows:

- **Buffer.** When you half-press the shutter-release button, the indicator displays the number of shots remaining until the buffer is full.

- **Capture mode indicator.** This indicates specific settings when the camera is connected to a computer through the USB (PC) port, and other settings when using Capture Control Pro 2 or the WT-4 wireless transmitter.

- **ISO sensitivity.** This is the ISO sensitivity setting number.

- **Preset white balance recording indicator.** When recording a custom WB, the indicator flashes PRE.

- **Active D-Lighting amount.** This only appears when you assign Active D-Lighting to the **Fn** or Preview button and press that button. It displays the current setting (Auto, Off, HP [Extra High], H [High], n [Normal], L [Low]).

- **Non-CPU lens number.** This only appears when you assign non-CPU lens data to the **Fn** or Preview button and press that button. It displays the number of the lens setting (n-1–n-9).

- **HDMI-CEC indicator.** When your camera is connected to an HDMI device that supports HDMI-CEC (Consumer Electronics Control), this icon appears. This means that the multi-selector is disabled and the HDMI device remote is controlling the playback.

Information Display

The Information display, which I refer to as the Info display for brevity, shows some of the same shooting information that appears in the viewfinder, but there are also quite a few settings that only appear here. When this display appears on the rear LCD, you can view and change some of the settings without looking through the viewfinder.

You activate the Info display by pressing the Info button (⊞), located on the bottom right of the camera directly under the focus selector lock. Pressing the ⊞ button twice brings up the Info display settings, which allows you to change some key settings on the camera. These settings are detailed in Figure 1.8. By default, when the Info display settings are active, using the multi-selector highlights the setting you want to change and the D600 displays the Screen tips to guide you through what each setting does. If you don't want Screen tips to appear, you can turn this feature off in ✐ d4.

The information remains on display until no buttons have been pushed for about 10 seconds (default) or you press the shutter-release or ⊞ button.

Shutter speed/Exposure compensation value/Flash Compensation value/Number of shots in bracketing sequence/Focal length (non-CPU lenses)

Flash sync indicator

Release mode/
Continuous
shooting
speed

Kelvin color temperature indicator

Flexible program indicator

Shooting mode

Aperture indicator

F-stop/Aperture number

Exposure indicator/
Auto-bracketing progress
indicator

Flash modes

Image quality

Camera battery indicator

MB-D14 battery indicator

Image size

Thousands indicator

AF-area/AF point/
Auto-AF/3D-tracking
indicator

Exposures remaining/
Non-CPU lens number/
Time lapse

HDR mode indicator White balance indicator

Copyright info indicator

Image comment indicator

Clock not set indicator

Multiple exposure indicator

Auto-bracketing indicator

AD-L bracketing amount

Image area

FV-Lock indicator

Picture Control
indicator

Beep indicator

Exposure Compensation
indicator

ISO sensitivity/
Auto ISO indicator

Flash Compensation
indicator

Eye-Fi indicator

Autofocus mode

Matrix button

Auto distortion control

Inverval timer/Time lapse indicator

GPS connection indicator

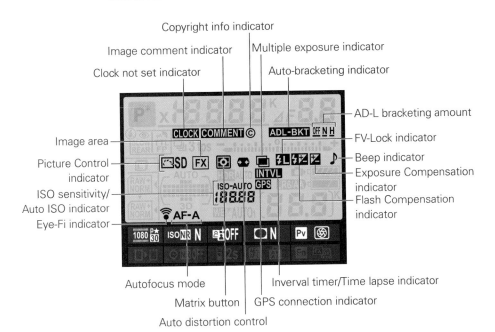

1.8 Information display

This display shows you everything you need to know about your camera settings. Additionally, the camera has a sensor built in that tells it when you are holding it vertically, and the Info display is shown upright, regardless of which way you are holding your camera.

▶ **Shooting mode.** This indicator displays the shooting mode that your camera is currently set to. This can be one of the scene modes (in which case it displays the appropriate icon), or one of the other exposure modes, such as *P*, *S*, *A*, or *M*. This display changes when you rotate the Mode dial.

▶ **Flexible program indicator (*P**).** This icon appears when using *P* mode to indicate that you have changed the default Autoexposure setting to better suit your creative needs.

▶ **Flash sync indicator (X).** This indicator appears when you set your camera to the sync speed in ✐ e1. This is only available in *S* or *M* mode. To set the camera to the preset sync speed, dial the shutter speed down one setting past the longest shutter time, which is 30 seconds in *S* mode and Bulb in *M* mode.

▶ **Shutter speed.** By default this indicator displays the shutter speed setting. It also shows a few other settings, as follows:

 ● **Exposure compensation value.** When you press the 🔲 button and rotate the Sub-command dial, the exposure value (EV) compensation number appears.

 ● **Flash Compensation value.** Pressing the ✦ button and rotating the Sub-command dial displays the Flash Compensation value.

 ● **Number of shots in bracketing sequence.** When you press the **BKT** button, you look here to determine the settings.

 ● **Focal length (non-CPU lenses).** When the camera's Function button is set to choose a non-CPU lens number when you press the **Fn** button, the focal length of the non-CPU lens is displayed. You must enter the lens data in the Y menu.

▶ **Kelvin color temperature indicator (K).** This indicates that the number immediately preceding it is the color temperature in the Kelvin scale. This isn't to be confused with the thousands indicator 🔲.

▶ **Aperture indicator.** This icon appears when a non-CPU lens is attached without the non-CPU lens data being entered. This indicates that the numbers next to it are not aperture settings, but aperture stops starting from F0, which is wide open.

▶ **F-stop/Aperture number.** At the default settings, this indicator displays the aperture at which the camera is set. It also displays other settings as follows:

- **Aperture (number of stops).** This shows the number of stops for a non-CPU lens with no data entered into the camera.

- **Auto-bracketing compensation increments.** You can adjust the exposure bracketing to over- and underexpose in 1/3-stop increments. When you press the **BKT** button to Auto-bracketing, the number of EV stops appears in this area. The choices are 0.3, 0.7, or 1.0 EV. You can also adjust the WB Auto-bracketing; the settings are 1, 2, or 3.

- **Maximum aperture (non-CPU lenses).** When a non-CPU lens is attached and the non-CPU lens data has been entered, the aperture setting of the specified lens appears.

- **Active D-Lighting amount.** This displays the number of shots left in the Active D-Lighting sequence if the auto-bracketing feature is set to Active-D Lighting.

▶ **Release mode/Continuous shooting speed.** This indicator displays the Release mode settings. When you set the camera to a Continuous Release mode, the frames per second (fps) also appears.

▶ **Exposure Indicator.** When the bars are in the center, you are at the proper settings to get a good exposure; when the bars are to the left, you are overexposed; when the bars are to the right, you are underexposing your image. You can reverse this setting in ✦ f8.

- **Exposure compensation display.** If any exposure compensation or flash compensation is applied, the indicator shows that you have an under- or overexposed image.

- **Auto-bracketing progress indicator.** When you have turned on Auto-bracketing, you can use this indicator to track your progress. The display shows a small line under the 0 (normal), the + side (overexposure), and the − side (underexposure).

- **White balance indicator.** When you set bracketing to WB, three small lines appear on either side of the zero, indicating each shot to be taken. The line disappears when you have taken the shot.

▶ **HDR mode indicator (HDR).** This indicator appears when you set the camera to shoot High Dynamic Range images. You set this option in the ◻ menu under HDR (high dynamic range). HDR is NOT available when shooting RAW or RAW + JPEG.

▶ **AF-area/AF point/Auto-AF/3D-tracking indicator.** This indicator shows the AF-area mode and the active AF point, and it denotes when the AF area is set to Auto or 3D-tracking.

▶ **Camera battery indicator.** This indicator shows the charge remaining on the battery that is in the camera.

▶ **MB-D14 battery indicator.** When you are using an optional MB-D14 battery grip, this indicator displays the type of battery being used as well as the amount of charge remaining on the battery.

▶ **Thousands indicator (ꓘ).** This icon lets you know that there are more than 1,000 exposures remaining on your memory card.

▶ **Exposures remaining/Non-CPU lens number/Time lapse.** This indicator displays the number of exposures remaining. When the **Fn** or Preview button is assigned to non-CPU lens data, this indicator displays the lens number for the selected lens. It also displays the shooting time left remaining in hours and minutes when you use the time-lapse photography option.

▶ **White balance indicator.** This indicator shows your WB settings. If the WB has been changed from the default, an asterisk appears.

▶ **Image quality.** The image quality settings appear here. There are two areas: one for slot 1 and one for slot 2.

▶ **Image size.** This indicator displays the size settings for JPEG images.

▶ **Flash modes.** This indicator displays the different flash modes and settings.

▶ **Image area.** This indicator shows whether the camera is set to FX (⬛) or DX (⬛) mode.

▶ **Metering (⬛).** This indicates your metering mode (⬛, ⊙, or ⬛).

▶ **Auto distortion control (⬛).** This indicator appears when you activate the auto distortion control (you can find this setting in the ⬛ menu).

▶ **Clock not set indicator.** When this indicator appears, the camera's internal clock has not been set and the time and date will not appear in the EXIF (Exchangeable Image File Format) data.

▶ **Image comment indicator.** You can add a line or two of text into the EXIF data using the Image comment option. This indicator informs you that this feature is on.

▶ **Copyright info indicator.** You can program the D600 to add copyright information to the EXIF data of all your images. When you turn this option on, this indicator appears.

▶ **Auto-bracketing indicator.** This indicator appears when you turn on the D600 Auto-bracketing feature.

▶ **AD-L bracketing amount.** This indicator shows the amount of Active D-Lighting that is being applied with AD-L bracketing.

▶ **Multiple exposure indicator.** This icon appears when you activate the multiple exposure feature.

▶ **Beep indicator (♪).** When you set the camera to beep for AF confirmation (✦ d1), ♪ appears here.

▶ **Exposure Compensation indicator (⊞).** This icon appears when exposure compensation is applied.

▶ **Flash Compensation indicator (⚡⊞).** This is displayed when the flash exposure has been adjusted using Flash Exposure Compensation.

▶ **FV-Lock indicator (⚡L).** This indicator is displayed when the flash value has been locked. To lock the flash value, you must assign either the Preview button or **Fn** button.

▶ **Interval timer/Time lapse indicator (INTVL).** When you set the camera to shoot at intervals or time-lapse, the **INTVL** icon is shown.

▶ **GPS connection indicator.** This indicator appears when using an optional GPS device with the D600. If the icon is flashing the GPS unit is searching for a signal, if no icon is shown there is no GPS connection, and if the GPS indicator is solid the GPS unit has a connection.

▶ **Aufofocus mode.** This indicator lets you know which AF-area mode is selected and in use.

▶ **Eye-Fi indicator.** When an optional Eye-Fi memory card is being used in the camera, this icon appears.

▶ **ISO sensitivity/Auto ISO indicator.** This indicator displays the ISO sensitivity setting. If you turn on Auto-ISO, the ISO-A appears.

▶ **Picture Control indicator (⊡).** This indicator displays your Picture Control settings.

The following are adjustable settings. Pressing the ⊡ button twice gives you access to these common settings so that you can change them quickly. Once you have selected an option, pressing ⓞⓚ brings up the Settings menu.

▶ **Movie quality settings.** This allows you to change the resolution quality of the videos.

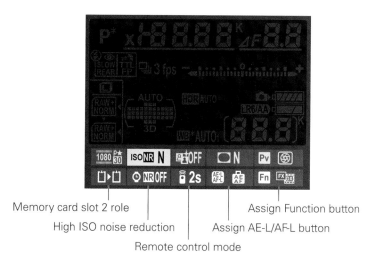

Memory card slot 2 role

High ISO noise reduction

Remote control mode

Assign Function button

Assign AE-L/AF-L button

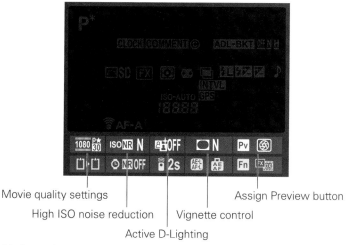

Movie quality settings

High ISO noise reduction

Active D-Lighting

Vignette control

Assign Preview button

1.9 Info settings display

▶ **High ISO noise reduction.** You can adjust the high ISO noise reduction settings here.

▶ **Active D-Lighting.** You can change the Active D-Lighting settings here.

▶ **Vignette control.** This option allows you set the lens vignette control quickly.

▶ **Assign Preview button.** This option allows you to change the settings for the Preview button.

▶ **Memory card slot 2 role.** This option allows you to change the settings for the function of the memory card in slot 2 (if one is used).

▶ **Remote control mode.** This option allows you to change the settings of the Remote control mode.

▶ **Assign** 🔒 **button.** You can assign different functions to the 🔒 button using this menu option.

▶ **Assign Fn button.** This is where you select the settings for the **Fn** button.

Nikon D600 Essentials

O nce you're comfortable with the basic layout of the D600 and all of its dials, switches, and buttons, you can dive into the most important settings. These settings allow you to capture your images exactly as you want. They are also the settings that will change most frequently as they include exposure modes, autofocus, metering, white balance, ISO sensitivity, and so on. All of these settings combined help create the image exactly as you envision it.

Knowing which modes and features to use in any given situation allows you to get a good exposure, no matter what. For this high contrast image I used the HDR feature.

Exposure Modes

Exposure modes dictate how the D600 chooses the aperture and shutter speed, as well as the metering mode. Metering modes control how the camera gathers the lighting information so that the camera can choose the appropriate settings based on the exposure mode.

The four main exposure modes are Programmed auto (**P**), Aperture-priority auto (**A**), Shutter-priority auto (**S**), and Manual (**M**). These are all you need to achieve the correct exposure, but for simplicity and ease of use, Nikon also offers scene modes. When you use these modes, the camera chooses the most ideal settings for different situations. The modes designate everything from AF modes to Picture Controls, flash, and ISO settings, although you are able to adjust some of these. To switch among the exposure modes, simply press the Mode dial lock release button and rotate the large Mode dial on the top of the camera.

Programmed auto

Programmed auto (**P**) is an automatic mode that's best for shooting snapshots and scenes where you're not concerned about having complete control over the settings.

When the camera is in **P**, it decides the shutter speed and aperture settings for you based on a set of algorithms. The camera does its best to select a shutter speed that allows you to shoot handheld without suffering from camera shake while also adjusting your aperture so that you get sufficient depth of field to ensure everything is in focus. When the camera body is coupled with a lens that has a CPU built in (all Nikon AF lenses have a CPU), the camera automatically knows what focal length and aperture range the lens has. The camera then uses this lens information to decide what the optimal settings should be.

This exposure mode chooses the widest aperture possible until the optimal shutter speed for the specific lens is reached. Then the camera chooses a smaller f-stop and increases the shutter speed as light levels increase. For example, when you use a 24-70mm f/2.8 zoom lens at the 24mm setting, the camera keeps the aperture wide open until the shutter speed reaches about 1/30 second (just above minimum shutter speed to avoid camera shake). Upon reaching 1/30 second, the camera adjusts the aperture to increase depth of field.

NOTE When you use Auto ISO (ISO-A) with **P** mode, the camera tries to hold the shutter speed at the number specified in the ISO-A sensitivity settings.

The exposure settings selected by the camera appear in both the LCD control panel and the viewfinder display. Although the camera chooses what it thinks are the optimal settings, it does not know your specific needs. For example, you may want a wider or smaller aperture for selective focus. Fortunately, you aren't stuck with the camera's exposure choice. You can engage what is known as *flexible program*.

Flexible program allows you to deviate from the camera's selected aperture and shutter speed when you are in *P* mode. You can automatically engage this feature by simply rotating the Main Command dial until you get the desired shutter speed or aperture. This allows you to choose a wider aperture/faster shutter speed when you rotate the dial to the right, or a smaller aperture/slower shutter speed when you rotate the dial to the left. With flexible program, you can maintain the metered exposure while still having some control over the shutter speed and aperture settings.

A quick example of using flexible program would be if the camera has set the shutter speed at 1/60 second with an aperture of f/8, you're shooting a portrait, and you want a wider aperture to throw the background out of focus. By rotating the Main Command dial to the right, you can open the aperture up to f/4, which causes the shutter speed to increase to 1/250 second. This is an *equivalent exposure,* meaning you get the same exposure but the settings are different.

When flexible program is on, an asterisk appears next to the *P* on the LCD control panel like this: *P**. Rotate the Main Command dial until the asterisk disappears to return to the default *P* settings (or turn the camera off and back on).

NOTE *P* mode is not available when you use non-CPU lenses. When you're in *P* mode with a non-CPU lens attached, the camera automatically selects *A* mode. *P* continues to appear on the LCD control panel, but **A** appears in the viewfinder display.

NOTE In *P* mode, if there is not enough light to make a proper exposure, the camera displays Lo in place of the shutter speed setting.

Aperture-priority auto

Aperture-priority auto (*A*) is a semiautomatic mode. In this mode, you decide which aperture to use by rotating the Sub-command dial, and the camera sets the shutter speed for the best exposure based on your selection. Situations in which you may

want to select the aperture include when you're shooting a portrait and you want a large aperture (small f-stop number) to blur out the background by minimizing depth of field, or when you're shooting a landscape and you want a small aperture (large f-stop number) to ensure the entire scene is in focus by increasing depth of field.

2.1 Shooting in Aperture-priority auto mode and setting a wide aperture of f/1.4 makes the background an indistinct blur. Exposure: ISO 100, f/1.4, 1/100 second using a Nikon 50mm f/1.4G.

2.2 Shooting Aperture-priority auto mode and setting a smaller aperture of f/5.6 makes the background more recognizable. Exposure: ISO 2800, f/5.6, 1/100 second using a Nikon 50mm f/1.4G.

Choosing the aperture to control depth of field is one of the most important aspects of photography and allows you to selectively control which areas of your image, from foreground to background, are in sharp focus and which areas are allowed to blur. Controlling depth of field enables you to draw the viewer's eye to a specific part of the image, which can make your images more dynamic and interesting to the viewer.

NOTE When using **A** mode, if there is not enough light to make a proper exposure, the camera displays Lo in place of the shutter speed setting.

Shutter-priority auto

Shutter-priority auto (**S**) is another semiautomatic mode. In this mode, you choose the shutter speed by rotating the Main Command dial, and the camera automatically sets the aperture. You can choose shutter speeds from as long as 30 seconds to as short as 1/4000 second.

TIP When you're in **S** mode, dialing the shutter speed one click past the longest shutter speed of 30 seconds sets the shutter speed to the Flash sync speed. You can set the Flash sync speed in the Custom Settings menu (✐ e1).

You generally use **S** mode for shooting moving subjects or action scenes. Choosing a fast shutter speed allows you to freeze the action of a fast-moving subject. A good example would be if you were shooting sports. Running athletes may move extremely fast, so you'd need to use a shutter speed of about 1/500 second or faster to freeze the motion of the athlete and prevent blur. This would allow you to capture the details of the subject with sharp definition.

You can also use **S** mode to set a slow shutter speed. A slow shutter speed allows you to introduce many creative effects into your photography. Selecting a slow shutter speed of about 1/2 to 4 seconds allows you to create a motion blur from any subjects that may be moving in the frame. Shooting flowing water with a slow shutter speed gives it a smooth, glassy appearance, while shooting a scene with moving automobiles creates cool light trails from the head- and taillights. Of course, to achieve a slow shutter speed, the lower the light the better. Also, keep in mind that it's best to use a tripod when attempting long exposures.

2.3 Using Shutter-priority auto mode and a fast shutter speed of 1/500 second, I froze the motion of these moving fan blades. Exposure: ISO 100, f/1.4, 1/500 second using a 50mm f/1.4G.

2.4 Using Shutter-priority auto mode and setting a slow shutter speed of 0.6 second, I was able to capture the motion of these moving fan blades. Exposure: ISO 100, f/14, 0.6 second using a 50mm f/1.4G.

Even when you shoot quick action, you may sometimes want to use a slower shutter speed. Panning along with a moving subject when using a slower shutter speed allows you to blur the background while keeping the subject in relatively sharp focus. The blur of the background is extremely effective at portraying motion in a still photograph.

> **NOTE** In **S** mode, if there is not enough light to make a proper exposure, the camera displays Lo in place of the aperture setting.

Manual

When the camera is in Manual mode (**M**), you set both the aperture and shutter speed settings. You can estimate the exposure, use a handheld light meter, or use the

electronic analog exposure display on the D600 to determine the exposure needed. In the following situations, you may want to set the exposure manually:

▶ **When you want complete control over exposure.** Usually the camera decides the optimal exposure based on technical algorithms and an internal database of image information. However, what the camera decides is optimal may not necessarily be optimal in your mind. You may want to underexpose the image to make it dark and foreboding, or you may want to overexpose it a bit to make the colors *pop* (making them bright and contrasty). When you set your camera to M, you can choose the settings and place your image in whatever tonal range you want without having to fool with exposure compensation settings.

▶ **When you use studio flash.** When you use studio strobes or external non-dedicated flash units, you don't use the camera's metering system. When using external strobes, you need a flash meter or manual calculation to determine the proper exposure. Using M mode, you can quickly set the aperture and shutter speed to the proper exposure; just be sure not to set the shutter speed above the rated sync speed of 1/250 second.

▶ **When you use non-CPU lenses.** When you use older non-CPU lenses, the camera is automatically set to A mode with the camera choosing the shutter speed. Switching to M allows you to select both the shutter speed and aperture while using the camera's analog light meter that appears in the viewfinder display.

U1/U2

First introduced on the D7000, the User Settings allow you to store two different presets so that you can quickly access the settings simply by rotating the Mode dial. This feature has quickly become a favorite with many D7000 users.

CROSS REF User Settings are covered in more detail in Chapter 8.

Scene modes

If you're accustomed to using the fully Auto modes, you may have noticed — especially when shooting in difficult lighting situations or other special circumstances — that they do not always give you the results that you desire. The D600 scene modes take into account different lighting situations and modify the way the camera meters the light. Scene modes also control the autofocus and flash settings, and the aperture, shutter speed, Picture Controls, and ISO sensitivity settings.

The camera may also determine whether there is enough light to make an exposure, and then activate the built-in flash if the light is insufficient. Conversely, in some scene modes, such as Landscape, the camera also makes sure that the flash is not used, even in low-light situations.

The D600 has 19 scene modes to cover almost every possible shooting scenario, which allows you to focus on capturing the image without worrying about the camera settings. The camera has the parameters programmed into it; you simply rotate the Mode dial to **SCENE**, and then choose the setting from the menu option on the LCD screen by rotating the Main Command dial.

NOTE When you use scene modes, you cannot adjust the white balance (WB), Picture Controls, or Active D-Lighting settings. Although each scene mode has default settings for ISO, AF-area, AF modes, and flash modes, you can change them. These settings return to their defaults when you turn the camera off or turn the Mode dial to another setting.

NOTE The D600 HDR and Multiple exposure features are disabled when using scene modes.

Portrait

Portrait mode (🖾) is for taking pictures of people. The camera automatically adjusts the colors to provide natural-looking skin tones. It focuses on the closest subject and also attempts to use a wide aperture, if possible, to reduce the depth of field. This draws attention to the subject of the portrait, leaving distracting background details out of focus. The built-in flash and AF-assist illuminator automatically activate in low-light situations. Picture Control is set to ⌧PT.

Landscape

Landscape mode (🖼) is for taking photos of far-off vistas. The camera automatically adjusts the colors to apply brighter greens and blues to skies and foliage. The camera also automatically focuses on the closest subject and uses a smaller aperture to pro-vide a greater depth of field to ensure focus throughout the entire image.

In this mode, the camera automatically disables the AF-assist illuminator and the flash. Picture Control is set to ⌧LS.

Child

Child mode (👶) is for taking portraits or candid shots of children. The camera auto-matically adjusts the colors to provide more saturation while still providing a natural skin tone. It automatically focuses on the closest subject and uses a fairly small aper-ture to capture background details. The built-in flash is automatically activated when the light is low. Picture Control is set to ⊡SD.

Sports

Sports mode (🏃) uses a fast shutter speed to freeze the action of moving subjects. The camera focuses continuously as long as you have the shutter-release button pressed halfway. The camera also uses Predictive Focus Tracking based on information from all the focus areas in case the main subject moves from the selected focus point.

The camera disables the built-in flash and AF-assist illuminator when you select this mode. Picture Control is set to ⊡SD.

> **TIP** To shoot a quick sequence shot, rotate the Release Mode dial to one of the two Continuous shooting modes, CH or CL.

Close Up

Close Up mode (🌷) is for close-up or macro shots. It uses a fairly wide aperture to provide a soft background while giving the main subject a sharp focus. In this mode, the camera focuses on the subject in the center of the frame, although you can use the multi-selector to choose one of the other focus points to create an off-center com-position.

When light is low, the camera automatically activates the built-in flash. Be sure to remove your lens hood when using the flash on close-up subjects because the lens hood can cast a shadow on your subject by blocking the light from the flash. Picture Control is set to ⊡SD.

Night Portrait

Night Portrait mode (🌃) is for taking portraits in low-light situations. The camera auto-matically activates the flash and uses a longer shutter speed (Slow Sync) to capture the ambient light from the background. This balances the ambient light and the light from the flash, giving you a more natural effect. You may want to use a tripod when you use this mode to prevent blurring from camera shake that can occur during longer exposure times. Picture Control is set to ⊡PT.

Night Landscape

Night Landscape mode (⛰) disables the flash, sets a small aperture, and uses a long shutter speed to capture ambient light. The AF-assist illuminator is automatically turned off. You will definitely need a tripod when using this mode. Picture Control is set to ⊡SD.

Party/Indoor

Party/Indoor mode (✻) automatically activates the built-in flash and uses the Red-Eye Reduction feature. Use this mode for capturing snapshots of people while retaining some of the ambient light for a more natural look. Picture Control is set to ⊡SD.

Beach/Snow

Sand and snow present a tricky situation for your camera's light meter, and often cause the camera to underexpose the scene, making the sand or snow appear a dingy, dull gray. Beach/Snow mode (🏖) adds some exposure compensation to ensure the sand or snow appears a natural, gleaming white. Picture Control is set to ⊡LS and flash is disabled.

Sunset

Sunset mode (🌄) captures the intense colors that occur during sunset or sunrise. The camera boosts color saturation to enhance this effect. The flash is disabled, and the camera focuses at the center of the frame. A tripod is recommended when using this mode. Picture Control is set to ⊡LS.

Dusk/Dawn

Dusk/Dawn mode (🌆) is similar to 🌄 mode, but it is intended for shooting *after* the sun sets or *before* it rises. This mode boosts the color saturation to accent the colors that are less visible when the sun has already set (or has yet to rise) and there is little light available. In this mode, the flash is disabled, and a tripod is strongly recommended. Picture Control is set to ⊡LS.

Pet Portrait

Pet Portrait mode (🐕) is obviously for taking photos of pets. This mode uses a faster shutter speed to freeze any movement a frisky pet might make. The flash is set to automatically activate in low light, but the AF-assist illuminator and Red-Eye Reduction are disabled so that the animal doesn't blink while the photo is being taken. Picture Control is set to ⊡SD.

Candlelight

Candlelight mode (🕯) gives you more natural colors when photographing under candle-light, which can be difficult on standard Auto WB settings due to the low light and extremely warm hue. The camera also uses wide aperture settings to effectively cap-ture all available light. The flash is disabled and Picture Control is set to ▣SD.

Blossom

Blossom mode (❀) is for shooting landscapes in which colorful flowers appear. This mode boosts the colors for a more vibrant look. The built-in flash is disabled. Picture Control is set to ▣LS.

Autumn Colors

When you select Autumn Colors mode (🍂), the camera automatically boosts the satu-ration of the reds, oranges, and yellows in the image because those are the most prevalent colors in fall foliage. The built-in flash is disabled. Picture Control is set to ▣VI.

Food

Food mode (🍴) is for photographing edible items. This mode boosts the colors and the camera selects a fairly wide aperture. When the lighting is low, the built-in flash is automatically activated. Picture Control is set to ▣SD.

Silhouette

Using Silhouette mode (🏔), the camera sets the exposure for the bright part of the scene to silhouette the dark subject against a bright background. This option is best when shooting at dusk or dawn. Picture Control is set to ▣LS.

High Key

Use High Key mode (▦) when shooting a light subject against a light background. The camera applies some exposure compensation to slightly overexpose and add some brightness to the scene. Picture Control is set to ▣SD.

Low Key

Use Low Key mode (▦) when photographing a dark subject against a dark back-ground. This mode also punches up the highlights just a bit to get good definition between the shadows and highlights. Picture Control is set to ▣SD.

Auto modes

The D600 has two fully automatic, or Auto, modes that do all the work for you. These are simple grab-and-go camera settings to use when you're in a hurry or you just don't want to be bothered with changing the settings. The Auto modes control everything from shutter speed and aperture to ISO sensitivity and white balance.

> **TIP** You can override the Auto ISO setting by changing the ISO sensitivity as you normally would. The override remains in effect unless you change the camera to P, S, A, or M, and return it to one of the scene modes. When you change back to a scene mode from P, S, A, or M, the Auto ISO function is reactivated.

Auto

Auto mode (⌖) is a point-and-shoot mode in which the camera takes complete control over the exposure. The camera's meter reads the light, the color, and the brightness of the scene and runs the information through a sophisticated algorithm. The camera uses this information to determine what type of scene you are photographing and chooses the settings that it deems appropriate for the scene.

If there isn't enough light to make a proper exposure, the camera's built-in flash pops up when you press the shutter-release button halfway for focus. The flash fires when the shutter is released, resulting in a properly exposed image. This mode is great when you're taking snapshots, and you simply want to concentrate on capturing the moment and let the camera determine the proper settings.

Auto (flash off)

The Auto (flash off) mode (⌖) functions in the same way as ⌖ mode, except that it disables the flash, even in low-light situations. In instances when the lighting is poor, the camera's AF-assist illuminator lights up to provide sufficient light to achieve focus. The camera uses the focus area of the closest subject to focus on.

This setting is preferable when you want to use natural or ambient light for your subject or in situations where you aren't allowed to use flash, such as in museums, or at events where the flash may cause a distraction, such as weddings.

Metering Modes

The D600 has three metering modes — Matrix (▣), Center-weighted (▣), and Spot (▣) — to help you get the best exposure for your image. You can change the modes

by pressing the metering mode button (⊞) just behind the shutter-release button (on the left side) and rotating the Main Command dial (you can see the metering mode icon on the LCD control panel or in the Info display). Metering modes determine how the camera's light sensor collects and processes the information used to determine exposure. Each of these modes is useful for different types of lighting situations.

Matrix

The default metering system that Nikon cameras use is a proprietary system called 3D Color Matrix Metering II, or just Matrix metering for short. Matrix metering (⊞) reads a wide area of the frame, and sets the exposure based on the brightness, contrast, color, and composition. Then the camera runs the data through sophisticated algorithms and determines the proper exposure for the scene. When you use a NIKKOR D- or G-type lens, the camera also takes the focusing distance into consideration.

CROSS REF For more on lenses and lens specifications, see Chapter 4.

The D600's 2016-pixel RGB (Red, Green, Blue) sensor measures the intensity of the light and color of a scene. After the meter takes the measurement, the camera compares it to information from 30,000 images stored in its database. The D600 determines the exposure settings based on the findings from the comparison.

In simple terms, it works like this: Imagine that you're photographing a portrait outdoors, and the sensor

Image courtesy of Nikon, Inc.

2.5 The 2016-pixel RGB sensor in the D600

detects that the light in the center of the frame is much dimmer than at the edges. The camera takes this information, along with the focus distance, and compares it to the images in the database. The database images with similar light, color patterns, and subject distance tell the camera that this must be a close-up portrait with flesh tones in the center and sky in the background. From this information, the camera decides to expose primarily for the center of the frame, although the background may be overexposed. The RGB sensor also reads the quantity of the colors and uses that information, as well.

The D600 automatically chooses a Matrix metering system, based on the type of Nikon lens that you use. Here are the options:

▶ **3D Color Matrix Metering II.** As mentioned earlier, this is the default metering system that the camera employs when you attach a G- or D-type lens to it. Most lenses made since the early to mid-1990s are one of these types. The only difference between the G- and D-type lenses is that there is no aperture ring on the G-type lens. When you use ▣ metering, the camera decides the exposure setting based mainly on the brightness and contrast of the overall scene, and the colors of the subject matter, as well as other data from the scene. It also takes into account the distance to the subject and which focus point is used, as well as the lens focal length, to further decide which areas of the image are important for getting the proper exposure. For example, if you're using a wide-angle lens with a distant subject with a bright area at the top of the frame, the meter takes this into consideration when setting the exposure so that the sky and clouds don't lose critical detail.

▶ **Color Matrix Metering II.** This type of metering is used when a non-D- or G-type CPU lens is attached to the camera. Most AF lenses made from about 1986 to the early to mid-1990s fit into this category. The Matrix metering recognizes this, and the camera uses only brightness, subject color, and focus information to determine the right exposure.

▶ **Color Matrix Metering.** This type of metering is used when you attach a non-CPU lens to the camera, and specify the focal length and maximum aperture using the non-CPU data in the D600 Setup menu. The camera then calculates the exposure based solely on the brightness of the scene and the subject color. If you attach a non-CPU lens and you do not enter any lens information, the camera's meter defaults to Center-weighted metering.

Matrix metering is suitable for most subjects, especially when you're dealing with a particularly tricky or complex lighting situation. Given the large amount of image data in the Matrix metering database, the camera can make a fairly accurate assessment of what type of image you are shooting and adjust the exposure accordingly. For example, for an image with a high amount of contrast and brightness across the top of the frame, the camera tries to expose for the scene so that the highlights retain detail. Paired with Nikon's Active D-Lighting, your exposure will have good dynamic range throughout the image.

Center-weighted

When you switch the camera's metering mode to Center-weighted (▣), the meter takes a light reading of the whole scene, but bases the exposure settings mostly on the light falling on the center of the scene. The camera determines about 75 percent

of the exposure from a circular pattern in the center of the frame and 25 percent from the area around the center.

By default, the circular pattern is 12mm in diameter, but you can choose to make the circle bigger or smaller depending on the subject. Your choices are 8, 12, 15, or 20mm and are found in ✔ b4.

There is also an Average setting. When you set it to Average, the camera takes a reading of the full frame and decides on an average setting. (I'm not sure why the Average option appears in the Center-weighted menu, because it's not center-weighted at all.) Averaging meters were one of the first types of meters used in SLR cameras and, although they worked okay in moderately tricky lighting situations, you had to know when to use exposure compensation or your image would come out flat and, well, average. An example of this is a snowy landscape — the averaging meter takes a look at all that white and wants to make it an 18 percent gray, causing the snow to look dingy. You have to know to adjust your exposure compensation +1 or 2 stops. Unless you're photographing a subject that is uniform in color and has very little contrast, I advise that you avoid the Average setting.

On the other hand, true Center-weighted metering is a very useful option. It works great when you are shooting photos with the main subject in the middle of the frame. This metering mode is useful when photographing a dark subject against a bright background, or a light subject against a dark background. It works especially well for portraits where you want to preserve the background detail while exposing correctly for the subject.

Using ⊙ metering, you can get consistent results without worrying about the adjustments in exposure settings that sometimes result when using ▦ metering.

Spot

In Spot metering mode (▯), the camera does just that: meters only a spot. This spot is only 3mm in diameter and only accounts for 2 percent of the frame. The spot is linked to the active focus point, which is good because you can focus and meter your subject at the same time, instead of metering the subject, pressing the Auto-Exposure Lock button (AE-L), and then recomposing the photo. The D600 has 39 focus points, so it's like having 39 spot meters to choose from throughout the scene.

Choose ▯ metering when the subject is the only thing in the frame that you want the camera to expose for. You select the spot meter to meter a precise area of light within the scene. This is not necessarily tied to the subject. For example, when you

photograph a subject on a completely white or black background, you need not be concerned with preserving detail in the background; therefore, exposing just for the subject works out perfectly. This mode works well for concert photography, where the musician or singer is lit by a bright spotlight. You can capture every detail of the subject and just let the shadow areas go black.

> **NOTE** When you use a non-CPU lens with ⬚ metering, the center spot is automatically selected.

Autofocus

The D600 has a new AF system based on the D7000's AF system. The Multi-CAM 4800FX has 39 focus points, nine of which are cross-type sensors, providing the ability to detect contrast for focusing purposes.

In simpler terms, the Multi-CAM 4800FX AF works by reading contrast values from a sensor inside the camera's viewing system. The D600 employs two sensor types: cross and horizontal. As you may have guessed, cross-type sensors are shaped like a cross while horizontal sensors appear as horizontal lines. You can think of them like plus and minus signs. Cross-type sensors are able to read the contrast in two directions, horizontally and vertically. Horizontal sensors can only interpret contrast in one direction. (When you position the camera in portrait orientation, the horizontal sensors are positioned vertically.)

Cross-type sensors can evaluate for focus much more accurately than horizontal sensors, but horizontal sensors can do it a bit more quickly (provided that the contrast runs in the right direction). Cross-type sensors require more light to work properly, so horizontal sensors are also included in the array to speed up the AF, especially in low-light situations.

Phase detection

The AF system on the D600 works by using phase detection, which is determined by a sensor in the camera's body. *Phase detection* is achieved by using a beam splitter to divert light that is coming from the lens to two optical prisms that send the light as two separate images to the AF sensor in the D600. This creates a type of rangefinder where the base is the same as the diameter or aperture of the lens. The larger the length of the base, the easier it is for the rangefinder to determine whether the two images are "in phase" or in focus.

This is why lenses with wider maximum apertures often focus faster than lenses with smaller maximum apertures, especially in low light. This is also why the AF usually can't work with slower lenses coupled with a teleconverter, which reduces the effective aperture of the lens. The base length of the rangefinder images is simply too small to allow the AF system to determine the proper focusing distance. The AF sensor reads the contrast, or phase difference between the two images that are being projected on it. This is the primary way that the D600 AF system works. This type of focus is also referred to as SIR-TTL, or Secondary Image Registration-Through the Lens, given that the AF sensor relies on a secondary image, as opposed to the primary image that is projected into the viewfinder from the reflex mirror.

Contrast detection

The D600 only uses contrast detection focus when you use Live View mode (Lv) and video. This is the same method that smaller compact digital cameras use to focus. Contrast detection focus is slower and uses the image sensor to determine whether the subject is in focus. It is a relatively simple operation in which the sensor detects the contrast between different subjects in the scene on the level. The camera does this by moving the lens elements until it achieves sufficient contrast between the pixels that lie under the selected focus point. With contrast detection, you can focus on a greater area of the frame, meaning you can set the focus area to anywhere within the scene.

Focus Modes

Focus modes simply control how the camera achieves focus when you press the shutter-release button halfway. There are four separate settings to choose from and each one is useful for different situations. Press the AF mode button (**MODE**) and rotate the Main Command dial to change focus modes. Note that when you set the AF switch to Manual (**M**), you cannot select an AF mode.

Continuous-servo AF (AF-C)

This is the AF mode you want to use when shooting sports or in any other situation in which the subject is moving. When you set the camera to Continuous-servo AF (**AF-C**), it continues to focus as long as you press the shutter halfway (or the AE-L/AF-L button [**AE-L/AF-L**] is set to **AF-ON** in ✎ f4). If the subject moves, the camera activates Predictive Focus Tracking. Predictive Focus allows the camera to track the subject and maintain focus by attempting to predict where the subject will be when the shutter is released.

When the camera is in ⬛ mode, it fires when you fully depress the shutter-release button, regardless of whether the subject is in focus. This AF setting is known as Release Priority.

If you want to be sure that the subject is completely in focus before the shutter is released, you can change the setting to Focus Priority. When you select the Focus Priority option, the camera continues to focus while you press the shutter-release button but the shutter releases only when the subject is in focus. This may cause your frame rate to slow down. You can choose between Focus and Release Priority in ✎ a1.

Single-servo AF (AF-S)

Using Single-servo AF mode (⬛) (not to be confused with the AF-S lens designation), the camera focuses when you press the shutter-release button halfway. When the camera achieves focus, the focus locks. The focus remains locked until the shutter is released or the shutter-release button is no longer pressed. By default, the camera does not fire unless focus has been achieved (Focus Priority), but you can change this to Release Priority in ✎ a2. This allows you to take a photo, regardless of whether the camera has achieved focus. I recommend sticking with Focus Priority for ⬛ and using Release Priority for ⬛. ⬛ mode is the best mode to use when shooting portraits, landscapes, or other photos in which the subject is relatively static. Using this mode helps ensure that you have fewer out-of-focus images.

Auto-servo (AF-A)

When you use Auto-servo mode (⬛), the D600's AF system automatically selects ⬛ or ⬛ by determining whether the subject is moving. This mode works adequately when shooting snapshots, but I wouldn't count on it to work perfectly in situations where focus is critical.

Manual (MF)

When you select Manual mode (⬛), the AF system on the D600 is disabled. You achieve focus by rotating the focus ring of the lens until the subject appears sharp as you look through the viewfinder. You can use ⬛ when shooting still-life photographs or other still subjects, when you want total control of the focus, or when you are using a non-AF lens. Keep in mind that the camera shutter releases, regardless of whether the scene is in focus.

When using ▥, the D600 offers a bit of assistance in the form of an electronic range-finder. The rangefinder shows that you are in focus by displaying a green dot in the lower-left corner of the viewfinder. In addition, the rangefinder has two arrows, one on either side of the green dot. If the arrow to the right is lit, the focus is behind the subject; an arrow to the left indicates that the focus is in front of the subject. You still need to choose a focus point so that the camera can determine where the subject is in the frame so that the rangefinder can work properly.

You can use Manual focus when shooting close-ups and macros, as well as portraits when you need to focus on a specific area.

Autofocus Area Modes

The D600 has four AF-area modes to choose from: Single-point AF (⌷), Dynamic-area AF (⌷⌷), 3-D tracking (3D), and Auto-area AF (▣). Each mode is useful in different situations and can be modified to suit a variety of needs. To change the AF-area mode, press **MODE** and rotate the Sub-command dial.

As discussed earlier in the chapter, the D600 employs an impressive 39 separate AF points. The 39 AF points can be used individually in Single-area AF mode (⌷), or they can be set to use in groups of 9, 21, or 39 in ⌷⌷ mode.

The D600 can also employ 3D mode, which enables the camera to automatically switch focus points and maintain sharp focus on a moving subject as it crosses the frame. 3D mode is made possible by the camera recognizing color and light information and using it to track the subject.

Nikon's Scene Recognition System uses the 2016-pixel RGB sensor to recognize color and lighting patterns in order to determine the type of scene that you are photograph-ing. This enables the AF to work faster than in previous Nikon dSLRs, and it also helps the D600 achieve more accurate exposure and white balance.

Single-point AF

Single-point AF (⌷) is the easiest mode to use when you shoot slow-moving or com-pletely still subjects. You can press the multi-selector ▲, ▼, ◄, or ▶ to choose one of the AF points. The camera only focuses on the subject if it is in the selected AF area. Once the point is selected, you can lock it in by rotating the focus point lock switch directly below the multi-selector.

By default, [□] mode allows you to choose from any one of the 39 AF area points. Sometimes selecting from this many points can slow you down; this is why the D600 also allows you to change the number of selectable points to a more widely spaced array of 11 focus points. Anyone who has used a D200 or D90 will be familiar with the 11-point pattern. You can choose the number of focus points in ✐ a6.

Switching from 39 points to 11 points can speed up your shooting process when using [□] mode. I often use 11 points when shooting concerts because I don't need to be super accurate on my focus point; this allows me to move the focus point to the preferred area in less than half of the button pushes it takes when using 39 points.

Dynamic-area AF

Dynamic-area AF (⊞) also allows you to select the AF point manually, but unlike [□] mode, the surrounding unselected points remain active; this way, if the subject happens to move out of the selected focus area, the camera's highly sophisticated autofocus system can track it throughout the frame.

You can set ⊞ to function with 9, 21, or 39 points by pressing the AF-mode button and rotating the Sub-command dial. The easiest way to see which mode you're selecting is by looking in the viewfinder. You can also see the mode in the LCD control panel and the Info display. When you set the focus to **AF-S**, the mode operates exactly the same as if you were using [□]. To take advantage of ⊞, you must set the camera to **AF-C**.

9 points

When you set your D600 to the 9-point option, you can select any one of the camera's 39 AF points to be the primary focus point. If your subject moves out of the selected focus area, the AF system uses the eight AF points immediately surrounding the selected point to achieve focus. Use this setting when you are shooting subjects that move predictably. For example, baseball players typically run in a straight line and you don't need many points for AF coverage as you track along with the subject.

21 points

As with the 9-point area AF mode, you can select the primary focus point from any one of the 39 points. The camera then uses information from the surrounding 20 points if the subject moves away from the selected focus area. The 21-point area gives you a little more leeway with moving subjects because the active AF areas are in a larger pattern. This mode is good for shooting sports with a lot of action, such as soccer or football. Players are a bit more unpredictable, and the larger coverage helps

you maintain focus when a player cuts left or right. However, the 21-point coverage is small enough that the camera's AF is less likely to jump to other players.

39 points

The 39-point area AF mode gives you the widest area of active focus points. You can select the primary focus point the same way you do with the 9-point and 21-point options. The camera then keeps the surrounding 38 points active in case the subject leaves the selected focus area. This mode is best for situations in which a lone subject is against a plain background, such as when capturing a bird or an airplane against a blue sky, or a single person against a simple background.

> **NOTE** When using ⊞ with 21 or 39 points, you may notice that AF takes a little longer to work. This is because the processor in the D600 has to sample more points.

3D-tracking

The 3D-tracking mode (▣) has all 39 AF points active. You select the primary AF point, but if the subject moves, the camera uses 3D-tracking to automatically select a new primary AF point. With 3D-tracking, the camera uses distance and color information from the area immediately surrounding the focus point to determine what the subject is; if the subject moves, the camera selects a new focus point. This mode works very well for subjects that move unpredictably; however, you need to be sure that the subject and the background aren't similar in color. When you photograph a subject that has a color similar to the background, the camera may lock focus on the wrong area, so use this mode carefully.

Auto-area AF

Auto-area AF (■) is exactly what it sounds like: the camera automatically determines the subject, and chooses one or more AF points on which to lock focus. Due to the D600's Scene Recognition System, when you use the camera with NIKKOR D- or G-type lenses, it is able to recognize human subjects. This means that the camera has a better chance of focusing where you want rather than accidentally focusing on the background when shooting a portrait. I tend not to use a fully automatic setting such as this, but I find it works reasonably well when I'm shooting snapshots with a relatively deep depth of field. When you set the camera to █, the active AF points light up in the viewfinder for about 1 second when the camera attains focus; when you set it to █, you can see the active point tracking the subject as it moves through the frame.

TIP If you'd like to see which AF point was selected, you can view the AF point while reviewing the image on the LCD screen. To do this, go to the Playback menu (▶), select the Playback Display option, and then select the focus point under Basic photo info. Be sure to highlight Done, and then press OK (ⓞⓚ) to lock in the setting. When the image plays back, the active focus points are overlaid. You can also view the focus points with Nikon Capture NX 2 and ViewNX 2 software. Note that when the camera is in **AF-C** mode, the active point does not appear during playback.

Release Modes

Release modes control how the shutter release operates. A number of different options are useful in many different shooting situations. You can quickly change the release modes by pressing the Release Mode dial lock button and rotating the Release Mode dial to the desired setting.

Single frame

When you select Single frame mode (s), the camera takes one picture when you fully depress the shutter-release button. Even if you hold the button down, only one frame is captured. The shutter-release button must not be pressed at all to reset it. You can use this mode when shooting portraits, still-life compositions, products, or any other static or still subjects.

Continuous low speed

When you select Continuous low speed mode (cL), the camera shoots repeatedly while you hold down the shutter-release button. You can set the speed from 1 to 5 fps (frames per second) using ✐ d5. I like to keep mine set to 3 fps. This is a good mode to use when trying to capture subjects that may be moving, but not too fast, such as children and pets.

Continuous high speed

When you select Continuous high speed mode (cH), the D600 shoots up to 5.5 fps while you press and hold the shutter-release button. This mode is for shooting fast action and sequence shots, or trying to capture a fleeting moment that may never happen again.

For the best results, you should set the shutter speed to at least 1/200 second and use a fast memory card. Shooting at 1/200 or faster ensures that you get the full frame rate speed. The frame rate drops once the buffer is filled, and resumes when the buffer is flushed and the data is written to the card. Using a faster rated memory card allows the camera to clear the buffer more quickly.

Quiet shutter-release

Quiet shutter-release mode (**Q**) operates similar to **s** mode, except that when you hold down the shutter-release button, the reflex mirror is held up in place until you release the button. Normally the shutter sound is made when the mirror flips up, the shutter opens and closes, and the mirror flips down. Using **Q** mode, you can split the noise into two distinct sounds: one when the mirror flips up and the shutter opens, and one when the mirror flips down when you release the shutter-release button.

In theory, this makes the shutter-release button half as noisy. The idea behind **Q** is that the photographer can snap a photo and move to another area before releasing the reflex mirror to the down position. In practice, however, the Quiet shutter-release mode isn't much quieter than Single frame mode.

NOTE In **Q** mode, the focus confirmation beep is disabled, regardless of the setting in ✐ d1.

Self-timer

Self-timer (⏱) is a handy option that allows a delay between the pressing of the shutter-release button and the actual release of the shutter. This allows you to quickly jump into the frame for self-portraits or join in on group shots. This feature is also useful when doing timed exposures, as it reduces camera shake caused by pressing the shutter-release button when the camera is mounted on a tripod.

You can find the ⏱ settings in ✐ c3. There you can select the length of the delay, the number of shots, and the time between shots.

Remote control

Remote control mode (▣◗))) is for use with the ML-L3 wireless remote, available separately from Nikon. This inexpensive remote uses infrared signals sent to infrared receivers on the front and rear of the D600. This eliminates the need to physically press the shutter-release button.

Using ✐ c5, you can select how long the camera waits for a signal before cancelling Remote control mode. Before using ■◗))), go to the Shooting menu (◙) and select the Remote control mode option. This allows you to select the settings for the ML-L3. You have the following three options:

▶ **Delayed remote (⬚⬚).** This gives a 2-second delay from the pressing of the ML-L3 button before the shutter is released.

▶ **Quick response remote (⬚).** This immediately releases the shutter when you press the ML-L3 button. The shutter is released, regardless of whether the camera is in focus. Manually focusing before shooting is recommended.

▶ **Remote mirror-up (⬚ MUP).** Pressing the ML-L3 button once raises the mirror. Pressing it a second time releases the shutter. The mirror is automatically lowered once the exposure is complete.

Mirror lockup

Mirror lockup mode (MUP) is for taking long exposures or extreme macro shots. It allows you to reduce any blur that may occur when the reflex mirror flips up to reveal the shutter.

Frame and focus the image, and then press the shutter-release button once to raise the mirror. Press the shutter-release button a second time to open the shutter. Once the exposure is finished and the shutter closes, the reflex mirror returns to its resting position.

ISO Sensitivity

ISO, which stands for *International Organization for Standardization,* is the rating for the speed of film, or in digital terms, the sensitivity of the sensor. The ISO numbers are standardized, which allows you to be sure that when you shoot at ISO 100, you get the same exposure no matter what camera you are using.

You can set the ISO very quickly on the D600 by pressing and holding the ISO button (ISO) and rotating the Main Command dial until the desired setting appears in the LCD control panel. As with other settings for controlling exposure, you can set the ISO in 1/3- or 1/2-stop increments. You can choose the ISO increments in ✐ b1.

The D600 has a native ISO range of 100 to 6400. In addition to these standard ISO settings, the D600 also offers some settings that extend the available range of the

ISO so you can shoot in very bright or very dark situations. These are labeled as H (high speed) or L (low speed). By default, the extended ISO options are set in 1/3-stop adjustments. The options are as follows:

▶ **L0.3, L0.7, and L1.0.** These settings allow you to adjust the ISO down to 50 in 1/3 steps.

▶ **H0.3, H0.7, and H1.0.** These settings give you up to ISO 12800 in 1/3 steps.

▶ **H2.0.** This setting isn't adjustable. You get one H2.0 setting that is equivalent to ISO 25600.

You can also set the ISO in the 📷 menu under the ISO sensitivity settings option.

> **CAUTION** When you set ✎ b1 to half step, you have the option of selecting H0.5 or L0.5.

It should be noted that the H and L settings do not produce optimal results. Shooting at the base ISO settings is advisable. When set to the L option, the camera overexposes the image and uses the processor to reduce the exposure. When set to the H option, the camera uses the processor to push the exposure. You can perform these same operations manually in your favorite RAW convertor with better accuracy. For this reason I don't recommend using the extended ISO settings unless you are shooting JPEGs.

Auto ISO

Auto ISO (ISO-A) automatically adjusts the ISO settings for you in situations in which the light changes. This frees you up from having to manually adjust the ISO as the lighting changes, giving you one less setting to worry about.

Nikon has made the ISO-A feature available for a few years now, and I have been a big proponent of it. I have found that this setting results in many more low-noise images, especially when doing low-light and concert photography. When I shoot in low light, I almost always enable this option.

In true Nikon fashion, an amazing feature has been made even better with the latest cameras. Auto ISO is more intuitive, smarter, and quicker to access. To turn on ISO-A , simply press ISO and rotate the Sub-command dial. Nikon has also added an Auto setting that selects the threshold for shutter speed versus ISO based on focal length, which is especially handy when using a zoom lens (which most people do these days).

Be sure to set the following options in the 🔲 menu under the ISO sensitivity settings option:

▶ **Maximum sensitivity.** Choose an ISO setting that allows you to get an acceptable amount of noise in your image. If you're not concerned about noisy images, then you can set it all the way up to H2. If you need your images to have less noise, you can choose a lower ISO; the choices are L1.0 to H2.0 in 1/3 stops.

▶ **Minimum shutter speed.** This setting determines when the camera adjusts the ISO to a higher level. At the default, the camera bumps up the ISO when the shutter speed falls below 1/30 second. If you're using a longer lens or you're photographing moving subjects, you may need a faster shutter speed. In that case, you can set the minimum shutter speed up to 1/4000 second. On the other hand, if you're not concerned about camera shake, or if you're using a tripod, you can set a shutter speed as slow as 1 second. When using the **ISO-AUTO** setting, the camera chooses the shutter speed based on the focal length of the lens (provided the lens has a CPU). When in **ISO-AUTO** mode, you can specify whether the camera gives priority to shutter speed or ISO sensitivity. Slower prioritizes shutter speed and Faster prioritizes ISO sensitivity.

NOTE The minimum shutter speed is only taken into account when using **P** or **S** mode.

Noise reduction

Noise starts appearing in images taken with the D600 when you shoot above ISO 1600 or use long exposure times. For this reason, most camera manufacturers have built-in noise reduction (NR) features. The D600 has two types of NR: Long exposure NR and High ISO NR; each approaches noise differently to help reduce it.

Long exposure NR

When you activate Long exposure NR, the camera applies a noise reduction algorithm to any shot taken with a long exposure (1 second or more). Basically, the camera takes another exposure (this time with the shutter closed), and then compares the noise from this dark image to the original. The camera then applies the NR.

The noise reduction takes about the same amount of time to process as the length of the shutter speed; therefore, you can expect just about double the time it takes to make one exposure. While the camera is applying NR, the LCD control panel blinks the message Job nr. You cannot take additional images until this process is finished. If you switch the camera off before the NR is finished, noise reduction is not applied. You can turn Long exposure NR on or off by accessing it in the ◘ menu.

High ISO NR

When you activate High ISO NR, any image shot at ISO 800 or higher is run through the noise reduction algorithm.

This feature works by reducing the coloring in the chrominance of the noise and slightly softening the image to reduce the luminance noise. You can set how aggressively this effect is applied by choosing the High, Normal, or Low settings.

NOTE *Chrominance* refers to the color of noise, and *luminance* refers to its size and shape.

You should also keep in mind that High ISO NR slows down the processing of your images; this can reduce the capacity of the buffer, causing your frame rate to slow down when you're shooting in C$_H$ or C$_L$.

When you turn off High ISO NR, the camera still applies NR to images shot at ISO 2500 and higher, although the amount of NR is less than when you set the camera to Low with NR on.

NOTE When shooting in NEF (RAW), no actual noise reduction is applied to the data, but NR is tagged in the file. For the in-camera NR to be applied to the final image, you must open and edit the RAW file using Nikon software.

For the most part, I do not use either of these in-camera NR features. In my opinion, even at the lowest setting, the camera is very aggressive in applying NR, and for that reason, there is a loss of detail. For some people, this is a minor quibble and not very noticeable, but I'd rather keep all of the available detail in my images and apply noise reduction in post-processing. This way I can decide how much to reduce the chrominance and luminance noise in post-production rather than letting the camera do it.

NOTE Photoshop's Adobe Camera Raw and other image-editing software include their own proprietary noise reduction.

White Balance

Light, whether from sunlight, a light bulb, a fluorescent light, or a flash, has a specific color. This color is measured using the Kelvin scale, and the measurement is also known as *color temperature*. The white balance (**WB**) allows you to adjust the camera so your images look natural, regardless of the light source. Given that white is the color most dramatically affected by the color temperature of the light source, this is what you base your settings on — hence the term *white balance*. You can change the white balance in the 📷 menu, or by pressing the **WB** button and rotating the Main Command dial.

The term *color temperature* may sound strange to you. After all, how can a color have a temperature? Once you know about the Kelvin scale, things make a little more sense.

What is Kelvin?

Kelvin is a temperature scale, normally used in the fields of physics and astronomy, where absolute zero (0K) denotes the absence of all heat energy. The concept is based on a theoretical object called a *black body radiator*. As this black body radiator is heated, it starts to glow. When it reaches a certain temperature, it glows a specific color. It is akin to heating a bar of iron with a torch. As the iron gets hotter it turns red, then yellow, and then eventually white before it reaches its melting point (although the theoretical black body does not have a melting point).

The concept of Kelvin and color temperature is tricky as it is the opposite of what you likely think of as *warm* and *cool* colors. For example, on the Kelvin scale, red is the lowest temperature, increasing through orange, yellow, white, and to shades of blue, which are the highest temperatures. Humans tend to perceive reds, oranges, and yellows as warmer, and white and bluish colors as colder. However, physically speaking, as defined by the Kelvin scale, the opposite is true.

White balance settings

Now that you know a little about the Kelvin scale, you can begin to explore the white balance settings. White balance is so important because it helps ensure that your

images have a natural look. When you're dealing with different lighting sources, the color temperature of the source can have a drastic effect on the coloring of the subject. For example, a standard light bulb casts a very yellow light; if the color temperature of the light bulb is not compensated for by introducing a bluish cast, the subject can look overly yellow or amber.

To adjust for the colorcast of the light source, the camera introduces a colorcast of the complete opposite color temperature. For example, to combat the green color of a fluorescent lamp, the camera introduces a slight magenta cast to neutralize the green.

Here are the D600's white balance settings:

▶ **AUTO.** The Auto setting is good for most circumstances. The camera takes a reading of the ambient light and makes an automatic adjustment. This setting also works well when you're using a Nikon CLS–compatible Speedlight because the color temperature is calculated to match the flash output. I recommend using this setting as opposed to the Flash WB setting (✦). In addition, you can choose from two Auto settings in the ◘ menu under the WB settings:

 • **Auto1 Normal.** This is your standard setting, which attempts to get a neutral white balance.

 • **Auto2 Keep warm lighting colors.** This setting gives the image a slightly warmer tone than the regular Auto1 setting. This can actually make images look a little more natural in some cases. I recommend using this option outside at high noon, but I don't recommend using it under incandescent lighting as it can cause images to look a little too yellow.

▶ **☀.** Use the Incandescent setting when the lighting is from a standard household light bulb or a tungsten-balanced fluorescent bulb.

▶ **▨.** Use the Fluorescent setting when the lighting is coming from a fluorescent-type lamp. You can also adjust for different types of fluorescent lamps, including high-pressure sodium and mercury-vapor lamps. To make this adjustment, go to the ◘ menu, choose White Balance, and then choose fluorescent. From there, use the multi-selector to choose one of the seven types of lamps.

▶ **☀.** Use the Direct sunlight setting outdoors in the sunlight.

▶ **✦.** Use the Flash setting when using the built-in Speedlight, a hot-shoe Speedlight, or external strobes.

▶ **☁.** Use the Cloudy setting under overcast skies.

▶ 🏠... Use the Shade setting when you are in the shade of trees, a building, an overhang or a bridge — any place where the sun is out, but blocked.

▶ 🄺. Use this setting to adjust the white balance to a particular color temperature that corresponds to the Kelvin scale. You can set it anywhere from 2500K (Red) to 10000K (Blue).

▶ PRE. The Preset manual setting allows you to choose a neutral object to measure for the white balance. It's best to choose an object that is either white or light gray. There are some accessories that you can use to set the white balance; one is a gray card, which is included with this book. Simply place the gray card in the scene and take the reading from it. Another accessory is the Expodisc. You attach it to the front of your lens like a filter, and then point the lens at the light source and set your **WB**. The PRE setting is best used under difficult lighting situations, such as when there are two light sources lighting the scene (mixed lighting). I usually use this setting when photographing with my studio strobes.

Figures 2.6 through 2.12 show the difference that white balance settings can have on your images.

2.6 Auto, 4850K

2.7 Incandescent, 2850K

2.8 Fluorescent, 3800K

2.9 Flash, 5500K

2.10 Daylight, 5500K

2.11 Cloudy, 6500K

2

2.12 Shade, 7500K

Picture Controls

With the release of the D3 and the D300, Nikon introduced its Picture Control System. All subsequent cameras, including the D600, are also equipped with this handy option. This feature allows you to quickly adjust your image settings — including sharpening, contrast, brightness, saturation, and hue — based on your shooting needs. This is great for photographers who shoot with more than one camera and batch process their images. It allows both cameras to record the images with the same settings so that global image correction can be applied without worrying about differences in color, tone, saturation, and sharpening.

Picture Controls are only adjustable when using *P*, *S*, *A*, or *M* modes, or in User Settings where one of these exposure modes is set.

You can also save Picture Controls to one of the memory cards and import them into Nikon's image-editing software, Capture NX 2 or ViewNX 2. You can then apply the settings to RAW images or even to images taken with other camera models. You can

also save and share these Picture Control files with other Nikon users, either by importing them to Nikon software or by loading them directly onto another camera.

The D600 comes with six Picture Controls already loaded on the camera, and you can customize up to nine Picture Control settings in-camera. Right out of the box, the D600 comes with the following six Picture Controls installed:

▶ ⊞SD. This is the Standard setting. It applies slight sharpening and a small boost of contrast and saturation. This is the recommended setting for most shooting situations.

▶ ⊞NL. This is the Neutral setting. It applies a small amount of sharpening and no other modifications to the image. This setting is preferable if you do extensive post-processing to your images.

▶ ⊞VI. This is the Vivid setting. It gives your images a fair amount of sharpening, and the contrast and saturation are boosted, resulting in brightly colored images. This setting is recommended for printing directly from the camera or CF card as well as for shooting landscapes. Personally, I feel that this mode is a little too saturated and often results in unnatural color tones. This mode is not ideal for portraits, as skin tones are not typically reproduced with accuracy.

▶ ⊞MC. This is the Monochrome setting. As the name implies, this option makes the images monochrome. This doesn't simply mean black and white; you can also simulate photo filters and toned images such as sepia, cyanotype, and more. You can also adjust the settings for sharpening, contrast, and brightness.

▶ ⊞PT. This is the Portrait setting. It gives you just a small amount of sharpening, which gives the skin a smoother appearance. The colors are slightly muted to help achieve realistic skin tones.

▶ ⊞LS. This is the Landscape setting. Obviously, this setting is for shooting landscapes and natural vistas. It appears to me that this is very close to the Vivid Picture Control with a little more boost added to the blues and greens.

You can customize all the Original Picture Controls to fit your personal preferences. You can adjust the settings to your liking, choosing from a myriad of options, such as giving the images more sharpening and less contrast.

NOTE Although you can adjust the Original Picture Controls, you cannot save over them, so there is no need to worry about losing them.

You can choose from the following customizations:

▶ **Quick adjust.** This option works with ⊡SD, ⊡VI, ⊡PT, and ⊡LS. It exaggerates or de-emphasizes the effect of the Picture Control in use. You can set Quick adjust from –2 to +2.

▶ **Sharpness.** This setting controls the apparent sharpness of your images. You can adjust this setting from 0 to 9, with 9 being the highest level of sharpness. You can also set this option to Auto (A) to allow the camera's imaging processor to decide how much sharpening to apply.

▶ **Contrast.** This setting controls the amount of contrast your images are given. In photos of scenes with high contrast (sunny days), you may want to adjust the contrast down; in scenes with low contrast, you may want to add some contrast by adjusting the settings up. You can set the Contrast from –3 to +3, or to A.

▶ **Brightness.** This setting adds or subtracts from the overall brightness of your image. You can choose 0 (default), +, or –.

▶ **Saturation.** This setting controls how vivid or bright the colors are in your images. You can set it between –3 and +3, or to A. This option is not available in the ⊡MC setting.

NOTE The Brightness and Saturation options are unavailable when you turn on Active D-Lighting.

▶ **Hue.** This setting controls how your colors look. You can choose from –3 to +3. Positive numbers make the reds look more orange, the blues look more purple, and the greens look more blue. Negative numbers make the reds look more purple, the greens look more yellow, and the blues look more green. This setting is not available in the MC Picture Control setting. I highly recommend leaving it at the default setting of 0.

▶ **Filter effects.** This setting is only available when you set your D600 to ⊡MC. The monochrome filters approximate the types of filters traditionally used with black-and-white film. These filters increase contrast and create special effects. The options are as follows:

 • **Yellow.** This adds a low level of contrast. It causes the sky to appear slightly darker than normal and anything yellow to appear lighter. It is also used to optimize contrast for brighter skin tones.

- **Orange.** This adds a medium amount of contrast. The sky appears darker, giving greater separation between the clouds. Orange objects appear light gray.

- **Red.** This adds a great amount of contrast, drastically darkening the sky while allowing the clouds to remain white. Red objects appear lighter than normal.

- **Green.** This darkens the sky and lightens any green plant life. You can use this color filter for portraits as it softens skin tones.

► **Toning.** Toning adds a color tint to your monochrome (black-and-white) images. Toning options are as follows:

- **B&W.** The black-and-white option simulates the traditional black-and-white film prints developed in a darkroom. The camera records the image in black, white, and shades of gray. This mode is suitable when the color of the subject is not important. You can use it for artistic purposes or, as with the sepia option, to give your image an antique or vintage look.

- **Sepia.** The sepia color option duplicates a photographic toning process that is based on a traditional darkroom technique using silver-based black-and-white prints. Sepia-toning a photographic image requires replacing the silver in the emulsion of the photo paper with a different silver compound, thus changing the color, or *tone,* of the photograph. Antique photographs generally underwent this type of toning; therefore the sepia color option gives the image an antique look. The images look reddish-brown. You may want to use this option to convey a feeling of antiquity or nostalgia in your photograph. This option works well with portraits as well as still-life and architectural images. You can also adjust the saturation of the toning from 1 to 7, with 4 being the default and the middle ground.

- **Cyanotype.** The cyanotype is another old photographic printing process. When the image is exposed to the light, the chemicals that make up the cyanotype turn deep blue. This method was used to create the first blueprints and was later adapted to photography. The images you take in this setting are in shades of cyan. Because cyan is considered to be a cool color, this mode is also referred to as cool. You can use this mode to make very interesting and artistic images. You can also adjust the saturation of the toning from 1 to 7, with 4 being the default setting.

- **Color toning.** You can also choose to add colors to your monochrome images. Although color toning is similar to the sepia and cyanotype toning options, it isn't based on traditional photographic processes. It simply involves adding a colorcast to a black-and-white image. You can choose from seven color options: red, yellow, green, blue-green, blue, purple-blue, and red-purple. As with sepia and cyanotype, you can adjust the saturation of these colors.

2.13 Black-and-white

2.14 Sepia

2.15 Cyanotype

2.16 Green color toning

To customize an Original Picture Control, follow these steps:

1. **Go to the Set Picture Control option in the ⬛ menu.** Press ▶.

2. **Choose the Picture Control you want to adjust.** Choosing ⬛NL or ⬛SD allows you to make smaller changes to the effect because they have relatively low settings (contrast, saturation, and so on). To make greater changes to color and sharpness, select ⬛VI. To make adjustments to monochrome images, choose ⬛MC. Press ▶.

3. **Press ▲ or ▼ to highlight the setting you want to adjust (sharpening, contrast, brightness, and so on).** When the setting is highlighted, press ◀ or ▶ to adjust the settings. Repeat this step until you've adjusted the settings to your preferences.

4. **Press ⊛ to save the settings.**

To return the Picture Control to the default setting, follow the preceding Steps 1 and 2 and press the Delete button (🗑). A dialog box appears, asking for confirmation. Select Yes to return to the default setting or No to continue to use the Picture Control with the current settings.

NOTE When you alter an Original Picture Control setting, an asterisk appears next to the Picture Control setting (such as SD*, VI*, and so on).

To save a Custom Picture Control, follow these steps:

1. **Go to the Manage Picture Control option in the ◘ menu.** Press ▶.

2. **Press ▲ or ▼ to select Save/edit.** Press ▶.

3. **Choose the Picture Control you want to edit.** Press ▶.

4. **Press ▲ or ▼ to highlight the setting you want to adjust (sharpening, contrast, brightness, and so on).** When the setting is highlighted, press ◀ or ▶ to adjust the settings. Repeat this step until you've adjusted the settings to your preferences.

5. **Press ⊛ to save the settings.**

6. **Use the multi-selector to highlight the Custom Picture Control to which you want to save.** You can store up to nine Custom Picture Controls; they are labeled C-1 to C-9. Press ▶.

7. **When the Rename menu appears, press the Zoom out button (⊞), and then press ◀ or ▶ to move the cursor to any of the 19 spaces in the name area of the dialog box.** New Picture Controls are automatically named with the Original Picture Control name and a two-digit number (for example, STANDARD_02 or VIVID_03).

8. **Press the multi-selector (without pressing ⊞) to select letters in the keyboard area of the dialog box.** Press ⊛ to set the selected letter, and then press the 🗑 button to erase the selected letter in the Name area. Once you type the name you want, press ⊕ to save it. The Custom Picture Control is then saved to the Picture Control menu and you can access it through the Set Picture Control option in the ◘ menu.

To return the Picture Control to the default setting, follow the preceding Steps 1 to 3 and press the 🗑 button. A dialog box appears, asking for confirmation; select Yes to return to the default setting or No to continue to use the Picture Control with the current settings.

You can rename or delete your Custom Picture Controls at any time by using the Manage Picture Control option in the ◘ menu. You can also save the Custom Picture Control to your memory card so that you can import the file to Capture NX 2 or ViewNX 2.

To save a Custom Picture Control to the memory card, follow these steps:

1. **Go to the Manage Picture Control option in the ⬜ menu.** Press ▶.
2. **Press ▲ or ▼ to highlight the Load/save option.** Press ▶.
3. **Press ▲ or ▼ to highlight the Copy to card option.** Press ▶.
4. **Press ▲ or ▼ to select the Custom Picture Control you want to copy.** Press ▶.
5. **Select a destination on the memory card to copy the Picture Control file to.** There are 99 slots in which to store Picture Control files. The Custom Picture Controls are saved to the Primary memory card.
6. **After you choose the destination, press ▶.** A message appears confirming that the file has been stored to your memory card.

After you copy your Custom Picture Control file to your card, you can import the file to the Nikon software by mounting the memory card on your computer using a card reader or USB camera connection. See the software user's manual for instructions on importing to the specific program.

You can also upload Picture Controls that are saved to a memory card to your camera. Follow these steps to do so:

1. **Go to the Manage Picture Control option in the ⬜ menu.** Press ▶.
2. **Press ▲ or ▼ to highlight the Load/save option.** Press ▶.
3. **Press ▲ or ▼ to highlight the Copy to camera option.** Press ▶.
4. **Select the Picture Control you want to copy.** Press ⊛ or ▶ to confirm.
5. **The camera displays the Picture Control settings.** Press ⊛. The camera automatically displays the Save As menu.
6. **Select an empty slot to save to (C-1 to C-9).**
7. **Rename the file if necessary.** Press ⊛.

D600 File Formats, Size, and Compression

The D600 creates and stores image data in to two types of files: NEF (or RAW) and JPEG. You can shoot one or the other, or both simultaneously. Each file type has its

strengths and weaknesses, although neither is the absolute correct type to shoot. For ease of use, more manageable file sizes, and compatibility with image editing software (especially older software) JPEGs are great. The drawback, though, is that you lose a lot of image information when the raw data from the sensor is converted into a JPEG file.

On the other side of the equation there is the NEF or RAW file. This file format stores all of the image data recorded by the sensor as the exposure is made. The imaging processor makes note of the camera settings, but doesn't make any final or lasting changes to the sensor data. This gives you more flexibility during the editing process. RAW files are much larger than JPEGs because they contain more information. A major drawback is that each camera's RAW files are proprietary and sometimes you may need to upgrade your software to the latest version to use the RAW file.

2

Each file type also has compression algorithms applied to keep file sizes as small as possible. With JPEGs, you can also set the camera to record a smaller image size by downsampling. All of this and more is covered in the following sections.

NEF (RAW)

Nikon's RAW files are referred to as NEF in Nikon literature. NEF stands for *Nikon Electronic File.* RAW files contain all the image data acquired by the camera's sensor. When a JPEG is created, the camera applies different settings to the image, such as WB, sharpness, noise reduction, and so on. When you save the JPEG, the rest of the unused image data is discarded to help reduce the file size. With a RAW file, this image data is saved so it can be used more extensively in post-processing. In some ways a RAW file is like a *digital negative* because you use it in the same way as a traditional photographic negative; that is, you take the RAW information and process it to create your final image.

Although some of the same settings are tagged to the RAW file (WB, sharpening, saturation, and so on), these settings aren't fixed and applied like they are in the JPEG file. This way, when you import the RAW file into your favorite RAW converter, you can make changes to these settings without detrimental effects. Capturing your images in RAW format allows you to be more flexible when post-processing them, and generally gives you more control over the quality of the images.

The D600 offers a few options for saving NEF (RAW) files. They include compression and bit depth. Like JPEGs, RAW files can be compressed to save space so that you can fit more images on your memory card. You can also choose to save the RAW file with more bit depth, which can give you more available colors in your image file.

Type

Under the NEF (RAW) recording option in the ▢ menu, you can choose the type of compression you want to apply to the NEF (RAW) file. You have the following two options:

▶ **Lossless compressed.** Unlike JPEG compression, this algorithm does not lose any data when you close and store the file. When you open the file, the algorithm reverses the compression scheme and the exact same data that was saved is retrieved. This is the camera's default setting for storing RAW files. You get a file that is approximately 15 to 40 percent the size of an uncompressed RAW file.

▶ **Compressed.** Similar to JPEG compression, with this algorithm some of the image data is lost when the file is compressed. The complex algorithms used to create these files actually run two different compression schemes to the same file. Given that our eyes perceive changes in the darker areas of images more than in the lighter areas, the image data for the shadow areas are compressed using a lossless method, while the data for the midtones and lighter areas is compressed using a lossy method. This compression scheme has very little impact on the image data and allows you to retain all of the shadow detail. The file size is also about 30 to 60 percent the size of an uncompressed file.

Bit depth

Simply put, bit depth refers to how many separate colors your sensor can record. The term *bit depth* is derived from digital terminology. A bit is the smallest unit of data; it is expressed in digital language as either a 1 or a 0. JPEG images are recorded in 8 bits, or 1 byte per channel, with each primary color being a separate color: Red, Green, and Blue (RGB)), resulting in a 24-bit image. For every 8 bits there are 256 possible colors; multiply this by three channels ($256 \times 256 \times 256$) and you get more than 16 million colors, which is more than enough information to create a realistic-looking digital image.

By default, the D600 records its RAW files using a bit depth of 12 bits per channel, giving you a 36-bit image. This means that your sensor can recognize many more shades of color, which gives you a smoother gradation in tones, thus allowing the color transitions to be much smoother. In addition to the 12-bit setting, the D600 offers the option of recording your NEF (RAW) files at 14 bits per channel, which gives you even more color information to deal with when processing your images.

All this comes with a cost: the higher the bit depth, the more information contained in the file. This makes your files bigger, especially when the camera is shooting 14-bit NEF (RAW) files. When shooting at 14 bits, the camera has much more image data to contend with, so your top frame rate is slightly reduced.

I find that for most applications, shooting NEF (RAW) files at 12 bits offers more than enough color information. I only switch to 14 bits when shooting portraits, especially when the portraits are low-key. This helps me get much smoother transitions from the shadow areas to the highlights.

> **NOTE** The Nikon D600 uses a 14-bit A/D converter, so its theoretical maximum dynamic range is 14 stops. High bit depth really only helps minimize image posterization because actual dynamic range is limited by noise levels. A high bit-depth image does not necessarily mean that the image contains more colors; it just has the capacity to store more color data.

JPEG

JPEG, which stands for *Joint Photographic Experts Group,* is a method of compressing photographic files as well as the name of the file format that supports this type of compression. The JPEG is the most common type of file used to save images on digital cameras. Due to the small size of the file that is created and the relatively good image quality it produces, JPEG has become the default file format for most digital cameras.

The JPEG compression format was developed because of the immense file sizes that digital images produce. Photographic files contain millions of separate colors, and each individual color is assigned a number. Therefore, the files contain vast amounts of data, which makes them quite large. In the early days of digital imaging, the huge file sizes and relatively small storage capacity of computers made it almost impossible for most people to store images. A little over 10 years ago, a standard laptop hard drive was only about 5GB. For people to efficiently store images, they needed a file format that could be compressed without losing too much of the image data during reconstruction. Enter the Joint Photographic Experts Group. This group of experts came in and designed what is now affectionately known as the JPEG.

JPEG compression is a very complicated process involving many mathematical equations, but the steps involved can be explained quite simply. The first thing the JPEG process does is break down the image into 8 × 8–pixel blocks. A color space transform is then applied to the RGB color information in each 8 × 8 block, and the RGB values are changed to represent luminance and chrominance values. The luminance value describes the brightness of the color while the chrominance value describes the hue.

Once the luminance and chrominance values have been established, the data is run through what is known as the *Discrete Cosine Transform* (DCT). This is the basis of the compression algorithm. Essentially, the DCT takes the information for the 8 × 8

block of pixels and assigns it an average number because, for the most part, the changes in the luminance and chrominance values will not be drastic in such a small part of the image.

The next step involves quantizing the coefficient numbers that were derived from the luminance and chrominance values by the DCT. *Quantizing* is basically the process of rounding off the numbers. This is where file compression comes in. How much the file is compressed depends on the quantization matrix. The *quantization matrix* defines how much the information is compressed by dividing the coefficients by a quantizing factor. The larger the number of the quantizing factor, the higher the quality (and therefore, the less compression). This is basically what is going on in Photoshop when you save a file as a JPEG and the program asks you to set the quality; you are simply defining the quantizing factor.

Once the numbers are quantized, they are run through a binary encoder that converts the numbers to the 1s and 0s our computers love so much. You now have a compressed file that is, on average, about one-quarter the size of an uncompressed file.

JPEG compression is known as a *lossy* compression because when the numbers are quantized, they lose information. For the most part, this loss of information is imperceptible to the human eye. A bigger issue to consider with JPEGs comes from what is known as *generation loss.* Every time you open, alter, and save a JPEG, it loses a small amount of detail. After multiple openings and savings, the image's quality starts to deteriorate, as less and less information becomes available. Eventually the image may start to look pixelated or jagged (this is known as a *JPEG artifact*). Obviously, this can be a problem, but you would have to open and resave the JPEG many hundreds of times before you would notice a reduction in image quality, provided you save at high-quality settings.

Image size

When saving to JPEG format, the D600 allows you to choose an image size. Reducing the image size is like reducing the resolution on your camera; it allows you to fit more images on your card. The size you choose depends on what your output is going to be. If you know you will be printing your images at a large size, you definitely want to record large JPEGs. If you're going to print at a smaller size (8 × 10 or 5 × 7), you can get away with recording at the Medium or Small setting. Image size is expressed in pixel dimensions. The large JPEG setting records your images at 6016 × 4016 pixels; this gives you a file that is equivalent to about 24 megapixels. Medium size gives you an image of 4512 × 3008 pixels, which is in effect the same as a 13.5-megapixel image. The small size gives you a dimension of 3008 × 2008 pixels, which is about a 6-megapixel image.

To determine what size print you can make from your file, you need to do a little math. Simply divide the pixel height and width of the file size by the intended output resolution in pixels-per-inch (ppi). Higher ppi numbers give more detailed prints. Most photo quality printers print from 240ppi to 300ppi. The latter is the most common and the best setting for just about all of your photo printing needs. At its largest size, the D600 gives you a 24MP image at 6016 × 4016 pixels. If you divide both 6016 and 4016 by 300, you get approximately 20 × 13 inches. See Table 2.1 for the actual print sizes for each resolution, as well as the closest common print sizes that correspond to the nearest actual measurements. Keep in mind that these sizes are at 300ppi.

Table 2.1 Common Print Sizes

Image Area	Size	Actual Print Size	Common Print Size
FX	Large: 6016 × 4016	20″ × 13″	17″ × 11″
	Medium: 4512 × 3008	15″ × 10″	14″ × 11″
	Small: 3008 × 2008	10″ × 6.5″	10″ × 8″
DX	Large: 3936 × 2624	13″ × 9″	12″ × 9″
	Medium: 2944 × 1968	10″ × 6.5″	10″ × 8″
	Small: 1968 × 1312	7″ × 4.5″	6″ × 4″

You can quickly change the image size by pressing the **QUAL** button and rotating the Sub-command dial on the front of the camera. You can also change the image size in the ◙ menu by selecting the image size menu option.

NOTE You can only change image size when using the JPEG file format. RAW files are recorded only at the largest size.

Image quality

With JPEGs, in addition to the size setting, which changes the pixel dimension, you have the Quality setting, which determines the compression ratio that is applied to your JPEG image. Your choices are Fine, Normal, and Basic. JPEG Fine files are compressed to approximately 1:4, Normal files are compressed to about 1:8, and Basic files are compressed to about 1:16. To change the image quality setting, simply press the **QUAL** button and rotate the Main Command dial. Doing this scrolls you through all of the available file-type options, including RAW, Fine (JPEG), Normal (JPEG), and Basic (JPEG). You can also shoot RAW and JPEG simultaneously with all the JPEG compression options available (RAW + Fine, RAW + Normal, or RAW + Basic).

RAW versus JPEG

Choosing between RAW and JPEG basically depends on the final output of the file. You don't have to choose one file format and stick with it. You can change the settings to suit your needs, or you can choose to record both RAW and JPEG simultaneously.

Here are some reasons to shoot JPEGs:

▶ **Small file size.** JPEGs are much smaller than RAW files; therefore you can fit many more of them on your memory card and later on your hard drive. If space limitations are a problem, shooting JPEG allows you to get more images in less space.

▶ **Printing straight from the camera.** RAW files can't be printed without first being converted to JPEGs (which you can do in-camera with the D600).

▶ **Continuous shooting.** JPEG files are smaller than RAW files, so they don't fill up the camera's buffer as quickly, allowing you longer bursts without slowing the frame rate.

▶ **Less post-processing.** If you're confident in your ability to get the image perfect at capture, you can save time by not having to process the image in a RAW converter and go straight to JPEG.

Here are some reasons to shoot RAW files:

▶ **16-bit images.** The D600 can capture RAW images in 12- or 14-bit. When converting the file using a RAW converter such as Adobe Camera Raw (ACR) or Capture NX 2, you can save your images as a 16-bit file. When the information is written to JPEG in the camera, the JPEG is saved as an 8-bit file. This gives you the option of working with more colors in post-processing.

▶ **White balance.** The WB setting is tagged in the RAW file, but it isn't fixed in the image data. Changing the WB on a JPEG image can cause posterization and usually doesn't yield the best results. However, changing the WB settings of a RAW file doesn't degrade the image.

▶ **Sharpening and saturation.** These settings are also tagged in the RAW file but not applied to the actual image data. You can add these in post-production to your own specifications.

▶ **Image quality.** Because the RAW file is an unfinished file, it allows you the flexibility to make many changes in the details of the image without any degradation to the quality of the image.

Setting up the Nikon D600

Following in the tradition of most of Nikon's higher-end cameras, the D600 is a highly customizable piece of equipment. There are numerous buttons that you can assign to any number of functions for quick access to the controls you use most often. Most of the features that are frequently accessed have a dedicated button, so the majority of items that are in the menu systems are settings that aren't changed frequently. If there are menu items that you do change frequently, you can add these items to the My Menu feature so that you can access them with maximum ease. These attributes make the D600 a versatile tool that you can use for just about any type of photography. To enter the Nikon D600 menu system, you simply press the Menu button (**MENU**).

Setting up your camera effectively allows you to focus on your art.

The Playback Menu

The Playback menu ([▶]) displays the options that allow you to control how your images are stored, as well as how the camera displays the images during image review and what information is available for you to view while reviewing your images. There are ten options, most of which you can pretty much set and forget.

Delete

This option allows you to delete selected images from your memory card, delete images from a certain date, or delete all the images at once.

To delete selected images, follow these steps:

1. **Press ▶, highlight Selected (default), and press ▶ again.** The camera displays an image selection screen.

2. **Press ⊕ to set the image or images that you want to delete.** You can also press ⊕ to review an image close up before deleting it. When you select the image for deletion, 🗑 appears in the upper-right corner of the thumbnail.

3. **Press the OK button (⊛) to erase the selected images.** The camera asks you for confirmation before deleting the images.

4. **Select Yes, and then press ⊛ to delete.** To cancel the deletion, highlight No (default), and then press ⊛.

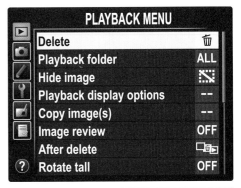

3.1 The Playback menu, shown in two parts

3.2 Selecting images to delete

To delete images from a specific date, use the multi-selector to highlight Select date and then press ▶ or ⊛. A list of dates (or a single date if you've only shot one day on the specific card) appears; use the multi-selector to highlight a date and press ▶ to select the date of the images for deletion. A check mark appears in the box next to the date of the images that will be deleted. You can press ⊞ to view the images taken on that date to confirm that you want to delete them. Press ⊛ to set the date range for deletion. When you're ready to delete the images, press ⊛ again; a dialog box appears, asking for confirmation. Select Yes to delete or No to cancel, and then press ⊛.

To delete all images, use the multi-selector to highlight All, and then press ⊛. Select Yes when asked to confirm the deletion, and then press ⊛ to delete. To cancel the deletion, highlight No (default), and then press ⊛.

Playback folder

The Nikon D600 automatically creates folders in which to store your images. The main folder that the camera creates is called DCIM, and within this folder the camera creates a subfolder to store the images; the first subfolder the camera creates is labeled 100ND600. After shooting 999 images, the camera automatically creates another folder, 101ND600, and so on. If you have used the memory card in another camera and have not formatted it, there will be additional folders on the card (ND700, ND3S, and so on).

You can change the current folder using the Active folder option in the Shooting menu (📷). You have three folder choices:

▶ **ND600.** This is the default setting. The camera only plays back images from folders that the D600 created, and ignores folders from other cameras that may be on the memory cards.

▶ **All.** This option plays back images from all folders that are on the memory cards, regardless of whether the D600 created them.

▶ **Current.** This option displays images only from the folder to which the camera is currently saving. This feature is useful when you have multiple folders from different sessions. Using this setting allows you to preview only the most current images.

Hide image

You can use this option to hide images so that they can't be viewed during playback. When you hide the images, you are also protecting them from being deleted. To select images to be hidden, select Hide image from the menu, press ⊛ or ▶, highlight select/set (default), and then press ▶. Use the multi-selector to highlight the thumbnail images you want to hide. Press ◌⊠/ISO to set, and press ⊕ for a closer look at the selected image. Press ⊛ to hide the image. To unhide the image, repeat this process and press ◌⊠/ISO to deselect; then press ⊛.

To hide images from a specific date, use the multi-selector to highlight Select date, and then press ▶ or ⊛. A list of dates (or a single date if you've only shot one day on the specific card) appears; use the multi-selector to highlight a date and press ▶ to set the date of the images to be hidden. A check mark appears in the box next to the date of the images that will be hidden. You can press ◌⊠ to view the images taken on that date to confirm that you want to hide them. When you're ready to hide the images, press ⊛. To unhide the images, repeat this process, pressing ▶ to remove the check mark, which indicates the images will again be viewable.

To allow all hidden images to be displayed, highlight Deselect all; the camera then asks you for confirmation before revealing the images. Select Yes, and then press ⊛ to display during playback. To cancel and continue hiding the images, highlight No (default) and then press ⊛.

Playback display options

A lot of image information is available to see when you are reviewing images, and the Playback display options settings allow you to customize that information. Enter the Playback display options menu by pressing ▶. Then use the multi-selector to highlight the option you want to set. When the option is highlighted, press ▶ or ⊛ to set the display feature. The feature is set when a check mark appears in the box to the left of the setting. Be sure to scroll up to Done and press ⊛ to set. If you do not perform this step, the information does not appear in the display.

The Playback display options are Basic photo info and Additional photo info. Basic photo info offers one option: Focus point. When you select this option, the focus point that was used will be overlaid on the image to be reviewed. No focus point appears if the camera did not achieve focus or if you used Continuous AF in conjunction with Auto-area AF.

The Additional photo info menu option offers five choices. You can select one, all, or any combination of the following options:

▶ **None (image only).** As indicated, this shows the image only, with no informa-tion at all.

▶ **Highlights.** When you activate this option, any highlights that are blown out will blink. If this happens, you may want to apply some exposure compensation or adjust your exposure to be sure to capture highlight detail. You can also view the highlight information in each separate color channel (RGB) by pressing and hold-ing ☒ and pressing ◀ or ▶. Looking at the bottom-left corner shows you which channel is selected: RGB, R, G, or B. The letter, or letters, blink.

▶ **RGB Histogram.** When you activate this option, you can view the separate his-tograms for the Red, Green, and Blue channels along with a standard luminance histogram. The highlights are also displayed in this option, and as with the stan-dard highlights option, you can choose to view the highlights in each separate channel by pressing and holding ☒ and pressing ◀ or ▶.

▶ **Shooting Data.** This option allows you to review the shooting data (metering, exposure, lens focal length, and so on).

▶ **Overview.** This option shows a thumbnail version of the image with the lumi-nance histogram, as well as general shooting data: shutter speed, aperture, ISO, and so on.

When you select any of these options, you can toggle through them by pressing ▲ and/or ▼.

Copy image(s)

This option allows you to copy images from card slot 1 to card slot 2, and vice versa. To do so, follow these steps:

1. **Choose the Select source option from the menu.** Press ▶ to view the options. Use ▲ or ▼ to highlight the card slot number. Press ⊛.

2. **Choose the Select image(s) option from the menu and press ▶ to view the options.** The menu displays a list of the available folders on the card. Select the folder you want to copy from and press ▶. This brings up the Default image selection submenu.

3. **From the Default image selection submenu, select one of the three options.**
These options determine which images (if any) are selected by default. Once
you determine which selection method you want to use, press ⊛ to display
thumbnails of all the images on the card. Use the multi-selector to browse the
images. When an image is highlighted, press ⊛ to set or unset the image for
copying. When the image is selected for transfer, a check mark appears in the
upper-left corner of the thumbnail. You can use 🔍 to take a closer look at the
highlighted image. Press ⊛ when you are finished making your selections.
There are three options:

- **Deselect all.** This option selects no images for transfer. Manually select any
images you want to copy.

- **Select all images.** This option selects all images for transfer. Manually
deselect any images you don't want to copy.

- **Select protected images.** This option selects only images that you have
protected by pressing the Protect button (**?⊶/WB**). You can manually select
or deselect any other images.

4. **Choose the Select destination folder option from the menu and press ▶ to
view the options.** You can select by folder number by using the multi-selector,
or you can choose Select Folder from list and use the multi-selector to highlight
an existing folder.

CAUTION Images are not copied if there isn't enough space on the destination
card.

5. **Select Copy image(s), press ⊛, and then select Yes.**

If an image with the same filename is in the destination folder, a dialog box appears,
asking what you want to do with the images. You have the following options:

▶ **Replace existing image.** This option overwrites the image on the destination
card with the image from the source card.

▶ **Replace all.** This option replaces all images from the source card with images
with the same name on the destination card. Use this option if you're positive
you don't want to lose any images that may be different yet have the same file-
name (this can happen if Custom Settings (✐) d7 File Number Sequence is set
to Off or Reset).

▶ **Skip.** This option skips copying that single image and continues on with the rest; the dialog box appears again if there is another issue with the filenames.

▶ **Cancel.** This option cancels any further image copying.

NOTE If the image is protected, the copy will also be protected. If you have set up the image as a DPOF, that image will *not* be copied. Hidden images are exempt from being copied.

Image review

This option allows you to choose whether the image is shown on the LCD immediately after you capture the image. When you turn this option off (the default setting), you can view the image by pressing the ▶ button. Keeping this option off conserves battery power because the LCD is actually the biggest drain on your battery. When shooting events with a lot of quickly changing action, such as sporting events and concerts, keep this option off. I have found that when trying to move focus points while the images are being previewed, instead of moving the focus point the camera is scrolling through the image's data.

If you're shooting portraits or other shots where you are shooting single images, you can turn this option on. This allows you a chance to preview the image to check the exposure, framing, and sharpness.

After delete

This option allows you to choose which image displays after you delete an image during playback. Here are the options:

▶ **Show next.** This is the default option. The next image that you take displays after you delete the selected image. If the deleted image is the last image, the previous image displays.

▶ **Show previous.** After you delete the selected image, the one you took before it displays. If you delete the first image, the following image displays.

▶ **Continue as before.** This option allows you to continue in the order that you were browsing the images. If you were scrolling through in the order they were shot, the next image displays (Show next). If you were scrolling through in reverse order, the previous image displays (Show previous).

Rotate tall

The D600 has a built-in sensor that can tell whether the camera was rotated while you took the image. This option rotates images that you have shot in portrait orientation to display upright on the LCD screen. I usually turn this option off because the portrait orientation image appears substantially smaller when displayed upright on the LCD.

You have two options:

▶ **On.** The camera automatically rotates the image to be viewed while holding the camera in the standard upright position. When you turn this option on (and set the Auto image rotation setting to On in the Setup menu [♈]), the camera orientation is recorded for use in image-editing software.

▶ **Off (default).** When you turn the auto-rotating function off, images taken in portrait orientation display sideways on the LCD in landscape orientation.

Slide show

This option allows you to display a slide show of images from the current active folder. You can use this feature to review the images that you have shot without having to use the multi-selector. This is also a good way to show friends or clients your images. You can connect the camera to an HDTV to view the slide show on a big screen. There are three options:

▶ **Start.** This option simply starts the slide show. It plays back both still images and movies.

▶ **Image type.** This option allows you to select what kinds of files are played back. You can select Still images and movies, Still images only, or Movies only.

▶ **Frame interval.** This option allows you to select how long the still images display. The options are 2, 3, 5, or 10 seconds.

While the slide show is in progress, you can use the multi-selector to skip forward or back (◀ or ▶) and view shooting information or histograms (▲ or ▼). You can also press the **MENU** button to return to the Playback menu, press ▶ to end the slide show, or tap the shutter-release button lightly to return to the Shooting mode.

Pressing ⊛ while the slide show is in progress pauses the slide show and offers you options for restarting the slide show, changing the frame rate, or exiting the slide show. Press ▲ or ▼ to make your selection, and then press ⊛.

DPOF print order

DPOF stands for Digital Print Order Format. This option allows you to select images to be printed directly from the camera. You can use this feature with Pict-bridge-compatible printers or DPOF-compatible devices such as a photo kiosk at your local photo printing shop. This is a handy feature if you don't have a printer at home and you want to have prints made quickly, or if you do have a printer and want to print your photos without downloading them to your computer.

CAUTION DPOF can only be made with JPEG files. If there are no JPEG images on the card, this option is not available. If you shoot RAW, you can use the RAW editing features in the Retouch menu (☑) to create a JPEG copy.

Follow these steps to create a print set:

1. **Use the multi-selector to choose the DPOF print order option and then press ▶ to enter the menu.**

2. **Use the multi-selector to highlight Select/set, and press ▶ to view thumbnails.** You can press ⨁ to view a larger preview of the selected image.

3. **Press ▶, ◀, ▲, or ▼ to highlight an image to print, and press ⊕ and ▲ when the desired image is highlighted to set the image and choose the number of prints you want of that specific image.** You can choose from 1 to 99. The number of prints and a small printer icon appear on the thumbnail. Continue this procedure until you have selected all the images that you want to print. Press ▼ to reduce the number of prints and to remove the image from the print set.

4. **Press ⊛.** A menu appears with three options:

 • **Done (default).** Press ⊛ to save and print the images as they are.

 • **Data imprint.** Press ▶ to set. A check mark appears in the box next to the menu option. When you select this option, the shutter speed and aperture setting appear on the print.

 • **Date imprint.** Press ▶ to set. A check mark appears in the box next to the menu option. When you select this option, the date the image was taken appears on the print.

5. **If you choose to set the imprint options, be sure to return to the Done option and press ⊛ to complete the print set.**

The Shooting Menu

The Shooting menu () allows you to control how the D600 handles files when you are shooting images. This includes ISO, image quality, white balance, Picture Controls, and more. In short, anything that affects the file or how the image is captured is set here. Some of the options in this menu, such as Image quality, WB, ISO, and Picture Control, can also be set using external buttons so that you don't need to enter this menu to change them.

Reset shooting menu

Simply put, selecting this option resets all the following ☐ menu options to their default settings. Select this option and press ⊛ or ▶. Two options appear: Yes and No. Select Yes to reset or No to cancel. Press ⊛.

Storage folder

The D600 automatically creates folders in which to store your images. The camera creates a folder named ND600, and then stores the images in subfolders starting with folder 100. You can choose to change the folder that the camera is saving to. You can also specify a number from 100 up to 999. You can use this option to separate different subjects into different folders. I separate my photos into different folders when I shoot concerts, festivals, or motorsports to make it easier to sort through the images later. If I am taking shots of five bands, I start out using folder 101, then 102 for the second act, and so

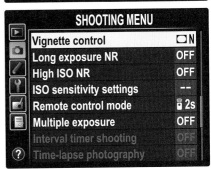

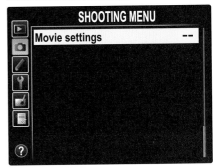

3.3 The Shooting menu, shown in four parts

on. If you are travelling, you can save your images from each destination to separate folders. These are just a couple of different examples of how you can use this feature.

> **TIP** Set this option to My Menu for quick access if you need to change the storage folder frequently.

When selecting the active folder, you can choose a new folder number or you can select a folder that has already been created. When you format your memory card, the camera deletes all preexisting folders and creates a folder with whatever number the active folder is set to. So if you set it to folder 105, the camera creates folder 105ND600 when the card is formatted. It does not start from the beginning with a folder 100. If you want to start with folder 100, you need to change the active folder back to 100 and then format your card.

Follow these steps to change the storage folder:

1. **From the 🗖 menu, use the multi-selector to choose Storage folder and press ▶ to highlight Select folder by number.**

2. **Press ◀ or ▶ to select a digit, and ▲ or ▼ to change the number.** Existing folders display an icon that tells you whether the folder is empty, contains images, or is full. Folders that contain 999 images cannot be used.

3. **Press ⓞⓚ to save your changes.**

If you already have a folder or folders created and you want to select a specific one, choose the Select folder from list option and press ▲ or ▼ to highlight the folder number you wish to select. Press ⓞⓚ when you're finished.

File naming

When an image file is created, the D600 automatically assigns it a filename. When you use the sRGB color space, the default filenames start with DSC_ followed by a four-digit number and the file extension (DSC_0123.jpg). When you use the Adobe RBG color space, the filenames start with _DSC followed by a four-digit number and the file extension (_DSC0123.jpg).

This menu option allows you to customize the filename by replacing the DSC prefix with any three letters of your choice. For example, I customize mine so that the filename reads JDT_0123.jpg.

Perform the following steps to customize the filename:

1. **Highlight the File naming option in the ☐ menu, and press ▶ to enter the menu.** The menu shows a preview of the filename (for sRGB, it would be DSC_1234; for Adobe RGB, it would be _DSC1234).

2. **Press ▶ to enter a new prefix within the text entry screen.** This text entry screen doesn't have lowercase letters or any punctuation marks because the file-naming convention only allows for files to be named using capital letters and the numbers 0 to 9.

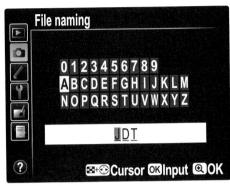

3.4 Text entry screen

3. **Use the multi-selector to choose the letters and/or numbers.** Press ⊛ when you finish.

Role played by card in Slot 2

This option determines the function of your secondary card slot. You have three items to choose from:

▶ **Overflow.** If this option is selected when the primary card is full, the camera automatically switches to the secondary card. If the primary card is replaced with a blank card, the camera automatically switches back to writing to the primary card. This is the option I usually choose.

▶ **Backup.** When you select this option, the camera automatically writes two copies of the images, one to the primary card and one to the secondary card.

▶ **RAW primary/JPEG secondary.** When you select this option and set the image quality to RAW + JPEG, RAW files are saved to the primary card and JPEGs to the secondary card.

NOTE When two cards are inserted into the camera, you can select one of them to be dedicated to video in the Movie settings → Destination option in the ☐ menu.

Image quality

This menu option allows you to change the image quality of the file. You can choose from these options:

▶ **NEF (RAW).** This option saves the images in RAW format. You can adjust the RAW recording settings in the NEF (RAW) recording option in the 📷 menu.

▶ **JPEG fine.** This option saves the images in JPEG format with minimal compression of about 1:4.

▶ **JPEG normal.** This option saves the images in JPEG format with standard compression of about 1:8.

▶ **JPEG basic.** This option saves the images in JPEG format with high compression of about 1:16.

▶ **NEF (RAW) + JPEG fine.** This option saves two copies of the same image, one in RAW and one in JPEG with minimal compression.

▶ **NEF (RAW) + JPEG normal.** This option saves two copies of the same image, one in RAW and one in JPEG with standard compression.

▶ **NEF (RAW) + JPEG basic.** This option saves two copies of the same image, one in RAW and one in JPEG with high compression.

You can also change these settings by pressing **QUAL** and rotating the Main Command dial to choose the file type and compression setting. You can view the setting on the LCD control panel on the top of the camera.

CROSS REF For more detailed information on image quality, compression, and file formats, see Chapter 2.

Image size

This option allows you to choose the size of the JPEG files. The choices are Large, Medium, and Small. The pixel sizes of the images vary, depending on what image area you have selected: FX (FX) or DX (DX) (this is covered in the next section). You can change the image size depending on the intended output of the file.

The file size settings are as follows:

▶ **FX (36X24)**

- **Large.** This setting gives you a high-resolution image of 6016 × 4016 pixels or 24.2 megapixels.

- **Medium.** This setting gives you a resolution of 4512 × 3008 pixels or 13.6 megapixels.

- **Small.** This setting gives you a resolution of 3008 × 2008 pixels or 6 megapixels.

CROSS REF For more detailed information on image size, see Chapter 2.

NOTE You can also change the image size for JPEG by pressing **QUAL** and rotating the Sub-command dial. The settings display on the LCD control panel on the top of the camera.

▶ **DX (24X16)**

- **Large.** This setting gives you a high-resolution image of 3936 × 2624 pixels or 10.3 megapixels.

- **Medium.** This setting gives you a resolution of 2944 × 1968 pixels or 5.8 megapixels.

- **Small.** This setting gives you a resolution of 1968 × 1312 pixels or 2.6 megapixels.

Image area

If you switched over from a Nikon DX format dSLR, such as the D300s or D7000, you have likely invested some money in DX lenses. Nikon enables you to use these DX lenses on the D600 by allowing you to switch between ⬚ and ⬚ formats. The relatively high resolution of the D600 allows you to use DX lenses and still have enough resolution for decent-sized prints. You have the following choices:

▶ **Auto DX crop.** This option allows the camera to recognize when a NIKKOR DX lens is attached and automatically switches the camera into DX mode. This is only guaranteed to work with NIKKOR DX lenses. With some third-party DX lenses, the camera may not recognize that the lens is DX. You can turn this

option on or off. If you have NIKKOR DX lenses that you want to use along with your FX lenses, you should keep this option on.

▶ **Choose image area.** This option allows you to manually choose between FX and DX. Select FX format (36 × 24) for full-frame, or DX format (24 × 16) for APS-C sensor size.

CROSS REF For more detailed information on using DX lenses, see Chapter 4.

JPEG compression

This menu allows you to set the amount of compression applied to the images when recorded in the JPEG file format. You have two options:

▶ **Size priority.** With this option, the JPEG images are compressed to a relatively uniform size. Image quality can vary, depending on the amount of image information in the scene you photographed. To keep the file sizes similar, some images must be compressed more than others.

▶ **Optimal quality.** This option provides the best compression algorithm. The file sizes vary with the information contained in the recorded scene. Use this mode when image quality is a priority.

3

NEF (RAW) recording

This option is for setting the amount of compression applied to RAW files. This menu is also where you choose the bit depth of your RAW files. Use the Type submenu (which you access from the RAW recording menu) to choose the compression. You have two options:

▶ **Lossless compressed.** This is the default setting. The RAW files are compressed, reducing the file size from 20 to 40 percent with no apparent loss of image quality.

▶ **Compressed.** The RAW file is compressed by 35 to 55 percent. There is some file information lost.

NOTE The Nikon D600 doesn't have the option to record uncompressed RAW files as the D800 and D4 do.

Use the NEF (RAW) bit depth submenu to choose the bit depth of the RAW file; there are two options:

▶ **12 bit.** This records the RAW file with 12 bits of color information.

▶ **14 bit.** This records the RAW file with 14 bits of color information. The file size is significantly larger, but there is much more color information for smoother color transitions in your images.

CROSS REF For more detailed information on RAW compression and bit depth, see Chapter 2.

White balance

You can change the white balance settings using this menu option, which allows you to fine-tune your settings with more precision. It also gives you a few more options than when using the WB button (**WB**). You can select a WB setting from the standard settings (Auto, Incandescent, Fluorescent, Direct sunlight, Flash, Cloudy, Shade) or you can choose to set the WB according to color temperature by selecting a Kelvin temperature (you can choose a temperature from 2500 K to 10,000 K). A third option is to select from a preset WB that you have set.

CROSS REF For detailed information on white balance settings and color temperature, see Chapter 2.

Using White Balance settings

To select one of the standard settings, choose the White balance option from the 🔾 menu, use the multi-selector to highlight the preferred setting, and then press ▶ or 🆗. This displays a new screen, giving you the option to fine-tune the standard setting. This screen displays a grid that allows you to adjust the color tint of the selected WB setting. The horizontal axis of the grid allows you to adjust the color from amber to blue, making the image warmer or cooler, while the vertical axis of the grid allows you to change the tint by adding a magenta or green cast to the image. Using the multi-selector, you can choose a setting from 1 to 6 in either direction; additionally, you can add points along the horizontal and vertical axes simultaneously. For example, you can add 4 points of amber to give it a warmer tone and also add 2 points of green, shifting the amber tone more toward yellow.

Choosing the fluorescent setting displays some additional menu options: You can choose from seven non-incandescent lighting types. This is handy if you know the specific type of fixture that is being used.

For example, most outdoor sporting arenas use mercury-vapor lights to light the field at night. Selecting the fluorescent WB setting from the ⬛ menu and choosing the #7 option, High temp. mercury-vapor, will give you a more accurate and consistent white balance, allowing you to more accurately assess the histogram.

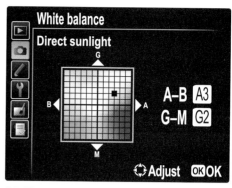

3.5 The White balance fine-tuning grid

There are seven settings:

▶ **Sodium-vapor.** These types of lights are often found in streetlights and parking lots. They emit a distinct, deep-yellow color.

▶ **Warm-white fluorescent.** These types of lamps give a white light with a slight amber cast to add some warmth to the scene. They burn at around 3000 K, similar to an incandescent bulb.

▶ **White fluorescent.** These lights cast a very neutral, white light at around 5200 K.

▶ **Cool white fluorescent.** As the name suggests, this type of lamp is a bit cooler than a white fluorescent lamp and has a color temperature of 4200 K.

▶ **Day white fluorescent.** This lamp approximates sunlight at about 5500 K.

▶ **Daylight fluorescent.** This type of lamp gives you about the same color as daylight. This lamp burns at about 6300 K.

▶ **High temp. mercury-vapor.** These lights vary in temperature, depending on the manufacturer, and usually run between 4200 and 5200 K.

NOTE Sunlight and Daylight are quite different color temperatures. Sunlight is light directly from the sun and is about 5500 K. Daylight is the combination of sunlight and skylight and has a color temperature of about 6300 K.

Choosing a color temperature

Using the K white balance option, you can choose a specific color temperature, assuming that you know the actual color temperature of the scene. Some light bulbs and fluorescent lamps are calibrated to emit light at a specific color temperature; for example, full-spectrum light bulbs burn at a color temperature of 5000 K.

As with the other settings, you get the option to fine-tune this setting using the grid.

Preset manual white balance

Preset manual white balance allows you to make and store up to four custom white balance settings. You can use this option when shooting in mixed lighting, for example, in a room with an incandescent light bulb and sunlight coming in through the window, or when the camera's auto white balance isn't quite getting the correct color.

You can set a custom white balance in two ways: using direct measurement, where you take a reading from a neutral-colored object (a gray card works best for this) under the light source; or copying it from an existing photograph, which allows you to choose a WB setting directly from an image that is stored on your memory card.

NOTE The camera can store up to four presets, which are labeled d-1 through d-4.

CROSS REF See Appendix C for instructions on using the included gray card to preset the white balance.

To manually preset the white balance, simply press the ?/o⌐/**WB** button, rotate the Main Command dial to PRE, and then rotate the Sub-command dial to the desired preset number (d-1 to d-4). Release ?/o⌐/**WB** momentarily, and then press and hold it for 2 seconds until PRE begins to flash on the control panel and the viewfinder display. Then aim the camera at a neutral subject and take a photo. If the preset was successful, "GD" flashes in the viewfinder. If "No GD" flashes in the viewfinder, you need to shoot another photo. You require a good amount of light to get a proper white balance setting.

The D600 also allows you to add a comment to any of the presets. You can use this to remember the details of your WB setting. For example, if you have a set of photographic lights in your studio, you can set the WB for these particular lights and enter "photo lights" into the comment section. You can enter up to 36 characters (including spaces). To enter a comment on a WB preset:

1. **Press MENU and use the multi-selector to choose White balance from the ◙ menu.**

2. **Select Preset manual from the White balance menu and press ▶ to view the preset choices.**

3. **Use the multi-selector to highlight one of the presets.** You can choose from d-1 to d-4.

4. **Press ꔈ/ISO.** The preset menu displays.

5. **Use the multi-selector to highlight Edit comment and press ▶.** This displays the text entry screen.

6. **Enter your text and press ⊕ to save the comment.**

Color Temperatures in the Kelvin Scale

3.6 The Kelvin color temperature scale

Copy white balance from an existing photograph

You can also copy the white balance setting from any photo that is saved on the memory card that's inserted into your camera. Follow these steps:

> **NOTE** If you have particular settings that you like, you should consider saving the images on a memory card. This way, you can always have your favorite WB presets saved so you don't accidentally erase them from the camera.

1. **Press MENU and use the multi-selector to choose White balance from the ◙ menu.**

2. **Select Preset manual from the White balance menu and press ▶ to view the preset choices.**

3. **Use the multi-selector to highlight d-1, d-2, d-3, or d-4 and press ꔈ/ISO.** This displays a menu.

4. **Use the multi-selector to highlight Select image and press ▶.** The LCD displays thumbnails of the images saved to your memory card. This is similar to the Delete and DPOF thumbnail display. Use the multi-selector directional buttons to scroll through the images. You can zoom in on the highlighted image by pressing ⊕.

5. **Press ⊛ to set the image to the selected preset (d-1, d-2, and so on) and press ⊛ again to save the setting.** Once you've selected the image, the thumbnail appears in the setting area. You can also go up to the fine-tune option for adjustments, enter a comment, or protect the setting as with the Manual preset option.

Once your presets are in order, you can quickly choose among them by following these easy steps:

1. **Press ?⊶/WB.**

2. **Rotate the Main Command dial until PRE appears on the LCD control panel.**

3. **Continue to press ?⊶/WB and rotate the Sub-command dial.** The top-right corner of the LCD control panel displays the preset options from d-1 to d-4.

Set Picture Control

Nikon has included Picture Controls in the D600. These controls allow you to choose how the images are processed, and you can also use them in Nikon View and Nikon Capture NX2 image-editing software. Picture Controls allow you to get the same results when using different cameras that are compatible with the Nikon Picture Control System.

You can adjust all these Picture Controls to suit your specific needs or tastes. In the color modes — Standard (⊡SD), Neutral (⊡NL), Vivid (⊡VI), Portrait (⊡PT), and Landscape (⊡LS) — you can adjust the sharpening, contrast, brightness, hue, and saturation. In Monochrome mode (⊡MC), you can adjust the filter effects and toning. After adjusting the Picture Controls, you can save them for later use. You can do this in the Manage Picture Control option described in the next section.

CROSS REF For detailed information on customizing and saving Picture Controls, see Chapter 2.

NOTE When you save to NEF, the Picture Controls are imbedded into the metadata. Only Nikon's software can use these settings. When you open RAW files using a third-party program such as Adobe Camera RAW in Photoshop, the Picture Controls are not used.

Manage Picture Control

This menu is where you can edit, save, and rename your Custom Picture Controls. There are four menu options:

▶ **Save/edit.** In this menu, you choose a Picture Control, make adjustments to it, and then save it. You can rename the Picture Control to help you remember what adjustments you made or to indicate what the Custom Picture Control is to be used for. For example, I have created one Picture Control named ultra-VIVID, which has the contrast, sharpening, and saturation boosted as high as it can go. I sometimes use this setting when I want crazy, oversaturated, unrealistic-looking images for abstract shots or light trails.

▶ **Rename.** This menu allows you to rename any of your Custom Picture Controls. You cannot, however, rename the standard Nikon Picture Controls.

▶ **Delete.** This menu gives you the option of erasing any Custom Picture Controls you have saved. This menu only includes controls you have saved or that you have downloaded from an outside source. You cannot delete the standard Nikon Picture Controls.

▶ **Load/save.** This menu allows you to upload Custom Picture Controls to your camera from your memory card; delete any Picture Controls saved to your memory; or save a Custom Picture Control to your memory card to export to Nikon View or Nikon Capture NX2 or to another camera that is compatible with Nikon Picture Controls.

CROSS REF For detailed information on creating and managing Picture Controls, see Chapter 2.

The D600 also allows you to view a grid graph that shows you how the Picture Controls relate to each other in terms of contrast and saturation. Each Picture Control is represented on the graph by a square icon with the letter of the Picture Control to which it corresponds. Custom Picture Controls are denoted by the number of the custom slot to which they have been saved. Standard Picture Controls that

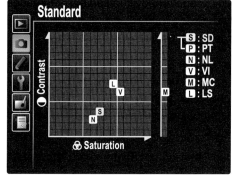

3.7 The Picture Control grid

you have modified display with an asterisk next to the letter. Picture Controls that have been set with one or more auto settings appear in green with lines extending from the icon to show you that the settings will change, depending on the images.

To view the Picture Control grid, select the Set Picture Control option from the 📷 menu. Press ⊛ and the Picture Control list appears. Press ⊕/ISO to view the grid. Once the Picture Control grid appears, you can use the multi-selector to scroll though the different Picture Control settings. After you highlight a setting, you can press ▶ to adjust the settings or press ⊛ to set the Picture Control. Press **MENU** to exit back to the 📷 menu, or tap the shutter-release button to ready the camera for shooting.

Auto distortion control

Some distortion occurs due to lens design. Each lens has its own specific distortion characteristics and Nikon has built-in software that automatically corrects lens distortion based on the specific lens used. Note that this feature only works with NIKKOR D- and G-type lenses. NIKKOR Perspective Control and fisheye lenses do not work with this feature because of the lens design. Nikon also warns that this feature is not guaranteed to work with third-party lenses. This feature is only applied to JPEGs or to NEF files opened using Nikon software. Auto distortion control does not work when shooting video.

Color space

Color space simply describes the range of colors, also known as the *gamut,* that a device can reproduce. With the D600, you have two choices of color spaces: sRGB and Adobe RGB. The color space you choose depends on what the final output of your images will be.

▶ **sRGB.** This is a narrow color space, meaning that it deals with fewer colors and also more saturated colors than the larger Adobe RGB color space. The sRGB color space is designed to mimic the colors that most low-end monitors can reproduce.

▶ **Adobe RGB.** This color space has a much broader color spectrum than is available with sRGB. The Adobe gamut was designed for dealing with the color spectrum that can be reproduced with most high-end printing equipment.

This leads to the question of which color space you should use. If you take pictures, download them straight to your computer, and typically only view them on your monitor

or upload them for viewing on the web, then sRGB is fine. The sRGB color space is also useful when printing directly from the camera or memory card with no post-processing.

If you are going to have your photos printed professionally or you intend to do a bit of post-processing to your images, using the Adobe RGB color space is recommended. This allows you to have subtler control over the colors than is possible using a narrower color space like sRGB.

I generally capture my images using the Adobe RGB color space. I then do my post-processing and make a decision on the output. If I know that I will be posting an image to the web, I convert it to sRGB; any images destined for my printer are saved as Adobe RGB. I usually end up with two identical images saved with two different color spaces. Because most web browsers don't recognize the Adobe RGB color space, any images saved as Adobe RGB and posted on the Internet usually appear dull and flat.

NOTE Some photo printing labs also require sRGB files. Consult with the lab to see what its requirements are before sending off the file.

Active D-Lighting

Active D-Lighting is a setting designed to help ensure that you retain highlight detail when shooting in a high-contrast situation — such as shooting a picture in direct, bright sunlight — which can cause dark shadows and bright highlight areas. Active D-Lighting helps preserve both shadow and highlight detail while also controlling mid-tone contrast. The exact nature of how this works is a proprietary Nikon feature that is encoded into the EXPEED III image processor.

Using Active D-Lighting changes all the Picture Control brightness and contrast settings to Auto; Active D-Lighting keeps detail in the shadow areas by adjusting the brightness and contrast.

Active D-Lighting has six settings: Auto, Extra high, High, Normal, Low, and Off.

CAUTION Using the Extra high or High setting can cause excessive noise or banding to appear in the shadow areas.

From my experiences using Active D-Lighting, I find that it works, but the changes it makes can be subtler when using the lower settings. For general shooting, I recommend setting Active D-Lighting to Auto. I prefer to shoot in RAW and although the

settings are saved to the metadata for use with Nikon software, I would rather do the adjustment myself in Adobe Photoshop, so I turn this feature off.

When using Active D-Lighting, the camera needs some extra time to process the images. Your buffer fills up faster when shooting continuously, so expect shorter burst rates.

High Dynamic Range (HDR)

Although this term has become synonymous with hyper-realistic imagery, HDR is really just a tool to make your images look more like they do to the human eye. Nikon's built-in HDR takes two shots and combines them using in-camera processing to expand the shadow and the highlight detail. Once you select the HDR mode from the ⬛ menu, you have a few options to choose from:

▶ **HDR mode.** This is where you turn the HDR on and off. There are three options:

- **On (series).** This allows you to shoot HDR continuously. On some previous cameras, the HDR setting only took one HDR shot and then you had to reset it for the next shot.

- **On (single photo).** With this setting, the camera takes one HDR image and then resets back to default photos.

- **Off.** This disables the HDR setting.

▶ **Exposure differential.** This option is used to set the difference between the exposures of the two images that are to be merged. You have four options:

- **Auto.** When you select this option, the camera meter assesses the scene and automatically adjusts the exposure difference of the two images. I've found that this option works best, especially with the D600's 2016-pixel RGB metering sensor.

- **1EV.** This option gives a 1-stop difference between exposures, which is a pretty safe setting for most HDR shots.

- **2EV.** This option gives you a 2-stop difference, which is pretty substantial. There should be a good amount of contrast in the scene when you select this option.

- **3EV.** This option provides 3 stops of exposure difference and should only be used in the most extreme contrast situations. A bright, sunlit day at high noon would probably be the best time to use this setting.

▶ **Smoothing.** This option controls how the two images are blended together. You have three options: High, Normal, and Low. The High option provides smoother blending, but I find that Normal works best for most applications, especially when using the Auto setting.

CAUTION The HDR feature is only available when shooting JPEG without RAW. When you set the image quality to RAW or RAW + JPEG, the HDR option is *not* available!

NOTE When the camera is combining the images, the text "Job HDR" flashes in the control panel and the LCD, and you cannot take any photos until the HDR is finished being processed.

Vignette control

Some lenses, especially wide-angle lens, tend to *vignette* or darken near the edges of the frame. This problem is more common on cameras with FX sensors than it is with DX cameras. The problem is due to the extremely oblique angle at which the light enters the lens. Vignetting is more pronounced when using wide apertures; therefore, reducing the aperture size also reduces the amount of vignetting that occurs.

Although you can correct vignetting in post-processing, Nikon includes a vignette control feature that lightens the edges to make the exposure more uniform.

There are four vignette control options: High, Normal, Low, and Off. I have tried this feature numerous times, and it still tends to leave a vignette, even on the High setting. I usually leave this option off because there are much better ways to control vignetting using image-editing software such as Adobe Lightroom or Adobe Camera RAW. Nikon even notes in the manual that this setting may cause fogging or noise on the edges of the frame when shooting JPEGs, and Custom Picture Controls may not function as desired — more reasons to leave this option off.

NOTE Vignette control is deactivated when shooting video or multiple exposures, as well as when you set the camera to 🔲 mode.

Long exposure NR

This menu option allows you to turn on noise reduction (NR) for exposures of 1 second or longer. When this option is on, after taking a long-exposure photo, the camera

runs a noise-reduction algorithm that reduces the amount of noise in your image to produce a smoother result. The technique the D600 employs for long exposures is called dark frame noise reduction and is calculated by making an exposure of the same time with the shutter closed; the camera analyzes the noise and bases the noise reduction on this second exposure. This doubles the processing time and slows your frame rate. Again, this is a setting I leave off, preferring to do my own noise reduction using other software in post-processing.

High ISO NR

This menu option allows you to choose how much noise reduction (NR) is applied to images that you take at high ISO settings. (Nikon doesn't specify at what setting this starts; it's probably somewhere around ISO 800.) There are four settings:

▶ **High.** This setting applies fairly aggressive NR. A fair amount of image detail can be lost when you use this setting.

▶ **Normal.** This is the default setting. Some image detail may be lost when you use this setting.

▶ **Low.** This setting applies a small amount of NR. Most of the image detail is preserved when you use this setting.

▶ **Off.** This setting only applies NR to images at ISO 2500 or higher, but it applies less NR than the Low setting.

ISO sensitivity settings

This menu option allows you to set the ISO. This is the same as pressing ⊕/**ISO** and rotating the Main Command dial. You can also change the ISO settings in the Info Settings display. The options go from ISO 50 (Lo1) on up to ISO 25,600 (Hi2). The base settings are ISO 100 to ISO 6400. It's recommended that you stick with the base settings rather than the Lo and Hi settings. The Lo settings give slightly lower contrast and the Hi settings cause excessive noise.

CROSS REF Pressing ⊕/**ISO** and rotating the Sub-command dial turns the Auto ISO setting on and off.

You also use this menu to set the Auto ISO parameters.

CROSS REF For more information on ISO settings, Auto ISO, and noise reduction, see Chapter 2.

Remote control mode

The Remote control mode menu option allows you to set the shutter-release options when using the optional wireless remote, the Nikon ML-L3. You have the following three options:

▶ **Delayed remote.** This option puts a two-second delay on the shutter release after you press the button on the ML-L3.

▶ **Quick response remote.** When you select this option, the shutter is released as soon as the camera achieves focus.

▶ **Remote mirror up.** When you select this option, it takes two button presses on the ML-L3 to complete a shutter cycle. The first button press flips up the reflex mirror, and the second button press releases the shutter. This option is used to prevent blur from camera shake caused by the mirror moving. Use this feature when shooting long exposures on a tripod.

Multiple exposure

3

This menu option allows you to record multiple exposures in one image. You can record two or three shots in a single image. This is an easy way to get off-the-wall multiple images without using image-editing software like Adobe Photoshop. Select Multiple exposure mode from the menu, and then (similar to the HDR menu) choose from these three settings:

▶ **On (series).** This allows you to shoot multiple exposures continuously. On previous cameras, the multiple exposure setting only took the amount of images selected for one multiple exposure and then you had to reset it for the next shot.

▶ **On (single photo).** The camera takes enough shots to create the multiple exposure and then resets back to default photos.

▶ **Off.** This disables the Multiple exposure setting.

To use this feature, follow these steps:

1. **Press ▶ to select the mode: On (series), On (single photo), or Off.** When you have selected the preferred option, press ⓄⓀ.

2. **Select the Number of shots menu option and press ▶.**

3. **Press ▲ or ▼ to set the number of shots, and press ⓄⓀ when the number of shots selected is correct.**

4. **Select the Auto gain option and press ▶.**

5. **Set the gain, and then press** ⓞ. Using auto gain enables the camera to adjust the exposure according to the number of images in the multiple exposures. This is the recommended setting for most applications. Setting the gain to Off does not adjust the exposure values and can result in an overexposed image. I only recommend using the Auto gain Off setting in low-light situations.

6. **Take your pictures.** I recommend using single burst and varying the subject matter.

Interval timer shooting

This menu option allows you to set your camera to shoot a specified number of still photos at pre-determined intervals throughout a set period of time. You can use this interesting feature to record the slow movements of plants or animals, such as a flower opening or a snail crawling. Another option is to set up your camera with a wide-angle lens and record the movement of the sun or moon across the sky. I've also set up my camera on a tripod and used the interval timer to shoot photos of my band while I was on stage.

Naturally, you need a tripod to do this type of photography, and if you plan on doing a lengthy shoot time, I suggest that you use the Nikon EH-5b AC power supply to be sure that your camera battery doesn't die in the middle of your shooting. At the very least, you should use an MB-D14 battery grip with an extra battery.

You can then set the following options:

▶ **Start time.** The camera can be set to start 3 seconds after the settings have been completed (Now), or you can set it to start photographing at a predeter-mined time in the future.

▶ **Interval.** This setting determines how much time elapses between each shot. You can set Hours, Minutes, and Seconds.

▶ **Number of intervals.** This set-ting allows you to specify how many times you want photos to be shot.

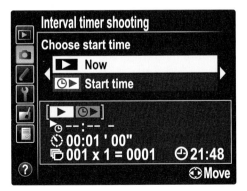

3.8 The Interval timer shooting menu screen

▶ **Shots per interval.** This setting specifies how many shots are taken at each interval.

▶ **On or Off.** This option starts or stops the camera from shooting with the current settings.

Time-lapse photography

The time-lapse photography option is very similar to the interval timer shooting option, except that it automatically joins the photos together as a video, creating a time-lapse movie file.

The time-lapse movie is filmed using the Movie settings that you have currently selected (covered in the next section). For consistency, you should use Ṁ mode and take the white balance setting off Auto. You can check the framing using Ⓛⓥ when setting up your shot prior to activating time-lapse. Be sure the Live View selector is set to the movie option before pressing Ⓛⓥ to frame. You need to use a tripod or rest the camera on something stable. You will need to exit Ⓛⓥ before starting the time-lapse because the time-lapse feature isn't available in Ⓛⓥ.

> **NOTE** Using Manual focus and using a set white balance (as opposed to Auto) is recommended for the most consistent results.

Here are a few things that you need to set before you begin shooting:

▶ **Interval.** This sets the time between video clips. Note that you can't choose an interval longer than 10 minutes. The interval needs to be longer than any expected shutter speed.

▶ **Shooting time.** This sets the allotted amount of time that the time-lapse covers. It cannot be longer than 7 hours and 59 minutes.

Just underneath the Interval and Shooting time settings, there appears to be another setting; however, this is actually an approximation of the length of the final time-lapse movie. It is calculated by dividing the number of shots by the frame rate.

Movie settings

The Movie settings options on the D600 allow you to adjust the size, frame rate, and quality of the videos you record.

CROSS REF You can find in-depth information about recording video in Chapter 7.

There are a number of different options to choose from:

▶ **Frame size / frame rate.** This option allows you to set the size of the HD video and select the frame rate that is appropriate for your output. The following options are available:

- 1920 × 1080; 30fps ([1080 30])
- 1920 × 1080; 25fps ([1080 25])
- 1920 × 1080; 24fps ([1080 24])
- 1280 × 720; 60fps ([720 60])
- 1280 × 720; 50fps ([720 50])
- 1280 × 720; 30fps ([720 30])
- 1280 × 720; 25fps ([720 25])

▶ **Movie quality.** There are two options, High quality and Normal. These options set the maximum bit rate at which the videos are recorded.

CROSS REF Bit rate is covered in depth in Chapter 7.

▶ **Microphone.** This option allows you to adjust the volume of the recording using the built-in microphone or an external microphone. There are three easy options:

- **Auto.** This simple option automatically adjusts the volume level so that the audio levels don't clip. This works well enough for most general video usage.

- **Manual Sensitivity.** This option allows you to set the microphone to record at a specified volume. This option is best for recording sound in a controlled environment.

- **Destination.** This option allows you to select which memory card the video records to. If you only have one memory card inserted, the camera defaults to that card, regardless of which one you select.

The Custom Settings Menu

The Custom Settings menu (✐) is where you really start customizing your D600 to shoot to your personal preferences. This is where you make the camera yours. There

are dozens of options that you can turn off or on to make shooting easier for you. This is probably the most powerful menu in the camera.

Reset custom settings

Choosing this option and selecting yes restores all the custom settings to their default values. I recommend doing this before programming the U1/U2 User Settings.

Custom Settings menu a: Autofocus

The ✎ a submenu controls how the camera performs its autofocus (AF) functions. Because focus is a very critical operation, this is a very important menu.

a1: AF-C priority selection

You can specify how the camera AF functions when in Continuous autofocus (AF-C) mode. You can choose from three modes:

▶ **Release.** This is the default setting. It allows the camera to take a photo whenever you press the shutter-release button, regardless of whether the camera has achieved focus. This setting is best used for fast action shots or for when it's imperative to get the shot whether or not it's in sharp focus.

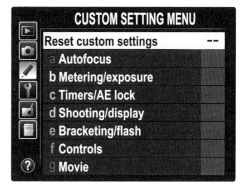

3.9 The Custom Settings menu

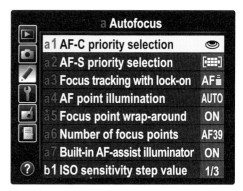

3.10 Custom Settings menu a

▶ **Focus.** This allows the camera to take photos only when the camera achieves focus and the focus indicator (green dot in the lower-left corner of the viewfinder) is lit. This is the best setting for slow-moving subjects where you want to be absolutely sure that your subject will be in focus.

a2: AF-S priority selection

This sets how the camera AF functions when in single autofocus (AF-S) mode. You can choose from two settings:

▶ **Release.** This is the default setting. It allows the camera to take a photo whenever you press the shutter-release button, regardless of whether the camera has achieved focus.

▶ **Focus.** This allows the camera to take photos only when the camera achieves focus and the focus indicator (green dot in the lower-left corner of the viewfinder) is lit.

a3: Focus tracking with lock-on

When photographing in busy environments, such as sporting events or weddings, things can often cross your path, resulting in the camera refocusing on the wrong subject. Focus tracking with lock-on allows the camera to hold focus for a time before switching to a different focus point. This helps stop the camera from switching focus to an unwanted subject that passes through your field of view.

In previous models there were three settings: Long, Normal, and Short. Like the D800, the D600 adds a numbering system of 1 to 5, adding number 2 between Short and Normal, and 4 between Normal and Long.

You can also set the focus tracking with lock-on to off, which allows your camera to quickly maintain focus on a rapidly moving subject. Normal is the default setting.

a4: AF point illumination

This menu option allows you to choose whether the active AF point is highlighted in red momentarily in the viewfinder when you achieve focus. When the viewfinder grid is turned on, the grid is also highlighted in red. When you choose Auto, which is the default, the focus point is lit only to establish contrast from the background when it is dark. When set to On, the active AF point is highlighted even when the background is bright. When set to Off, the active AF point is not highlighted in red but appears black.

a5: Focus point wrap-around

When using the multi-selector to choose your AF point, this setting allows you to keep pressing the multi-selector in the same direction and wrap around to the opposite side or stop at the edge of the focus point frame (no wrap). Personally, I like to set mine to wrap to allow me to quickly switch to the other side of the frame if I need to when shooting in a fast-paced environment.

a6: Number of focus points

This option allows you to choose from the number of available focus points when using AF. You can specify 39 points, which allows you to choose all the D600's available focus points. You can also set it to 11 points, which allows you to choose from only 11 focus points, similar to the D5100 and D3200 series cameras. When you choose the 11-point option, you can select your focus points much more quickly than when using 39 points. However, the 39-point option allows you to more accurately choose where in the frame the camera will focus.

a7: Built-in AF-assist illuminator

The AF-assist illuminator lights up when there isn't enough light for the camera to focus properly (when using the viewfinder only). In certain instances, you may want to turn this option off, such as when shooting faraway subjects, or in dim settings, like concerts or plays where the light may be a distraction. When set to On, the AF-assist illuminator lights up in a low-light situation only when in AF-S mode and Auto-area AF is chosen. When in Single point mode or when Dynamic area AF is chosen, the center AF point must be active.

When set to Off, the AF-assist illuminator does not light at all.

3

Custom Settings menu b: Metering/exposure

This is where you change the settings that control exposure and metering. These settings allow you to adjust the exposure, ISO, and exposure compensation adjustment in increments. Setting the increments to 1/3 stops allows you to fine-tune the settings with more accuracy than setting them to 1/2 or 1 full stop. There are five options to choose from.

b1: ISO sensitivity step value

This is where you control whether the ISO is set in 1/3-, 1/2-, or 1-stop increments. Setting the ISO using smaller steps enables you to fine-tune your sensitivity with more precision, allowing you to keep high ISO noise to a minimum.

b2: EV steps for exposure cntrl

This determines how the increments for shutter speed, aperture, and auto bracketing are set. The choices here are also 1/3 or1/2 1/2 stops. Choosing a smaller increment gives you a much less drastic change in exposure and allows you to get a more exact exposure in critical situations.

b3: Easy exposure compensation

By default, to set the exposure compensation, you must first press ⊞ and use the Main Command dial to add or subtract from the selected exposure. If you use exposure compensation frequently, you can save yourself some time by using this option to set Easy exposure compensation. When you set this function to On, it's not necessary to press ⊞ to adjust exposure compensation. Simply rotate the Main

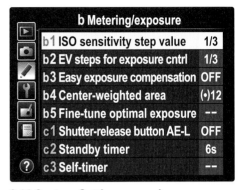

b Metering/exposure	
b1 ISO sensitivity step value	1/3
b2 EV steps for exposure cntrl	1/3
b3 Easy exposure compensation	OFF
b4 Center-weighted area	(•)12
b5 Fine-tune optimal exposure	--
c1 Shutter-release button AE-L	OFF
c2 Standby timer	6s
c3 Self-timer	--

3.11 Custom Settings menu b

Command dial when in Aperture-priority auto mode (**A**), or the Sub-command dial when in Shutter-priority auto mode (**S**) or Programmed auto mode (**P**) to adjust the exposure compensation. The exposure compensation is then applied when you rotate the appropriate command dial until the exposure compensation indicator disappears from the LCD control panel.

If you choose to use Easy exposure compensation, probably the best setting to use is the On (Auto reset) setting. This allows you to adjust your exposure compensation while shooting, but returns the exposure compensation to the default setting (0) when you turn off the camera or when the camera goes to sleep. If you've ever accidentally left exposure compensation adjusted and ended up with improperly exposed images the next time you used your camera, then you will appreciate this helpful feature.

When you set Easy exposure compensation to Off, you apply exposure compensation normally by pressing ⊞ and rotating the Main Command dial.

b4: Center-weighted area

This menu allows you to choose the size of your center-weighted metering area. You can choose from four sizes: 8, 12, 15, or 20mm. You also have the option of setting the meter to Average.

Choose the area size, depending on how much of the center of the frame you want the camera to meter for. The camera determines the exposure by basing 75 percent of the exposure on the circle.

Average uses the whole frame to assess the exposure and can lead to flat, low-contrast images.

CROSS REF For more information on center-weighted metering, see Chapter 2.

b5: Fine-tune optimal exposure

If your camera's metering system consistently over- or underexposes your images, you can adjust it to apply a small amount of exposure compensation for every shot. You can apply a different amount of exposure fine-tuning for each of the metering modes: Matrix (█▄), Center-weighted (◙), and Spot (◻).

You can set the EV ±1 stop in 1/6-stop increments.

CAUTION When Fine-tune optimal exposure is on, there is no warning indicator that tells you that exposure compensation is being applied.

Custom Settings menu c: Timers/AE lock

This small submenu controls the D600's various timers and also the Autoexposure lock setting. There are five options.

c1: Shutter-release button AE-L

When you set this option to default (Off), the camera only locks exposure when you press the Autoexposure-lock/Autofocus-lock button (⚿). When you set it to On, the autoexposure settings are locked when you half-press the camera's shutter-release button.

c2: Standby timer

This menu option is used to determine how long the camera's exposure meter is active before turning off when no other actions are being performed. You can choose 4, 6, 10, or 30 seconds, or 1, 5, 10, or 30 minutes. You can also specify that the meter remain on at all times while the camera is on (No limit).

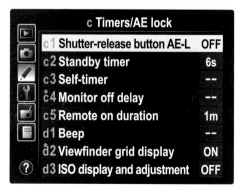

3.12 Custom Settings menu c

c3: Self-timer

This setting puts a delay on when the shutter is released after you press the

109

shutter-release button. This is handy when you want to take a self-portrait and you need some time to get yourself into the frame. You can also use the Self-timer release mode (⟳) to reduce camera shake caused by pressing the shutter-release button on long exposures.

There are three settings that you can adjust:

▶ **Self-timer delay.** You can set the delay to 2, 5, 10, or 20 seconds.

▶ **Number of shots.** You can press ▲ or ▼ to set the camera to take from one to nine photos.

▶ **Interval between shots.** When ⟳ is set to more than one shot, use this option to select the interval between shots by pressing ▲ or ▼. You can set the interval to 0.5, 1, 2, or 3 seconds.

c4: Monitor off delay

This option controls how long the LCD monitor remains on when you do not push any buttons. Because the LCD monitor is the primary drain on power consumption for any digital camera, choosing a shorter delay time is usually preferable.

▶ **Playback:** 4s, 10s (default), 20s, 1min, 5min, 10min

▶ **Menu:** 4s, 10s, 20s, 1min (default), 5min, 10min

▶ **Information display:** 4s, 10s (default), 20s, 1min, 5min, 10min

▶ **Image review:** 2s, 4s (default), 10s, 20s, 1min, 5min, 10min

▶ **Live view:** 5min, 10min (default), 15min, 20min, 30min, No Limit

c5: Remote on duration

This setting controls how long the camera stays active while waiting for a signal from the ML-L3 wireless remote. You can set it to 1, 5, 10, or 15 minutes. After the preset amount of time has passed, the camera's exposure meter is turned off. To reactivate the camera, tap the shutter-release button.

Custom Settings menu d: Shooting/display

The ✎ d submenu is where you make changes to some of the minor shooting and display details.

d1: Beep

When this option is on, the camera emits a beep when the self-timer is counting down or when the AF locks in Single focus mode. You can choose 3, 2, 1, or Off, as well as high or low pitch. Although the beep can be useful when in self-timer mode, it can also be an annoying feature, especially if you are photographing in a relatively quiet area. The beep does not sound when using Live View or when shooting in Quiet shutter release mode (**Q**). The default setting is Off.

d2: Viewfinder grid display

This handy option displays a grid in the viewfinder to assist you in composing your photograph. I find this option to be very helpful, especially when composing landscape and architectural photos.

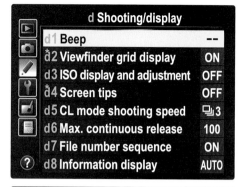

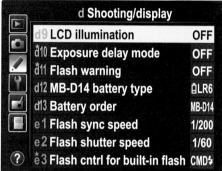

3.13 Custom settings menu d, shown on two screens so all options are visible

d3: ISO display and adjustment

There are three options for this setting. Selecting Show ISO shows the ISO setting instead of the remaining number of frames on the control panel. Selecting Show ISO/ Easy ISO shows the ISO setting in place of the number of remaining exposures. This setting also allows you to quickly change the ISO setting by rotating the Sub-command dial when using **S** or **P** modes, or the Main Command dial when in **A** mode. The default setting is Show frame count, which shows how many remaining exposures you have on the active memory card.

d4: Screen tips

When this option is turned on, the camera displays descriptions of the menu options that are available when using the information display. The menu options in the display are pretty self-evident, so I have this option turned off. If you're unsure of any menu option, then pressing the Help button (**?**) displays a screen that describes the function.

d5: CL mode shooting speed

This option allows you to set the maximum frame rate in the Continuous low-speed shooting mode (CL). You can set the frame rate between 1 and 5 fps. This setting limits your burst rate for shooting slower-moving action. This is a handy option to use when you don't necessarily need the highest frame rate, such as when shooting action that is moving at a moderate speed. I have this set to 3 fps, which is about half the normal frame rate.

d6: Max. continuous release

This option sets the maximum number of images that can be captured in a single burst when the camera is set to CL or CH shooting mode. You can set an amount anywhere from 1 to 100. Setting this option doesn't necessarily mean that your camera is going to capture 100 frames at the full frame rate speed. When shooting continuously, especially at a high frame rate, the camera's buffer fills up and the camera's frame rate slows down or even stops while the buffer transfers data to the memory card. How fast the buffer fills up depends on the image size, compression, and the speed of your memory card. With the D600's large file sizes, I find it very beneficial to use a faster card to achieve the maximum frame rate for extended periods.

d7: File number sequence

The D600 names files by sequentially numbering them. This option controls how the sequence is handled. When set to Off, the file numbers reset to 0001 when a new folder is created, a new memory card is inserted, or the existing memory card is formatted. When set to On, the camera continues to count up from the last number until the file number reaches 9999. The camera then returns to 0001 and counts up from there. When you set this option to Reset, the camera starts at 0001 when the current folder is empty. If the current folder contains images, the camera starts at one number higher than the last image in the folder.

d8: Information display

This option controls the color of the shooting information display on the LCD panel. When set to Auto (default), the camera automatically sets the display to white on black or black on white to maintain contrast with the background. The setting is automatically determined by the amount of light coming in through the lens. You can also specify that the information be displayed consistently, regardless of how dark or light the scene is. You can choose B (black lettering on a light background) or W (white lettering on a dark background).

d9: LCD illumination

When this option is set to Off (default), the LCD control panel on the camera (and on a Speedlight if attached) is lit only when you turn the power switch all the way to the right, engaging the momentary switch. When set to On, the LCD control panel is lit as long as the camera's exposure meter is active, which can be quite a drain on the batteries (especially for the Speedlight).

d10: Exposure delay mode

Turning this option on causes the shutter to open 1, 2, or 3 seconds after you press the shutter-release button and the reflex mirror has been raised. This option is for shooting long exposures with a tripod where camera shake from pressing the shutter-release button and mirror slap vibration can cause the image to be blurry. It's best to use a longer delay when using longer lenses.

d11: Flash warning

When this option is turned on, the flash symbol (⚡) appears in the viewfinder when the light is low or the subject is backlit.

d12: MB-D14 battery type

When using the optional MB-D14 battery pack with AA batteries, use this option to specify what type of batteries are being used to ensure optimal performance. Here are your choices:

▶ **LR6 (AA alkaline).** These are standard, everyday AA batteries. I don't recommend them as they don't last very long when used with the D600.

▶ **HR6 (AA Ni-MH).** These are standard, nickel-metal hydride rechargeable batteries, available at most electronics stores. I recommend buying several sets of them. Make sure they are rated at least 2500 MaH for longer battery life.

▶ **FR6 (AA lithium).** These lightweight batteries are not rechargeable but last up to seven times longer than standard alkaline batteries. Lithium batteries cost about as much as a good set of rechargeable batteries.

NOTE When using an EN-EL15 battery, selecting this option is unnecessary.

d13: Battery order

This option allows you to set the order in which the batteries are used when the optional MB-D14 battery grip is attached. Choose MB-D14 to use the battery grip first, or choose D600 to use the camera battery first. If you're using AA batteries in the MB-D14 only as a backup, set this option to use the camera battery first.

Custom Settings menu e: Bracketing/flash

This submenu is where you set the controls for the built-in Speedlight. Some of these options also affect external Speedlights. This menu also contains the controls for bracketing images. There are seven choices.

e Bracketing/flash	
e1 Flash sync speed	1/200
e2 Flash shutter speed	1/60
e3 Flash cntrl for built-in flash	CMD⚡
e4 Exposure comp. for flash	🖾
e5 Modeling flash	OFF
e6 Auto bracketing set	AE⚡
e7 Bracketing order	N
f1 OK button (shooting mode)	RESET

3.14 Custom Settings menu e

e1: Flash sync speed

This is where you determine what shutter speed your camera uses to sync with the Speedlight. You can set the sync speed between 1/60 and 1/200 second. When using an external Speedlight, you can also set the sync to 1/200 (Auto FP) or 1/250 (Auto FP); this allows you to use faster shutter speeds to maintain wider apertures in bright situations if needed.

CROSS REF For more information on sync speed and Auto FP, see Chapter 6.

e2: Flash shutter speed

This option lets you decide the slowest shutter speed that is allowed when you do flash photography using Front or rear-curtain sync or Red-Eye Reduction mode when the camera is in **P** or **A**. You can choose from 1/60 second all the way down to 30 seconds.

When the camera is set to **S** or the flash is set to any combination of Slow sync, this setting is ignored.

e3: Flash cntrl for built-in flash

This submenu has other submenus nested within it. Essentially, this option controls how your built-in flash operates. There are four submenus:

▶ **TTL.** This is the fully auto flash mode. You can make minor adjustments using Flash Compensation (⚡️±).

▶ **Manual.** You choose the power output in this mode. You can choose from full power all the way down to 1/128 power.

▶ **Repeating flash.** This mode fires a specified number of flashes.

▶ **Commander mode.** Use this mode to control a number of off-camera CLS-compatible Speedlights.

CROSS REF For more information on flash photography and Nikon Creative Lighting System (CLS), see Chapter 6.

e4: Exposure comp. for flash

This is a new feature that was initially introduced on the D4, but inexplicably left out of the D800. Surprisingly enough, this cool feature has made it to the D600. This feature allows you to choose what effect exposure compensation has when using flash. This allows you greater control over your flash exposures and also allows you to manually balance the flash and ambient light more quickly and easily. There are two options:

▶ **Entire frame.** When dialing in exposure compensation, both the flash exposure and the ambient exposure are affected. Increasing or decreasing the exposure compensation is noticeable across the whole scene.

▶ **Background only.** When you select this option, the flash exposure stays as metered and only the ambient or background exposure is affected. The flash stays as metered by TTL or as it is set manually.

This setting is only used when dialing in exposure compensation by pressing ±; when dialing in Flash Compensation (⚡️±), this setting is ignored and only the flash exposure is affected.

e5: Modeling flash

When using the built-in flash or an external Speedlight, pressing the Preview button fires a series of low-power flashes that allow you to preview what the effect of the flash is going to be on your subject. When using CLS and Advanced Wireless Lighting with multiple Speedlights, pressing the button causes all the Speedlights to emit a modeling flash. You can set this option to On or Off. I prefer Off because it is easy to press the Preview button accidentally, causing the flash to fire.

e6: Auto bracketing set

This option allows you to choose how the camera brackets when Auto-bracketing is turned on. You can choose for the camera to bracket AE and flash, AE only, Flash only, WB, or ADL bracketing. WB bracketing is not available when the image quality is set to record RAW images.

e7: Bracketing order

This option determines the sequence in which the bracketed exposures are taken. When set to N (default), the camera first takes the metered exposure, then the under-exposures, and then the overexposures. When set to Under → MTR → over, the camera starts with the lowest exposure, increasing the exposure as the sequence progresses. This is the setting I prefer, as it follows a more natural progression.

Custom Settings menu f: Controls

This submenu allows you to customize some of the functions of the different buttons and dials on your D600. There are nine options.

f1: OK button (shooting mode)

This option allows you to set specific options for pressing ⊛ when in shooting mode.

► **RESET.** This option allows you to automatically select the center focus point by pressing the center button of the multi-selector. This is my preferred setting.

► **Highlight active focus point.** This option causes the active focus point to light up in the view-finder when you press the center button of the multi-selector.

► **Not used.** When you select this option, the center button has no effect when in Shooting mode.

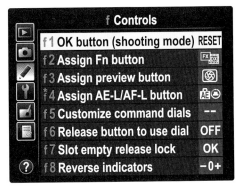

3.15 Custom Settings menu f

f2: Assign Fn button

This menu allows you to choose what functions the Function button (**Fn**) performs when you press it. Be aware that not all options are available, depending on which

particular setting you choose. You can also access this setting using the Quick Settings menu. Here are the options:

▶ **Preview.** Just in case you want to use the Preview button for another function, you can reassign it to this button. This option closes down the aperture so you can see in real time what effect the aperture will have on the image's depth of field. This function is cancelled when you select a function for Fn button + command dials. If you choose this setting for button press only, the function for Fn button + command dials is deactivated.

▶ **FV lock.** This option allows you to use the **Fn** button to fire a preflash to determine flash exposure; you can then recompose the frame and the flash will expose for the original subject as long as you continue to hold the **Fn** button down. This function is cancelled when you select a function for Fn button + command dials. If you choose this setting for button press only, the function for Fn button + command dials is deactivated.

▶ **AE/AF lock.** With this option, the focus and exposure lock when you press and hold the button.

▶ **AE lock only.** With this option, the exposure locks when you press and hold the button. Focus continues to function normally.

▶ **AE lock (hold).** With this option, the exposure locks until you press the button a second time or the exposure meter is turned off.

▶ **AF lock only.** With this option, the focus locks while you press and hold the button. The AE continues as normal.

▶ **AF-ON.** This option allows the **Fn** button to activate the camera's AF system.

▶ **Flash off.** With this option, the built-in flash (if popped up) or an additional Speedlight does not fire when the shutter is released as long as you press **Fn**. This allows you to quickly take available-light photos without having to turn off the flash. This is quite handy, especially when shooting weddings and events.

▶ **Bracketing burst.** With this option, the camera fires a burst of shots when you press and hold the shutter-release button while in Single shot mode when Auto-bracketing is turned on. The number of shots fired depends on the Auto-bracketing settings. When in Continuous shooting mode, the camera continues to run through the bracketing sequence as long as you hold down the shutter-release button.

▶ **Active D-Lighting.** This option allows you to quickly adjust the Active D-Lighting settings by pressing the **Fn** button and rotating the command dials.

▶ **+ NEF(RAW).** When this option is activated and the camera is set to record JPEG, pressing **Fn** allows the camera to simultaneously record a RAW file and a JPEG. Pressing the button again allows the camera to return to recording only JPEGs. This function is cancelled when you select a function for Fn button + command dials. If you choose this setting for button press only, the function for Fn button + command dials is deactivated.

▶ **Matrix metering.** This option allows you to automatically use ▦, regardless of what the metering Mode dial is set to.

▶ **Center-weighted.** This option allows you to automatically use ⊙, regardless of what the metering Mode dial is set to.

▶ **Spot metering.** This option allows you to automatically use ⊡, regardless of what the metering Mode dial is set to.

▶ **Framing Grid.** With this option, pressing the **Fn** button and rotating the Main Command dial allows you to turn the framing grid on and off.

▶ **Choose image area.** With this option, you can press the **Fn** button and rotate either command dial to choose between FX (⊠) and DX (⊠) settings.

▶ **Viewfinder virtual horizon.** When you select this option, pressing the **Fn** button shows the pitch and roll virtual horizon bars in the viewfinder.

▶ **My Menu.** With this option, pressing the **Fn** button brings up My Menu on the monitor.

▶ **Access top item in My Menu.** This brings up the top item set in the My Menu option. You can use this to quickly access your most used menu option. This function is cancelled when you select a function for Fn button + command dials. If you choose this setting for button press only, the function for Fn button + command dials is deactivated.

▶ **1 step spd/aperture.** With this option, when you press the **Fn** button, the aperture and shutter speed are changed in 1-stop intervals.

▶ **Choose non-CPU lens number.** With this option, you can press the **Fn** button and rotate the Main Command dial to choose one of your presets for a non-CPU lens.

▶ **Playback.** This option allows the **Fn** button to display the playback review, which can be handy when you are using a heavy lens and you want to keep both hands on the camera.

▶ **None.** This is the default setting. No function is performed when you press the button.

f3: Assign preview button

This option allows you to assign a function to the Preview button. The choices are exactly the same as that of the **Fn** button, as described in the previous section.

f4: Assign AE-L/AF-L button

This option allows you to assign a function to ⚏.

▶ **AE/AF lock.** The focus and exposure lock when you press and hold the button.

▶ **AE lock only.** The exposure locks when you press and hold the button. Focus continues to function normally.

▶ **AE lock (hold).** The exposure locks until you press the button a second time or the exposure meter is turned off.

▶ **AF lock only.** The focus locks while you press and hold the button. The AE continues as normal.

▶ **AF-ON.** This option activates the camera's AF system. This works best when a4 is set to AF-ON only.

▶ **FV lock.** This option allows you to use the **Fn** button to fire a preflash to determine flash exposure; you can then recompose the frame, and the flash exposes for the original subject as long as you continue to hold down the **Fn** button. This function is cancelled when you select a function for Fn button + command dials. If you choose this setting for button press only, the function for Fn button + command dials is deactivated.

▶ **None.** With this option, no function is performed when you press the button.

f5: Customize command dials

This menu allows you to control how the Main Command and Sub-command dials function. Here are the options:

▶ **Reverse rotation.** This option causes the settings to be controlled in reverse of what is normal. For example, by default, rotating the Sub-command dial right makes your aperture smaller. Reversing the dials gives you a larger aperture when rotating the dial to the right.

▶ **Change main/sub.** This option switches functions of the Main Command dial to the front and the Sub-command dial to the rear of the camera.

▶ **Aperture setting.** This option allows you to change the aperture only using the aperture ring of the lens when using Nikon AF-D or third-party equivalent lenses. Note that most newer lenses have electronically controlled apertures (NIKKOR G-type lenses) and do not have an aperture ring. When used with a lens without an aperture ring, the Sub-command dial controls the aperture by default.

▶ **Menus and playback.** This option allows you to use the command dials to scroll the menus and images in much the same way that you use the multi-selector. When set to On, in Playback mode, you use the Main Command dial to scroll through the preview images and you use the Sub-command dial to view the shooting information and/or histograms. When in Menu mode, the Main Command dial functions the same as pressing ▲ or ▼, and the Sub-command dial operates the same as pressing ◄ or ►. When set to On (image review excluded), the command dials only work for the menus. When set to Off, the command dials don't do anything when in Playback or Menu modes.

f6: Release button to use dial

When changing modes or settings, you must press and hold the corresponding button and rotate a command dial to make changes. This setting allows you to press and release the button, make changes using the command dials, and then press the button again to set the value.

f7: Slot empty release lock

This setting controls whether the shutter will release when no memory card is present in the camera. When you set it to Enable release, the shutter fires and an image that is displayed in the monitor is temporarily saved. When you set it to Release locked, the shutter does not fire. If you happen to be using Camera Control Pro 2 shooting tethered directly to your computer, the camera shutter releases, regardless of what this option is set to.

f8: Reverse indicators

This option allows you to reverse the indicators on the electronic light meter that appears in the viewfinder and on the LCD control panel on the top of the camera. This option also reverses the display for the Auto Bracketing feature.

f13: Assign MB-D14 AE-L/AF-L button

This option allows you to customize the button on the optional MB-D14 vertical grip. There are eight options:

▶ **AE/AF lock.** With this option, the focus and exposure lock when you press and hold the button.

▶ **AE lock only.** With this option, the exposure locks when you press and hold the button. Focus continues to function normally.

▶ **AE lock (hold).** With this option, the exposure locks until you press the button a second time or the exposure meter is turned off.

▶ **AF lock only.** With this option, the focus locks while you press and hold the button. The AE continues as normal.

▶ **AF-ON.** This option allows you to initiate the autofocus without half-pressing the shutter-release button.

▶ **FV lock.** This option allows you to use the ▧ on the MB-D14 to fire a preflash to determine flash exposure; you can then recompose the frame and the flash exposes for the original subject as long as you continue to hold the button down.

▶ **Same as Fn button.** This option sets ▧ on the MB-D14 to perform the same task as **Fn**.

Custom Settings menu g: Movie

This is a brand-new menu that deals with settings solely for the video features. It mostly deals with customizing button assignments.

g1: Assign Fn button

This submenu allows you to customize what the **Fn** button does when in Live View Movie mode. There are eight options:

▶ **Index marking.** Pressing the **Fn** button places an index mark at that position in the video. Index marks are used when editing videos.

▶ **View photo shooting info.** Setting this option allows you to view the shooting information, including shutter speed, aperture, frame rate, and so on. Pressing the **Fn** button again allows you to return to the standard movie recording scene.

▶ **AE/AF lock.** The focus and exposure lock when you press and hold the **Fn** button.

▶ **AE lock only.** The exposure locks when you press and hold the **Fn** button. Focus continues to function normally.

▶ **AE lock (hold).** The exposure locks until you press the **Fn** button a second time or the exposure meter is turned off.

▶ **AF lock only.** The focus locks while you press and hold the **Fn** button. The AE continues as normal.

▶ **AF-ON.** This option allows you to initiate the autofocus by pressing the **Fn** button.

▶ **None.** Pressing the **Fn** button does nothing.

g2: Assign preview button

Similar to Assign Fn button, this allows you to select the options for the Preview button. The options are the same as for **Fn**.

g3: Assign AE-L/AF-L button

This allows you to set the options for ⚏. It has the same options as ✱ g1 and g2.

g4: Assign shutter button

This option sets the shutter-release button to either record movies or take stills. You have the following options:

▶ **Take photos.** When you select this option, pressing the shutter-

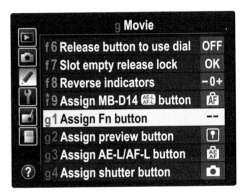

3.16 Custom Settings menu g

release button fully ends movie recording and takes a still photo. The still photo is recorded in the cinematic 16:9 aspect ratio.

▶ **Record movies.** When set to this option, you press the shutter-release button halfway to engage Live View; release the button and press halfway again to focus. Fully press the button to start recording, half-press to refocus, and fully press again to end recording.

The Setup Menu

The Setup menu (🔧) contains a smattering of options, most of which aren't changed very frequently. Some of these settings include the time and date. A couple of other options are Clean image sensor and Battery info, which you may access from time to time.

Format memory card

This option allows you to completely erase everything on your memory card. Formatting your memory card erases all the data on the card. It's a good idea to format your card every time you download the images to your computer (just be sure all the files are successfully transferred before formatting). Formatting the card helps protect against corrupt data. Simply erasing the images leaves the data on the card and allows it to be overwritten; sometimes this older data can corrupt the new data as it is being written. Formatting the card gives your camera a blank slate on which to write. If two cards are present, use the multi-selector to select which slot you want to format, SD or CF.

> TIP You can also format the card using the much more convenient two-button method (pressing and holding the 🗑 button and the Mode button [**MODE**] simultaneously and pressing them again after holding for approximately 2 seconds).

Save user settings

The Save user settings option allows you to save all your settings so that you can recall them instantly by simply twisting the Mode dial to U1 or U2. If you concentrate on a particular type of photography, you will appreciate this feature. See Chapter 8 for more information on user settings.

Reset user settings

The Reset user settings option returns the user settings (U1 and U2 on the Mode dial) to the camera default settings.

Monitor brightness

This menu sets the brightness of your LCD screen. You may want to make it brighter when viewing images in bright sunlight, or dimmer when viewing images indoors or to save battery power. You can adjust the LCD ±3 levels. The menu shows a graph with ten bars ranging from black to gray to white. The optimal setting is where you can see a distinct change in color tone in each of the ten bars. If the last two bars on the right side blend together, your LCD is too bright; if the last two bars on the left side blend together, your LCD is too dark.

There is also an Auto setting that uses the ambient light sensor on the back of the camera to automatically adjust the brightness.

Clean image sensor

The camera uses ultrasonic vibration to knock any dust off the filter in front of the sensor. This helps keep most of the dust off your sensor, but it is not going to keep it absolutely dust free forever. You may need to have the sensor professionally cleaned periodically.

You can choose Clean now, which cleans the image sensor immediately, or there are four separate options for cleaning that you access in the Clean at startup/shutdown option menu. These include:

▶ **Clean at startup.** The camera goes through the cleaning process immediately after you turn the camera on. This may slightly delay your startup time.

▶ **Clean at shutdown.** The camera cleans the sensor when you power the camera down. This is my preferred setting because it doesn't interfere with the startup time.

▶ **Clean at startup and shutdown.** The camera cleans the image sensor when you turn the camera on and also when you power it down.

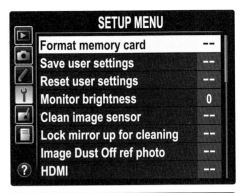

3.17 The Setup menu, shown in three parts

▶ **Cleaning off.** This option disables the dust reduction function when you turn the camera on and off. You can still use the Clean now option when this is set.

Lock mirror up for cleaning

This option locks up the mirror to allow access to the image sensor for inspection or for additional cleaning. The sensor is also powered down to reduce any static charge that may attract dust. Although some people prefer to clean their own sensor, I

recommend taking your camera to an authorized Nikon service center for any sensor cleaning during the initial factory warranty period. Any damage caused to the sensor by improper self-cleaning will *not* be covered by warranty and can lead to a very expensive repair bill.

That being said, learning to clean your own sensor is not difficult, and after the camera's initial factory warranty is up, you may want to clean the sensor yourself.

Image Dust Off ref photo

This option allows you to take a dust reference photo that shows any dust or debris that may be stuck to your sensor. Nikon Capture NX2 then uses the image to automatically retouch any subsequent photos where the specks appear.

To use this feature, select either "Start" or "Clean sensor and then start." Next, you are instructed by a dialog box to take a photo of a bright, featureless white object that is about 10cm from the lens. The camera automatically sets the focus to infinity. A Dust Off reference photo can only be taken when using a CPU lens. It's recommended to use at least a 50mm lens, and when using a zoom lens, you should zoom all the way in to the longest focal length. The reference image, however, can be used for images taken at any focal length.

HDMI

The D600 has an HDMI (high-definition multimedia interface) output that allows you to connect your camera to a high-definition TV (HDTV) to review your images. There are five settings: Auto, 480p, 576p, 720p, and 1080i. The Auto feature automatically selects the appropriate setting for your TV. Before plugging your camera in to an HDTV, I recommend reading the owner's manual for your TV to find the specific settings.

The second option in this menu is Device Control. There are two options: On or Off. This may seem pretty simple, but this setting is actually very important because if it's not set right, the Live View feed for the HDMI device can be disabled.

Here are the options:

▶ **On.** Select this option only when you want to use your HDTV to view image playback as you would see it on your camera's LCD screen. If your HDTV is HDMI-CEC capable, you will be able to use the TV remote control as you would the multi-selector. Be aware that if this setting is On, you will *not* be able to use Live View!

▶ **Off.** Use this option if you want to use the HDTV as a monitor to view Live View for shooting video or stills. This enables the camera to display what is on the LCD monitor directly to your HDTV or HDMI device.

NOTE If you want to change the HDMI settings, you must first disconnect the camera from the HD device.

Flicker reduction

Some light sources, such as older florescent and mercury vapor lights, can cause the video to flicker, depending on the local AC power grid. In the United States, the frequency is 60hz; in Europe, 50hz is the standard. The Auto option generally takes care of the problem, but if you aren't getting good results, try adjusting your shutter speed to 1/60 second or faster.

Time zone and date

This is where you set the camera's internal clock. There are four options:

▶ **Time zone.** Use the multi-selector to choose your time zone using the map display.

▶ **Date and time.** This is where you set the clock. It's pretty self-explanatory.

▶ **Date format.** You can set the order in which the date appears: Year/Month/Date, Month/Date/Year, or Date/Month/Year.

▶ **Daylight saving time.** If you turn this option on when Daylight saving time is in effect, then the time is changed by one hour.

Language

This is where you set the language that the menus and dialog boxes display.

Image comment

You can use this feature to attach a comment to the images taken by your D600. You can enter the text using the Input Comment menu. You can view the comments in Nikon's Capture NX2 or ViewNX 2 software or you can view them in the photo information on the camera. Setting the attach comment option applies the comment to all images you take until you disable this setting.

NOTE The image comment is limited to 36 characters.

Auto image rotation

When you select this option, the camera records its orientation when you shoot a photo (portrait or landscape). This allows the camera and also image-editing software to show the photo in the proper orientation so you don't have to take the time in post-processing to rotate images shot in portrait orientation.

Battery info

This handy little menu allows you to view information about your batteries. It shows you the current charge of the battery as a percentage and how many shots have been taken using that battery since the last charge. This menu also shows the remaining charging life of your battery before it is no longer able to hold a charge. I access this menu quite a bit to keep a real-time watch on my camera's power levels. Most of these information options only work with standard Nikon batteries. AA batteries cannot provide the camera with data.

▶ **Charge.** This tells you the percentage of remaining battery life, from 100 percent to 0 percent. When you attach the MB-D14 battery grip and load it with AA batteries, a percentage is not shown but there is a battery indicator that shows full, 50%, and 0% power levels.

▶ **No. of shots.** This tells you how many shutter actuations the battery has had since its last charge. This option is not displayed for the MB-D14 battery grip when using AA batteries.

▶ **Battery age.** This is a gauge that goes from 0 to 4 that tells you how much working life you have left in your battery, because Li-ion batteries have a finite life. This option is not shown for AA batteries. When shooting outside in temperatures below 41 degrees F (5 degrees C), this gauge may temporarily show that the battery has lost some of its charging life. The battery will show normal when brought back to an operating temperature of about 68 degrees F.

Copyright information

This is a great feature that allows you to embed your name and copyright information directly into the EXIF data of the image as it is being recorded. Enter the information using the text entry screen. You can turn this option on or off without losing the actual

information. You may want to use this feature when doing work for hire where you get paid to take the photos but relinquish all copyright and ownership to the person that hired you.

Save/load settings

This option allows you to save the current camera settings to the memory card in Slot 1. The camera stores the setting as a binary zip file (BIN). You can then store this memory card somewhere or transfer the file to your computer and save it. If you accidentally reset the camera settings and you want to change back to your custom settings, you can simply do this by inserting the memory card that you stored the settings on or by transferring the BIN file from your computer to a memory card, then insert the card in Slot 1, select Load settings and your settings will be restored.

> **NOTE** This option does *not* affect the U1/U2 user settings.

GPS

You use this menu to adjust the settings of an optional GPS unit, such as the Nikon GP-1, which you can use to record longitude and latitude to the image's EXIF data. There are three options:

▶ **Standby timer.** There are two options for this setting, On and Off. Setting the option to On allows the standby timer to operate as set in ✐ c2. When the standby timer puts the camera to sleep, the GPS unit is disabled and will need to reestablish GPS connections when reactivated or "woken up." When set to Off, the camera does not go into standby mode in order to keep the GPS connection active. The downside to this option is that the GPS unit puts a drain on the battery.

▶ **Position.** Selecting this option displays the longitude and latitude of the GPS unit reading.

▶ **Use GPS to set camera clock.** This option uses the GPS unit to set the internal clock of your D600.

Virtual horizon

Selecting this option displays a virtual horizon that shows the pitch and roll of your camera so that you can get it absolutely level. This is very handy when shooting with a tripod.

Non-CPU lens data

You use this menu to input lens data from a non-CPU lens. You can save focal length and aperture values for up to nine lenses. This feature is handy because if the camera knows the focal length and aperture of the attached lens, it can apply the information to some of the automatic settings that wouldn't normally be available without the lens communicating with the camera body. Some of the automatic settings referred to include the Auto-zoom on optional Speedlights. The focal length and aperture appear in the EXIF data, flash level can be adjusted automatically for changes in aperture, and Color Matrix metering can be used.

To set the lens data when using a non-CPU lens, follow these steps:

1. **Select Non-CPU lens data from the Y menu using the multi-selector, and then press ▶.**

2. **Select Lens number to set the information by pressing ◀ or ▶, choose from 1 to 9, and then press ▼.**

3. **Select the focal length of your non-CPU lens and press ▼.** You can use a lens from as wide as 6mm to as long as 4000mm.

4. **Choose the maximum aperture of your lens.** You can choose from f/1.2 to f/22.

5. **Press ▲ to highlight Done and press ⊛ to save the lens data.**

AF fine-tune

This option allows you to adjust the autofocus to fit a specific lens. Lenses are manu-factured to tight specifications, but every once in a while there may be something a little off in the manufacturing process that might cause the lens to mount a little differ-ently, or perhaps one of the lens elements has shifted a few microns. These small abnormalities can cause the lens to shift its plane of focus behind or in front of the imaging sensor. I would say that this is a rare occurrence, but it's a possibility.

You can fine-tune the camera's AF to correct for any focusing problems. Another good thing about this feature: If you're using a CPU lens, the camera remembers the fine-tuning for that specific lens and adjusts it for you automatically.

There is really no simple way to determine if your lens needs an AF fine-tune adjust-ment unless it's so out of whack that it's completely obvious. Discussions on Internet forums might make it appear as if lens misalignment is a widespread problem, but I assure you it's not. Most focus problems are caused by improper technique.

If you are interested in testing this feature, here is a brief description of how to go about doing so:

1. **Use the multi-selector to choose AF fine-tune from the Y menu and press ⊛.**

2. **Highlight Saved value and press ⊛.**

3. **Press ▲ or ▼ to adjust the plane of focus.** You'll have to use a little guesswork. Determine if the camera is focusing behind the subject or in front of it, and if so, how far?

4. **Once it's adjusted, press ⊛.**

5. **Set the Default and press ⊛.** This should be set to 0.

The saved value stores separate adjustment values for each individual lens. This is the value that will be applied when you attach the specific lens and turn on the AF fine-tune feature.

> **NOTE** When you turn on the AF fine-tune feature and attach a lens that does not have a stored value, the camera uses the default setting. This is why I recommend setting the default to 0 until you can determine whether the lens needs fine-tuning.

Each CPU lens that you fine-tune is saved into the menu. To view them, select List Saved Values. From there, you can assign a number to the saved values from 0 to 99 (although the camera only stores 12 lens values). You could use the number to denote what lens you're using; for example, you could use the number 50 for a 50mm lens, 85 for an 85mm lens, and so on, or you could use the last two digits of the lens serial number if you happen to have two of the same lenses (for example, I have two 17–35 lenses).

The best thing to do when attempting to fine-tune your lenses is to set them up one by one and do a series of test shots. The test shots have to be done in a controlled manner so there are no variables to throw off your findings.

The first thing to do is to get an AF test chart. You can find these on the Internet or you can send me an e-mail through my website, http://deadsailorproductions.com, and I can send you one that you can print out. An AF test chart has a spot in the center that you focus on and a series of lines or marks set at different intervals. Assuming you focus on the right spot, the test chart can tell you whether your lens is spot on,

back focusing, or front focusing. The test chart needs to be lit well for maximum con-trast. Not only do you need the contrast for focus, but it also makes it much easier to interpret the test chart. Using bright, continuous lighting is best, but flash can work as well. Lighting from the front is usually best.

Next, set your camera Picture Control to ND or neutral. Ensure that all in-camera sharpening is turned off and contrast adjustments are at zero. This is to ensure that you are seeing actual lens sharpness, not sharpness created by post-processing.

Lay the AF test chart on a flat surface. This is important, as there must be no bumps or high spots on the chart or your results won't be accurate. Mount the camera on a tripod and adjust the tripod head so that the camera is at a 45-degree angle. Be sure that the camera lens is just about at the minimum focus distance to ensure the nar-rowest depth of field. Set the camera to Single AF mode, use Single area autofocus, and use the center AF point. Focus on the spot at the center of the AF test chart. Be sure not to change the focus point or move the tripod while making your tests. Set the camera to A and open the aperture to its widest setting to achieve a narrow depth of field (this makes it easier to figure out where the focus is falling — in the front or the back). Use a Nikon ML-L3 wireless remote control release or the self-timer to be sure there is no blur from camera shake. You can also use the mirror lock up feature to further reduce vibrations. The first image should be shot with no AF fine-tuning.

Look at the test chart. Decide whether the camera is focusing where it needs to be or if it's focusing behind of or in front of where it needs to be.

Next, you can make some large adjustments to the AF fine-tuning (+5, −5, +10, −10, +15, −15, +20, −20), taking a shot at each setting. Be sure to defocus and refocus after adjusting the settings to ensure accurate results. Compare these images and decide which setting brings the focus closest to the selected focus point. After com-paring them, you may want to do a little more fine-tuning, to −7 or +13, for example.

This can be a very tedious and time-consuming project. That being said, most lenses are already spot on and it probably isn't necessary to run a test like this on your lens unless it is extremely noticeable that the lens is consistently out of focus.

Eye-Fi upload

This option only appears in the menu when an Eye-Fi memory card is inserted into the camera. The Eye-Fi card allows you to transfer your images to your computer using your wireless router.

There are a number of different types of Eye-Fi cards, so it's best to check the owner's manual that comes with your specific card for more details.

Firmware version

This menu option displays which firmware version your camera is currently operating under. Firmware is a computer program that is embedded in the camera that tells it how to function. Camera manufacturers routinely update the firmware to correct for any bugs or to make improvements on the camera's functions. Nikon posts firmware updates on its website at www. nikonusa.com.

The Retouch Menu

The Retouch menu (⊠) allows you to make changes and corrections to your images without using imaging-editing software. As a matter of fact, you don't even need to download your images to a computer. You can make all the changes in-camera using the LCD preview (or hooked up to an HDTV if you prefer). The ⊠ menu only makes *copies* of the images so you don't need to worry about doing any destructive editing to your actual files.

Here is the first and quickest method:

1. **Press ▶ to enter Playback mode.** Your most recently taken image appears on the LCD screen.

2. **Use the multi-selector to review your images.**

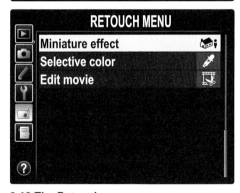

3.18 The Retouch menu

3. **When you see an image you want to retouch, press ⊛ to display the ☑ menu options.**

4. **Use the multi-selector to highlight the Retouch option you want to use.** Depending on the Retouch option you choose, you may have to select additional settings.

5. **Make adjustments if necessary.**

6. **Press ⊛ to save.**

> **NOTE** This method of entering the ☑ menu doesn't display all options.

Here is the second method:

1. **Press MENU to view menu options.**

2. **Press ▼ to move to ☑.**

3. **Press ▶ and press ▲ and ▼ to highlight the Retouch option you want to use.** Depending on the Retouch option you select, you may have to select additional settings. Once you have selected your option(s), thumbnails appear.

4. **Use the multi-selector to select the image to retouch and then press ⊛.**

5. **Make the necessary adjustments.**

6. **Press ⊛ to save.**

D-Lighting

This option allows you to adjust the image by brightening the shadows. This is not the same as Active D-Lighting. D-Lighting uses a curves adjustment to help bring out details in the shadow areas of an image. This option is for use with backlit subjects or images that may be slightly underexposed.

When you select the D-Lighting option from ☑, you can use the multi-selector to choose a thumbnail and press ⊕ to get a closer look at the image. Press ⊛ to choose the image to retouch, and two thumbnails are displayed; one is the original image, and the other is the image with D-Lighting applied.

You can press ▲ or ▼ to select the amount of D-Lighting: Low, Normal, or High. You can view the results in real time and compare them with the original before saving. Press ⊛ to save, ▶ to cancel, and ⊕ to view the full-frame image.

Red-eye correction

This option enables the camera to automatically correct for the red-eye effect that can sometimes be caused by using the flash on pictures taken of people. This option is only available on photos taken with flash. When you choose images to retouch from the Playback menu by pressing ⊛ during preview, this option is grayed out and cannot be selected if the camera detects that a flash was not used. When you attempt to choose an image directly from the ☑ menu, a message appears, stating that this image cannot be used.

Once you have selected the image, press ⊛; the camera then automatically corrects the red-eye and saves a copy of the image to your memory card.

If you select an image that flash was used on but there is no red-eye present, the camera displays a message stating that red-eye is not detected in the image and no retouching will be done.

Trim

This option allows you to crop your image to remove distracting elements or to allow you to crop closer to the subject. Use the multi-selector to find the image to crop and press ⊛ to select it. You can also use 🔍 and 🔍 to adjust the size of the crop. This allows you to crop closer in, or back it out if you find that you've zoomed in too much.

Use the multi-selector to move the crop around the image so you can center the crop on the part of the image that you think is most important. When you are happy with the crop you have selected, press ⊛ to save a copy of your cropped image or press ▶ to return to the main menu without saving.

Rotating the Main Command dial allows you to choose different aspect ratios for your crop. You can choose the aspect ratio to conform to different print sizes. Here are the options:

▶ **3:2.** This is the default crop size. This ratio is good for prints sized 4 × 6, 8 × 12, and 12 × 18.

▶ **4:3.** This is the ratio for prints sized 6 × 8 or 12 × 16.

▶ **5:4.** This is the standard size for 8 × 10 prints.

▶ **1:1.** This gives you a square crop.

▶ **16:9.** This is what's known as a cinematic crop. This is the ratio that movie screens and widescreen televisions use.

Monochrome

This option allows you to make a copy of your color image in a monochrome format. There are three options:

▶ **Black-and-white.** This option changes your image to shades of black, white, and gray.

▶ **Sepia.** This option gives your image the look of a black-and-white photo that has been sepia toned. Sepia toning is a traditional photographic process that gives the photo a reddish-brown tint.

▶ **Cyanotype.** This option gives your photos a blue or cyan tint. A cyanotype is an old form of photographic printing.

When using the Sepia or Cyanotype options, you can press ▲ or ▼ to adjust the lightness or darkness of the effect. Press ⊛ to save a copy of the image or press ▶ to cancel without saving.

> **NOTE** The Monochrome Picture Control offers more flexible settings than simply retouching the images using the ✍ menu. You may want to consider shooting your images using the Picture Control rather than using this option.

Filter effects

Filter effects allow you to simulate the effects of using certain filters over your lens to subtly modify the colors of your image. You can choose from the following seven filter effects:

▶ **Skylight.** A skylight filter is used to absorb some of the UV rays emitted by the sun. The UV rays can give your image a slightly bluish tint. Using the skylight filter effect causes your image to be less blue.

▶ **Warm filter.** A warming filter adds a little orange to your image to give it a warmer hue. This filter effect can sometimes be useful when using flash because flash can sometimes cause your images to feel a little too cool.

▶ **Red intensifier.** This filter boosts the saturation of reds in the image. Press ▲ or ▼ to lighten or darken the effect.

▶ **Green intensifier.** This filter boosts the saturation of greens in the image. Press ▲ or ▼ to lighten or darken the effect.

▶ **Blue intensifier.** This filter boosts the saturation of blues in the image. Press ▲ or ▼ to lighten or darken the effect.

▶ **Cross screen.** This effect simulates the use of a star filter, creating a star-shaped pattern on the bright highlights in your image. If your image doesn't have any bright highlights, the effect is not apparent. Once you select an image for the cross screen filter, you see a submenu with a few options that you can adjust. You can choose the number of points on the stars: 4, 6, or 8. You can also choose the amount; there are three settings that give you more or fewer stars. You can choose three angle settings that control the angle at which the star is tilted. You also have three settings that control the length of the points on the stars.

▶ **Soft.** This filter applies a soft glow to your images. This effect is mostly used for portraiture but can also be used effectively for landscapes.

After choosing the desired filter effect, press ⊛ to save a copy of your image with the effect added.

Color balance

You can use the Color balance option to create a copy of an image on which you have adjusted the color balance. Using this option, you can use the multi-selector to add a color tint to your image. You can use this effect to neutralize an existing color tint or to add a color tint for artistic purposes.

Press ▲ to increase the amount of green, ▼ to increase the amount of magenta, ◀ to add blue, and ▶ to add amber.

A color chart and color histograms are displayed along with an image preview so you can see how the color balance affects your image. When you are satisfied with your image, press ⊛ to save a copy.

CAUTION Adjusting your color balance using the LCD monitor as a reference may not yield the most accurate results.

Image overlay

This option allows you to combine two RAW images and save them as one. You can only access this menu option by entering the ✑ menu using **MENU** (the longer route); you cannot access this option by pressing ⊛ when in Playback mode.

NOTE To use this option, you must have at least two RAW images saved to your memory card. This option is not available for use with JPEG.

Follow these steps to use this option:

1. Press **MENU** to view the menu options, use the multi-selector to scroll down to ⊘, and press ▶ to enter the ⊘ menu.

2. Press ▲ or ▼ to highlight **Image overlay, and press ▶.** This displays the Image overlay menu.

3. Press ⊛ to view RAW image thumbnails.

4. Use the multi-selector to highlight the first RAW image to be used in the overlay and press ⊛ to select it.

5. Adjust the exposure of Image 1 by pressing ▲ or ▼ and press ⊛ when the image is adjusted to your liking.

6. Press ▶ to switch to Image 2.

7. Press ⊛ to view RAW image thumbnails.

8. Use the multi-selector to highlight the second RAW image to be used in the overlay and press ⊛ to select it.

9. Adjust the exposure of Image 2 by pressing ▲ or ▼ and press ⊛ when the image is adjusted to your liking.

10. Press ▶ to highlight the Preview window.

11. Press ▲ or ▼ to highlight Overlay to preview the image, or use the multi-selector to highlight Save to save the image without previewing.

NEF (RAW) processing

This option allows you to do some basic editing to images saved in the RAW format without downloading them to a computer and using image-editing software. This option is limited in its function but allows you to fine-tune your image more precisely when printing straight from the camera or memory card.

You can save a copy of your image in JPEG format. You can choose the image quality and size at which the copy is saved, you can adjust the white balance settings, fine-tune the exposure compensation, and select a Picture Control setting to be applied.

To apply RAW processing, follow these steps:

1. **Enter the NEF (RAW) Processing menu through ✍.**

2. **Press ⊛ to view thumbnails of the images stored on your card.** Only images saved in RAW format appear.

3. **Press ◀ or ▶ to scroll through the thumbnails and press ⊛ to select the highlighted image.** This brings up a screen with the image adjustment submenu located to the right of the image you have selected.

4. **Press ▲ or ▼ to highlight the adjustment you want to make.** You can set image quality, image size, white balance, exposure compensation, Picture Control, Hi ISO NR, color space, vignette, and D-Lighting. You can also press ⊕ to view a full-screen preview.

5. **When you have made your adjustments, use the multi-selector to highlight EXE, and then press ⊛ to save changes or ▶ to cancel without saving.** EXE sets the changes and saves a copy of the image in JPEG format at the size and quality that you have selected. The camera default saves the image as a Large, Fine JPEG.

CROSS REF For more information on image size, quality, white balance, and exposure compensation, see Chapter 2.

Resize

This is a handy option that allows you to make a smaller-sized copy of your images. Smaller pictures are more suitable for making small prints and web-sized images, and for e-mailing to friends and family.

NOTE When using two memory cards, you are asked to choose a destination for the saved copies.

The first thing you need to do when creating a resized image is to select the Choose size option from the submenu. You have the following four options:

▶ **2.5M.** 1920 × 1280 pixels.

▶ **1.1M.** 1280 × 856 pixels.

▶ **0.6M.** 960 × 640 pixels.

▶ **0.3M.** 640 × 424 pixels.

After you decide on the size at which you want your small pictures copied, go to the Select picture option. When the Select picture option is chosen, the LCD displays thumbnails of all the images in the current folder. To scroll through your images, press ▶ or ◀. To select or deselect an image, press ▲ or ▼. You can select as many images as you have on your memory card. When all the images from which you want to make a resized copy are selected, press ⊛ to make the copies.

Quick retouch

The Quick retouch option is the easiest option. The camera automatically adjusts the contrast and saturation, making your image brighter and more colorful, perfect for printing straight from the camera or memory card. In the event that your image is dark or backlit, the camera also automatically applies D-Lighting to help bring out details in the shadow areas of your picture.

Once your image has been selected for Quick retouch, you have the option to choose how much of the effect is applied. You can choose from High, Normal, or Low. The LCD monitor displays a side-by-side comparison between the image as shot and the retouched image to give you a better idea of what the effect looks like.

Once you decide how much of the effect you want, press ⊛ to save a copy of the retouched image, or you can press ▶ to cancel without making any changes to your picture.

Straighten

This feature allows you to fix images that may have been shot at a slight angle, which is another nice feature when printing directly from the camera. When you select an image, press ▶ and ◀ to adjust the tilt amount. A grid overlay is displayed over the image so you can use it to align with the horizon or another straight object in the photo.

Distortion control

As discussed in Chapter 4, some lenses are prone to distortion. This retouch option allows you to make in-camera corrections for lens distortion. There are two options, Auto and Manual. Auto automatically applies any needed corrections, and Manual allows you to apply the effect yourself using the multi-selector. Press ▶ to reduce barrel distortion (wide-angle), and press ◀ to reduce pincushion distortion (telephoto).

CAUTION The Auto setting is recommended for use with NIKKOR G- and D-type lenses only.

139

Fisheye

This option does the opposite of what distortion control does: It adds barrel distortion to the image to make it appear as if it was taken using a fisheye lens. Press ◀ to add to the effect and ▶ to decrease it. To be honest, however, the effect isn't very good, so use at your own peril.

Color outline

The color outline feature takes the selected image and creates an outline copy that you can open in image-editing software, such as Adobe Photoshop or Corel Paintshop Pro, and color in manually. This option works best when used on an image with high contrast. It's a pretty cool effect and the image can even be used straight from the camera, which gives it the look of a drawing.

Color sketch

This option gives your image the appearance that it was drawn with colored pencils. Selecting Vividness allows you to increase the color saturation of the effect. The Outlines option allows you to change the thickness of the outlines of the "sketch."

Perspective control

This option allows you to correct for problems with perspective caused by pointing the camera upward or shooting at an angle instead of shooting something straight on. Think of shooting a tall building; when you tilt the camera up at the building, it causes the base to look larger than the top of the building. You can correct for this by using the Perspective control option. Using ▲ or ▼, you can adjust the vertical perspective; using ◀ and ▶, you can adjust the horizontal perspective.

Miniature effect

This effect is modeled after a technique that some people call (erroneously) the *tilt-shift effect* because it can be achieved optically with a tilt-shift lens. Quite simply, what this effect does is simulate the shallow depth of field normally present in macro shots. This tricks the eye into seeing something large as something very tiny. The effect only works with very far-off subjects and works better when the vantage point is looking down. It's a pretty cool effect, but only works with limited subjects, so use this effect with that in mind.

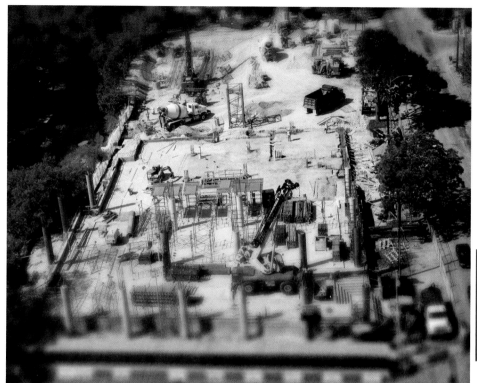

3.19 An overhead shot with the miniature effect added. Taken with a Nikon 28-70mm f/2.8D wide-angle lens at 28mm. Exposure: ISO 100, f/5.6, 1/2000 second.

Selective color

You can use this option to turn your image black and white while retaining up to three colors. After selecting the image, use the multi-selector to maneuver the cursor over an object of a particular color. Once you have the cursor over the color, press ᴬᴱ⁻ᴸ/ᴬꜰ⁻ᴸ to select the color. Use ▲ or ▼ to adjust the purity of the color. Lower numbers are more specific with the color; higher numbers select a broader range of the color selection.

Rotate the Main Command dial right to select the other color options and follow the same procedures. For more precise color selection, use ⊕ to magnify the image. To reset the image, press 🗑. Press ⊛ to save the image.

Edit movie

This option allows you to make basic edits to videos that you shoot with the D600. You have three options: choose the Start frame, choose the End frame, and grab a still image from the video. Each edit you make is saved as a new file so there's no need to worry about making any permanent changes to your original file. To edit your video, follow these steps:

1. **Press MENU and use the multi-selector to select the** ✎ **menu.**

2. **Select Edit movie.** Press ⊛ or ▶ to view menu options.

3. **Choose the edit you want to make.** The options are Choose start point, Choose end point, or Save selected frame. Press ⊛ or ▶. This pulls up a menu with all videos that are saved to the current card.

4. **Select the video.** Use the multi-selector to scroll through the available videos. The selected video is highlighted in yellow. Press ⊛ when your video is selected.

5. **Play the video.** Press ⊛ to begin playback. Press ▲ at the moment you want to make the edit. You can press ▼ to stop playback and ◀ and ▶ to go back or forward in the video clip.

6. **Make the edit.** Press ▲ to make the cut. I prefer to actually pause the movie by pressing ▼ so I can be absolutely sure that's where I want the edit to be. I then make the edit. The movie is automatically saved.

Side-by-side comparison

This option allows you to view a side-by-side comparison of the retouched image and the original copy of the image. You can only access this option by selecting an image that has been retouched.

Follow these steps to use this option:

1. **Press** ▶ **and use the multi-selector to choose the retouched image to view.**

2. **Press** ⊛ **to display the Retouch menu.**

3. **Use the multi-selector to highlight Side-by-side comparison, and then press** ⊛ **.**

4. **Use the multi-selector to highlight either the original or retouched image.** You can then press ⚲ to view closer.

5. **Press** ▶ **to exit the Side-by-side comparison and return to Playback mode.**

My Menu

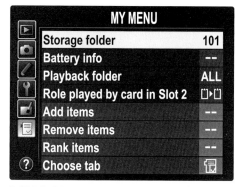

The My Menu option (🖼) allows you to create your own customized menu by choosing the options that it contains. You can also set the different menu options to whatever order you want. This allows you to have all the settings you change most often right at your fingertips without having to go searching through all the menus and submenus. For example, I have the My Menu option set to display all the

3.20 My Menu

menu options I frequently use, including Storage folder, Battery info, ✎ e3, and Active D-Lighting, among a few others. This saves me an untold amount of time because I don't have to go through a lot of different menus.

Follow these steps to set up your custom My Menu:

1. **Select My Menu, and press ⊛.**

2. **Select Add items and press ⊛.**

3. **Use the multi-selector to navigate through the menus to add specific menu options and press ⊛.**

4. **Use the multi-selector to position where you want the menu item to appear and press ⊛ to save the order.**

5. **Repeat Steps 2 through 4 until you have added all the menu items you want.**

To reorder the items in My Menu, follow these steps:

1. **Select My Menu and press ⊛.**

2. **Select Rank items and press ⊛.** A list of all the menu options that you have saved to My Menu appears.

3. **Use the multi-selector to highlight the menu option you want to move and press ⊛.**

4. **Using the multi-selector, move the yellow line to where you want to move the selected item and press ⊛ to set.** Repeat this step until you have moved all the menu options that you want.

5. **Press MENU or tap the shutter-release button to exit.**

To delete options from My Menu, simply press 🗑 when the option is highlighted. The camera asks for confirmation that you indeed want to delete the setting. Press 🗑 again to confirm, or press **MENU** to exit without deleting the menu option.

As I mentioned earlier, you can replace the My Menu option with the Recent settings option. The Recent settings menu stores the last 20 settings you have adjusted. Follow these steps to switch from My Menu to Recent settings:

1. **Select My Menu from the Menu tabs and press ⊛ to view My Menu.**

2. **Use the multi-selector to scroll down to the Choose tab menu option and press ⊛.**

3. **Select Recent settings and press ⊛ or ▶ to change the setting.**

4. **Press MENU or tap the shutter-release button to exit.**

The Information Display Settings

Although this is not a true menu, it allows you to access several of the most commonly changed menu items. To access the information display settings, press ⓘ. This displays the shooting info screen on the rear LCD. While the shooting information is displayed, press ⓘ again. This grays out the shooting information and highlights the settings shown at the bottom of the shooting info screen. Use the multi-selector directional buttons to highlight the setting you want to change, and then press ⊛. This takes you straight to the specific menu options.

3.21 The information display

Here are the options:

▶ Movie settings

▶ High ISO NR

▶ Active D-Lighting

▶ Vignette control

▶ Assign preview button

▶ Role played by slot 2

▶ Long exposure NR

▶ Remote control mode

▶ Assign ᴬᴱ⁻ᴸ button

▶ Assign **Fn**

3

Selecting and Using Lenses with the Nikon D600

The lens that you put in front of your D600 sensor has an enormous impact on image quality, especially with the amount of fine detail that high-resolution sensors reveal. The lens affects not only the sharpness of your images but also the contrast and color rendition. A quality lens, such as a professional-level NIKKOR, will likely outlast a number of camera bodies if you take care of it. I have lenses that I've used for more than a decade and they still function perfectly.

One of the great things about a dSLR is that the lenses are interchangeable. With interchangeable lenses, you can choose how to

A high-quality lens is an investment that should last you throughout many dSLR camera bodies.

show others the world. You can use ultrawide-angle lenses to distort spatial relations, or you can use a macro lens to give a bug's eye view.

Lens Compatibility

Nikon has been manufacturing lenses since about 1937 and is known to make some of the highest-quality lenses in the industry. You can use almost every Nikon lens made since about 1977 on your D600, although some lenses will have limited functionality. In 1977, Nikon introduced the Auto Indexing (AI) lens. Auto Indexing allows the aperture diaphragm on the lens to stay wide open until the shutter is released; the diaphragm then closes down to the desired f-stop. This allows maximum light to enter the camera, which makes focusing easier. You can also use some of the earlier lenses, now referred to as *pre-AI*, but most need some modifications to work with the D600.

All these early lenses are manual focus and lack a CPU. When using these lenses, you can enter the non-CPU lens data into the D600 to ensure that you get the most functionality out of them. You can enter the non-CPU lens data, including focal length and aperture size, in the Setup menu (**Y**).

In the 1980s, Nikon started manufacturing autofocus (AF) lenses. Many of these are very high quality and can be found at a much lower cost than their 1990s counterparts, the AF-D lenses. The main difference between AF lenses and AF-D lenses is that the AF-D lenses provide the camera with distance information based on how far away the subject is when focused on. Both types of lenses are focused with a screw-type drive motor found inside the camera body.

Nikon's current line is the AF-S lens. These lenses have a built-in Silent Wave Motor that allows the lens to focus much more quickly than the traditional, screw-type lenses, and also makes focusing ultraquiet. Most of these are also known as G-type lenses. These lenses lack a manual aperture ring; you control the aperture by using the Sub-command dial on the camera body.

Nikon offers a full complement of professional AF-S lenses for FX cameras like the D600, ranging from the ultrawide 14-24mm f/2.8G to the super-telephoto 600mm f/4G.

Deciphering Nikon Lens Codes

When shopping for lenses, you may notice all sorts of letter designations in the lens names. So, what do all those letters mean? Here's a simple list to help you decipher them:

▶ **AI/AI-S.** These are Auto Indexing lenses that automatically adjust the aperture diaphragm down when you press the shutter-release button. All lenses, including AF lenses, made after 1977 are Auto Indexing, but when referring to AI lenses, most people generally mean the older manual focus (MF) lenses.

▶ **E.** These were Nikon's budget series lenses, made to go with the lower-end film cameras, such as the EM, FG, and FG-20. Although these lenses are compact and often constructed with plastic parts, some of them, especially the 50mm f/1.8, are of good quality. These lenses are also manual focus only. E lenses are not to be confused with Nikon's Perspective Control (PC-E) lenses.

▶ **D.** Lenses with this designation convey distance information to the camera to aid in metering for exposure and flash.

▶ **G.** These are newer lenses that lack a manually adjustable aperture ring. You must set the aperture on the camera body. Like D lenses, G lenses also convey distance information to the camera.

▶ **AF, AF-D, AF-I, and AF-S.** All these codes denote that the lens is an autofocus (AF) lens. The AF-D represents a distance encoder for distance information, the AF-I indicates an internal focusing motor type, and the AF-S represents an internal Silent Wave Motor.

▶ **DX.** This code lets you know that the lens was optimized for use with Nikon's DX-format sensor. You can use these lenses with your D600 but with reduced resolution.

NOTE Full-frame lenses do not carry an FX designation as you can use them effectively on DX cameras without limitation.

4

▶ **VR.** This code tells you that the lens is equipped with Nikon's Vibration Reduction image stabilization system. Nikon's newest lenses employ a technology known as VR-II, which is capable of detecting side-to side as well as up-and-down motion. Both technologies are designated as VR.

▶ **ED.** This code indicates that some of the glass in the lens is Nikon's Extra-Low Dispersion glass, which means the lens is less prone to lens flare and chromatic aberrations.

▶ **Micro-NIKKOR.** Even though they're labeled as micro, these are Nikon's macro lenses.

▶ **IF.** IF stands for *internal focus.* The focusing mechanism is inside the lens, so the front of the lens doesn't rotate when focusing. This feature is useful when you don't want the front of the lens element to move — for example, when you use a polarizing filter. The internal focus mechanism also allows for faster focusing.

▶ **DC.** DC stands for *Defocus Control.* Nikon offers only a couple of lenses with this designation. These lenses make the out-of-focus areas in the image appear softer by using special lens elements to add spherical aberration. The parts of the image that are in focus aren't affected. Currently, the only Nikon lenses with this feature are the 135mm and the 105mm f/2. Both of these are considered portrait lenses.

▶ **N.** On some of Nikon's higher-end lenses, you may see a large golden N. This means the lens has Nikon's Nano-Crystal Coating, which is designed to reduce flare and ghosting.

▶ **PC-E.** This is the designation for Nikon's Perspective Control lenses. PC stands for Perspective Control, and the E means that it has an electro-magnetic Auto Indexing aperture control instead of the typical mechanical one found in all other AI lenses.

Third-Party Lenses

Nikon is not the only manufacturer of lenses that fit the D600. Quite a few companies make lenses that work flawlessly with Nikon cameras. In the past, third-party lenses had a reputation for being, at best, cheap knockoffs of the original manufacturer's lenses. This is not the case anymore as many third-party lens makers have stepped up to the plate and started releasing lenses that rival some of Nikon's best lenses (usually at half the price). Although you can't beat Nikon's professional lenses for build and image quality, many excellent third-party lens choices are available. The three most prominent third-party lens manufacturers are Sigma, Tokina, and Tamron.

Sigma is a company that has been around for over 40 years and was the first lens manu-facturer to make a wide-angle zoom lens. Sigma makes very good lenses with a great build quality. Unlike some other third-party lens manufacturers, Sigma designs about two-thirds of its lenses around the FX format and optimizes them for use with digital sensors. The lenses are also available with what Sigma calls an HSM, or Hyper-Sonic Motor. This is an AF motor that is built in to the lens, and it operates in much the same way that the Nikon AF-S or Silent Wave Motor does. It allows very fast and quiet AF.

Sigma has recently announced a couple of new FX lenses: the 35mm f/1.4 and the 120-300mm f/2.8 OS. These are the first lenses that you can plug into your computer via a USB dock and use Sigma's proprietary software to update firmware and make micro-adjustments for focusing. This is an amazing new feature. The Sigma Corporation is blazing new trails in lens technology. Sigma lenses are a viable and affordable alternative to Nikon's professional offerings.

Buying Lenses Secondhand

Because many D600 owners have stepped up to FX from DX cameras, I have noticed that the market for legacy lenses from the film era has boomed. When the D600 was announced, I saw prices for kit lenses for cameras like the Nikon N60 skyrocket from $20 to about $80 or more in just a few days.

While most of these lenses can be used with the D600, a lot of them just aren't very good when paired with a high-resolution dSLR like the D600. Lenses designed for film cameras don't control flare and ghosting as effectively because the lens optics aren't coated as well; this is because film doesn't reflect light back into the lens like a shiny glass-covered sensor does.

The optics on some of the budget lenses also tend to be softer. Because film is a more forgiving format than digital and most amateur photographers didn't print larger than 8 × 10, the lenses didn't need to be tack sharp.

I think you'll find most of the third-party lenses from the film era to be lacking a little in quality, although at the beginning of the digital era, some of these companies (most notably Sigma and Tamron) started adapting their lenses for digital sensors while retaining full-frame capability. These lenses are designated DG by Sigma and Di by Tamron. Keep a close eye on lens designations; the Sigma DC lenses and Tamron Di II lenses are DX only (Tamron's newest lenses, Di III, are for mirrorless compact cameras).

That being said, most of the high-end Nikon AF and AF-D film lenses work great, albeit with the possibility of a little more flare. These lenses have a higher build quality than most third-party lenses of the same era and are often a little faster.

The key to buying secondhand lenses is to do your homework before you buy. Get the full name of the lens, including any designations it may have, and search the Internet. There are vast amounts of information on lenses out there. Keep in mind that you must try to disseminate the truth from fiction. Read through a few different reviews and look at examples of photographs taken with the lens. Be an informed buyer.

The Tokina company currently only offers three lenses that are compatible with full-frame cameras like the D600: the 16-28mm f/2.8, the 100mm f/2.8 Macro, and the 80-400mm f/4.5-5.6. Of these three lenses, only the 16-28mm has a built-in silent motor. However, Tokina has been making lenses for film cameras for many years. These lenses are readily available secondhand at reasonable prices.

Tamron is another major player in the third-party lens market. The company currently offers about 10 lenses that are well regarded, with the 28-75mm f/2.8 and the 90mm f/2.8 Macro being the most popular. Tamron has been working through some problems with its built-in focus motor technology, so there are a few different iterations of its most popular lenses.

They have a standard, screw-type focus technology; a technology referred to as *Built-in-Motor* (BIM), which focuses very slowly and loudly with an internal focus motor; and the Ultrasonic Silent Drive, a recent addition that is comparable to Nikon's Silent Wave or AF-S lenses. All of these focus motor technologies work with the D600. Tamron's latest FX lens is the 24-70mm f/2.8 VC USD, the first standard zoom lens for FX that features Vibration Control (VR in Nikon terms). This lens is a real winner at about half the price of Nikon's venerable 24-70mm f/2.8G.

Wide-Angle Lenses

The focal-length range of wide-angle lenses starts at about 12mm (ultrawide) and extends to about 35mm (wide angle). Many of the most common wide-angle lenses on the market today are zoom lenses, although quite a few prime lenses are available. Wide-angle lenses are generally *rectilinear,* meaning that the lens has molded glass elements to correct the distortion that's common with wide-angle lenses; this keeps the lines near the edges of the frame straight rather than curved. Fisheye lenses, which are also a type of wide-angle lens, are *curvilinear;* the lens elements aren't corrected, resulting in severe optical distortion (which is desirable in a fisheye lens).

Wide-angle lenses have a short focal length, which projects an image onto the sensor that has a wider field of view. This allows you to fit more of the scene into your image. In the past, ultrawide-angle lenses were rare, prohibitively expensive, and out of reach for most nonprofessional photographers. These days, it's easy to find a relatively inexpensive ultrawide-angle lens. Ultrawide-angle lenses usually run in focal length from about 12mm to 20mm. Most wide-angle zoom lenses run the gamut from ultrawide to wide angle. Here are some that work with the D600:

▶ **NIKKOR 14-24mm f/2.8G.** This is one of Nikon's best lenses (see Figure 4.1). It has excellent image sharpness from corner to corner at all apertures. It also has a fast constant aperture and is great for low-light shooting. It's a truly spectacular lens, but it comes at a premium cost of just about $2,000. One caveat about this lens is that you can't use any filters with it due to the protruding front element.

Image courtesy of Nikon, Inc.
4.1 The NIKKOR 14-24mm f/2.8G

▶ **Sigma 12-24mm f/4-5.6.** This is the widest lens available for FX cameras. The extra 2mm really adds some depth to the images. This lens isn't one of the top performers in its class, as it's pretty soft in the corners when shooting wide open. However, if you can live with the optical shortcomings, it's a well-built lens that allows you to create some truly interesting images.

▶ **Nikon 16-35mm f/4G VR.** This is a standard wide-angle zoom that is also the first Nikon wide-angle lens to incorporate VR. This lens is a full stop slower than other pro lenses from Nikon. It's nice and sharp and a bit smaller and more con-venient to use than the 14-24mm f/2.8G.

▶ **Sigma 17-35mm f/2.8-4.** This is a great standard wide-angle lens that Sigma has discontinued. You can still easily find them used for about $250–$350. There are three versions; however, only the EX-DG with HSM motor was designed with a digital sensor in mind. While the EX with HSM motor and the plain EX model with aperture ring will work with your D600, the D600's high resolution shows their flaws. You'd be best to stick to the EX-DG version.

Zoom Lenses versus Prime Lenses

Some photographers prefer primes, and some prefer zooms. It's largely a personal choice, and each type has its advantages. One of the main advantages of the zoom lens is its versatility. You can attach one lens to your camera and use it in a wide variety of situations, which reduces how often you need to change your lenses. This is a very good feature because each time you take the lens off your camera, the sensor is vulnerable to dust and debris. Also, in the time it takes to change from one lens to another, you may miss the shot.

Although today's zoom lenses can be just as sharp as a prime lens, you do have to pay for this quality. A $150 zoom lens isn't going to give you near the quality that a $1,500 zoom lens will. These days, you can easily find an affordable, fast zoom lens — one with an aperture of at least f/2.8. However, because you can easily change the ISO on a digital camera and the noise created from using a high ISO is decreasing, a fast zoom lens isn't always completely necessary. Some photographers prefer a zoom lens with a wider aperture, not so much for the speed of the lens, but for the option of being able to achieve a shallower depth of field, which is very important for isolating subjects.

Some of the most important features of prime lenses are that they can have a faster maximum aperture, they are far lighter, and they usually cost less (which, however, isn't the case with Nikon's latest wide-angle, super-fast f/1.4 primes). The standard prime lenses aren't very long, so the maximum aperture can be faster than with zoom lenses. Standard primes also require fewer lens elements and moving parts, so the weight is considerably reduced. Also, because there are fewer elements, the overall cost of production is lower, therefore, you pay less.

You can use wide-angle lenses for a variety of subjects, and they're great for creating dynamic images with interesting results. Once you get used to seeing the world through a wide-angle lens, you may find that your images become more creative, and you may look at your subjects and the world in general in a different way. There are many factors to consider when you use a wide-angle lens, such as the following:

▶ **Deeper depth of field.** Wide-angle lenses allow you to get more of the scene in focus than you can when you use a midrange or telephoto lens at the same aperture and distance from the subject.

154

Chapter 4 Selecting and Using Lenses with the Nikon D600

▶ **Wider field of view.** Wide-angle lenses allow you to fit more of your subject into your images. The shorter the focal length, the more you can fit in. This can be especially beneficial when you shoot landscape photos where you want to fit an immense scene into your photo or when you shoot a large group of people.

▶ **Perspective distortion.** Using wide-angle lenses causes things that are closer to the lens to look disproportionately larger than things that are farther away. You can use perspective distortion to your advantage to emphasize objects in the foreground if you want the subject to stand out in the frame.

▶ **Handholding.** At shorter focal lengths, it's possible to hold the camera steadier than you can at longer focal lengths. At 14mm, it's entirely possible to handhold your camera at 1/15 second without worrying about camera shake.

▶ **Environmental portraits.** Although using a wide-angle lens isn't the best choice for standard close-up portraits, wide-angle lenses work great for environmental portraits where you want to show a person in his or her surroundings.

4.2 Wide-angle lenses really help you draw the viewer into the scene. Taken with a Sigma 17-35mm f/2.8-4 DG HSM at 17mm. Exposure: ISO 160, f/2.8, 1/640 second.

Using DX Lenses

If you are upgrading to the D600 from a DX camera, such as the D300, and have invested in very good lenses that are made for use with the smaller-sensor DX cameras, there is good news. These DX lenses are fully functional when used with the FX D600. The D600 can be set to automatically detect when a DX lens is attached to it, and it will shoot in DX crop mode (Shooting menu [📷] → Image area). What's even better is that with the high-resolution 24MP sensor, even in DX crop mode, you are getting a 10MP image, which offers enough resolution for most standard applications.

When a DX lens is attached and the camera is in DX mode, you see an outline of the image area when you look through the viewfinder. A little trick to make it easier to frame is to go to the Custom Settings menu (✐) a4 – AF point illumination and set it to Off. Now when you look through the viewfinder, the camera masks the unused portion of the viewfinder, and it appears grayed out and blurry. The only caveat to using this technique is that your AF points do not light up red, so in low-light situations this may be a problem.

Wide-angle lenses can also help pull you into a subject. With most wide-angle lenses, you can focus very close to a subject while creating the perspective distortion for which wide-angle lenses are known. Don't be afraid to get close to your subject to make a more dynamic image. The worst wide-angle images are those that have a tiny subject in the middle of an empty area.

A few prime lenses fit into the wide-angle category: the 20mm f/2.8, 24mm f/2.8, 28mm f/2.8, 28mm f/1.8, and 35mm f/2 are great all-around lenses. They come with apertures of f/2.8 or faster and can be found for less than $400, with the exception of the Nikon 28mm f/1.8G, which is about $600 new (there's also the discontinued 28mm f/1.8D that is considered one of Nikon's best lenses. It goes for well over $3,000 used). The 24mm and 35mm f/1.4G lenses are amazing, but come with a hefty price tag of over $2,000. Sigma's new 35mm f/1.4 prime is an excellent lens that's relatively affordable, coming in at an $899 price point, which is well below the NIKKOR version.

Wide-angle lenses are very distinctive in the way they portray your subjects, but they also have some limitations that you may not find in lenses with longer focal lengths. Here are some pitfalls that you need to be aware of when using wide-angle lenses:

▶ **Soft corners.** The most common problem that wide-angle lenses have, especially zooms, is that they soften the images in the corners. This is most prevalent at wide apertures, such as f/2.8 and f/4; the corners usually sharpen up by

f/8 (depending on the lens). This problem is most noticeable in lower-priced lenses. The high resolution of the D600 can really magnify these flaws.

▶ **Vignetting.** This is the darkening of the corners in the image. Vignetting occurs because the light that's needed to capture such a wide angle of view must come in at a very sharp angle. When the light comes in at such an angle, the aperture is effectively smaller. The aperture opening no longer appears as a circle but is shaped like a cat's eye (you can see this effect in the bokeh of very fast lenses). Stopping down the aperture reduces this effect, and reducing the aperture by 3 stops usually eliminates any vignetting.

▶ **Perspective distortion.** Perspective distortion is a double-edged sword: it can make your images look very interesting or make them look terrible. One of the reasons that a wide-angle lens isn't recommended for close-up portraits is that it distorts the face, making the nose look too big and the ears too small. This can make for a very unflattering portrait.

▶ **Barrel distortion.** Wide-angle lenses, and even rectilinear lenses, are often plagued with this specific type of distortion, which causes straight lines outside the image center appear to bend outward (similar to a barrel). This can be undesirable when doing architectural photography. Fortunately, Photoshop and other image-editing software enable you to fix this problem relatively easily.

Focal Length and Depth of Field

Although focal length seems to be a factor in depth of field, technically speaking, this isn't true. Telephoto lenses appear to have a shallower depth of field due to a higher magnification factor, but if the subject stays the same size in the frame, the depth of field is consistent at any given aperture, regardless of the focal length.

What *does* change, however, is the distribution of the zone of acceptable sharpness. At shorter focal lengths, most of the zone is behind the focal point or subject. At longer focal lengths, the zone of acceptable sharpness falls more in front of the focal point. This means that, although mathematically the depth of field is consistent at all focal lengths, the distribution of the zone of sharpness is different.

Wide-angle lenses have a more gradual falling off of sharpness, which makes the depth of field appear deeper. Telephoto lenses appear to have a shallower depth of field because the zone of sharpness falls off more quickly behind the focal point, and also because the background is magnified due to compression distortion. This causes the background to appear much larger in relation to the subject than when using a short focal length.

4

Standard or Midrange Zoom Lenses

Standard, or midrange, zoom lenses fall in the middle of the focal-length scale. Zoom lenses of this type usually start at a moderately wide angle of around 24mm to 28mm, and zoom in to a short telephoto range between 70mm and 85mm. These lenses work great for most general photography applications and can be used successfully for everything from architectural to portrait photography. This type of lens covers the most useful focal lengths and will probably spend the most time on your camera. For this reason, I recommend buying the best quality lens you can afford.

Some of the options for midrange lenses include:

▶ **NIKKOR 24-70mm f/2.8G.** This is Nikon's top-of-the-line, standard zoom lens (see Figure 4.3). A professional lens, it has a fast aperture of f/2.8 over the whole zoom range, and is extremely sharp at all focal lengths and apertures. The build quality of this lens is excellent, as are most Nikon pro lenses. The 24-70mm f/2.8G features the super-quiet and fast-focusing Silent Wave Motor, as well as ED glass elements to reduce chromatic aberration. This lens is top-notch all around and worth every penny of the price tag.

Image courtesy of Nikon, Inc.
4.3 The NIKKOR 24-70mm f/2.8G

▶ **NIKKOR 28-70mm f/2.8D.** This lens is the precursor to the newer 24-70mm. It is a very high-quality, pro lens and can be found used for much less than the newer version. This lens also features the Silent Wave Motor for fast, silent focusing, and is very sharp at all apertures. This is a great bargain pro lens.

▶ **Sigma 24-70mm f/2.8.** This lens is a low-cost alternative to the Nikon 24-70mm and has a fast f/2.8 aperture. You can get this lens for about one-third the cost of the Nikon version. It has a sturdy build and a fast, silent HSM motor.

In the standard range for primes, the most popular are the 50mm normal lenses. They are referred to as *normal* because they approximate about the same field of view as the human eye. There are two NIKKOR offerings: the 50mm f/1.8 and the 50mm f/1.4. The current versions are G lenses with the AF-S motor, but the D lenses are still plentiful and are a great bargain. The 50mm f/1.8D lenses are a favorite for their sharpness and inexpensiveness (they can be found for about $100).

Image courtesy of Nikon, Inc.

4.4 The Nikon 50mm f/1.8G is a favorite of a lot of photographers.

Telephoto Lenses

Telephoto lenses have very long focal lengths that are used to get closer to distant subjects. They provide a very narrow field of view and are handy when you're trying to focus on the details of a far-off subject. Telephoto lenses have a much shallower depth of field than wide-angle and midrange lenses, and you can use them to blur out background details to isolate a subject. Telephoto lenses are commonly used for sports and wildlife photography. The shallow depth of field also makes them one of the top choices for photographing portraits.

Like wide-angle lenses, telephoto lenses also have their quirks, such as perspective distortion. As you may have guessed, telephoto perspective distortion is the opposite of wide-angle distortion. Because everything in the photo is so far away with a telephoto lens, the lens tends to *compress* the image. Compression causes the background to look closer to the foreground than it actually is. Of course, you can use this effect creatively. For example, compression can flatten out the features of a model, resulting in a pleasing effect. Compression is one of the main reasons photographers often use a telephoto lens for portrait photography.

A standard telephoto zoom lens usually has a range of about 70 to 200mm. If you want to zoom in close to a subject that's very far away, you may need an even longer lens. These super-telephoto lenses can act like telescopes, really bringing the subject in close. They range from about 300mm up to about 800mm. Almost all super-telephoto lenses are prime lenses, and they're very heavy, bulky, and expensive. To keep costs lower, some super-telephoto lenses have a slower aperture of f/4.0.

There are quite a few telephoto prime lenses available. Most of them, especially the longer ones (105mm and longer), are expensive, although you can sometimes find older Nikon primes that are discontinued or used — and at decent prices — such as the NIKKOR 300mm f/4.0.

Some of the most common telephoto lenses include the following:

▶ **NIKKOR 70-200mm f/2.8G VR II.** This is Nikon's latest, top-of-the-line standard telephoto lens. The VR makes this lens useful when photographing far-off subjects handheld. This is a great lens for sports, portraits, and wildlife photography.

Image courtesy of Nikon, Inc.
4.5 The NIKKOR 300mm f/2.8G VR

▶ **NIKKOR 70-200mm f/4G VR III.** Nikon's latest affordable alternative to the 70-200mm f/2.8G VR lens. It is sharp and has a constant f/4.0 aperture. This makes for a smaller lighter lens when speed isn't a necessity.

▶ **NIKKOR 80-200mm f/2.8D.** A great, affordable alternative to the 70-200mm VR lens, this lens is sharp and has a fast, constant f/2.8 aperture. There are a few different versions of the 80-200mm. The most desirable one has the AF-S motor for fast silent focusing.

▶ **NIKKOR 80-400mm f/4.5-5.6G VR.** This is a high-power, VR image stabilization zoom lens that gives you a lot of reach. Its versatile zoom range makes it especially useful for wildlife photography when the subject is far away. As with most lenses with a very broad focal-length range, you make concessions with fast apertures and a moderately lower image quality when compared to the 70-200mm or 80-200mm f/2.8 lenses.

Super-zoom Lenses

Most lens manufacturers (Nikon included) offer what's commonly called a *super-zoom*, or sometimes a *hyper-zoom*. Super-zooms are lenses that encompass a very broad focal length, from wide angle to telephoto. The most popular of the super-zooms is the Nikon 28-300mm f/3.5-5.6 VR.

These lenses have a large focal-length range that you can use in a wide variety of shooting situations without having to switch out lenses. This would come in handy if, for example, you were photographing a Himalayan mountain range using a wide-angle setting, and suddenly a Yeti appeared on the horizon. You could quickly zoom in with the super-telephoto setting and get a good close-up shot, without having to fumble around in your camera bag to grab a telephoto and switch out lenses, possibly causing you to miss the shot of a lifetime.

Super-zooms come with a price (figuratively and literally). To achieve the great ranges in focal length, concessions must be made with regard to image quality. These lenses are usually less sharp than lenses with a shorter zoom range and are more often plagued with optical distortions and chromatic aberration. Super-zooms often show pronounced barrel distortion at the wide end and can have moderate to severe pincushion distortion at the long end of the range. Luckily, these distortions can be fixed in Photoshop or other image-editing software.

Another caveat to using these lenses is that they usually have appreciably smaller maximum apertures than zoom lenses with shorter ranges. This can be a problem, especially because larger apertures are generally needed at the long end to keep a high enough shutter speed to avoid the blurring that results from camera shake when handholding. Of course, some manufacturers include some sort of image stabilization to help control this problem.

4

Special-Purpose Lenses

Nikon has a few options when it comes to lenses that are designed specifically to handle a certain task. Nikon special-purpose lenses include the Perspective Control (PC-E), Micro-NIKKOR (macro) lenses, Defocus Control (DC) and fisheye lenses. They even offer a lens that combines both perspective control and macro features. These lenses, especially the PC-E lenses, aren't typically designed for everyday use and are rather specific in their applications.

Micro-NIKKOR lenses

A macro lens is a special-purpose lens used in macro and close-up photography. It allows you to have a closer focusing distance than regular lenses, which in turn allows you to get more magnification of your subject, revealing small details that would otherwise be lost. True macro lenses offer a magnification ratio of 1:1; that is, the image projected onto the sensor through the lens is the exact same size as the object being photographed. Some lower-priced macro lenses offer a 1:2 or even a 1:4 magnification ratio, which is one-half to one-quarter the size of the original object. Although lens manufacturers refer to these lenses as macro, strictly speaking they are not.

One major concern with a macro lens is depth of field. When you focus at such a close distance, the depth of field becomes very shallow. As a result, it's often advisable to use a small aperture to maximize your depth of field and ensure everything is in focus. Of course, as with any downside, there's also an upside — you can use the shallow depth of field creatively. For example, you can use it to isolate a detail in a subject.

Macro lenses come in a variety of focal lengths, and the most common is 60mm. Some macro lenses have substantially longer focal lengths that allow more distance between the lens and the subject. This comes in handy when the subject needs to be lit with an additional light source. A lens that's very close to the subject while focusing can get in the way of the light source, casting a shadow.

When buying a macro lens, you should consider a few things: How often are you going to use the lens? Can you use it for other purposes? Do you need AF? Because newer dedicated macro lenses can be pricey, you may want to consider some less expensive alternatives.

It's not absolutely necessary to have an AF lens. When shooting very close up, the depth of focus is very small, so all you need to do is move slightly closer or farther away to achieve focus. This makes an AF lens a bit unnecessary. You can find plenty

of older Nikon manual focus (MF) macro lenses that are very inexpensive, but have superb lens quality and sharpness.

Nikon currently offers the following three focal-length macro lenses under the Micro-NIKKOR designation:

▶ **NIKKOR 60mm f/2.8.** Nikon offers two versions of this lens — one with a standard AF drive and one with an AF-S version with the Silent Wave Motor. The AF-S version also has the new Nano-Crystal lens coating to help eliminate ghosting and flare.

▶ **NIKKOR 105mm f/2.8 VR.** This lens, shown in Figure 4.6, is my favorite Nikon lens. It not only allows you to focus extremely close, but also enables you to back off and still get a good close-up shot (see Figure 4.7). It is also equipped with VR. This can be invaluable with macro photography because it allows you to handhold at slower shutter speeds — a necessity when stopping down to maintain a good depth of field. This lens can also double as a very impressive portrait lens.

Image courtesy of Nikon, Inc.
4.6 NIKKOR 105mm f/2.8G VR macro lens

▶ **NIKKOR 200mm f/4.0.** This telephoto macro lens provides a longer working distance, which can be beneficial when photographing small animals or insects. This is a good lens for nature and wildlife photography and gives you a true 1:1 macro shot.

4.7 A macro shot taken with a 105mm f/2.8G VR at 1:1 magnification. Exposure: ISO 6400, f/4.0, 1/400 second.

Defocus Control lenses

Defocus Control (DC) lenses are dedicated portrait lenses from Nikon. This feature allows you to control the spherical aberration of the lens. Spherical aberration is evident in the out-of-focus areas of the image and is the determining factor in whether a lens's bokeh is considered pleasing. *Bokeh* is a term derived from the Japanese word *boke,* which is roughly translated as "fuzzy." Bokeh refers to the out-of-focus areas of an image.

The specific technical details of how this lens achieves this effect are outside the scope of this chapter. Just know that it can make the out-of-focus areas, either in front of or behind the subject, appear sharper or softer. It can also produce ethereal, soft focus effects on your subject. This lens takes some time and effort to learn how to use effectively, but once you master it, your portraits will look amazing.

Nikon currently offers two lenses with DC: the 105mm f/2D and the 135mm f/2D. Both are telephoto lenses and have a wide f/2.0 aperture for achieving a super-shallow depth of field. These lenses are fairly expensive but well worth the cost if you shoot a lot of portraits.

Fisheye lenses

Fisheye lenses are ultrawide-angle lenses that aren't corrected for distortion like standard rectilinear wide-angle lenses. These lenses are known as *curvilinear,* meaning that straight lines in your image, especially near the edge of the frame, are curved. Fisheye lenses have extreme barrel distortion. What makes fisheye lenses appealing is the very thing we try to get rid of in other wide-angle lenses.

4.8 An image taken with a Nikon 16mm fisheye lens. Exposure: ISO 1800, f/2.8, 1/200 second.

Fisheye lenses cover a full 180-degree area, allowing you to see everything that's immediately to the left and right of you in the frame. You need to take special care so that you don't get your feet in the frame, which often happens when you use a lens with a field of view this extreme.

Fisheye lenses aren't made for everyday shooting, but with their extreme perspective distortion, you can achieve interesting, and sometimes wacky, results. You can also *de-fish* or correct for the extreme fisheye by using image-editing software, such as Photoshop, Capture NX or NX 2, and DxO Optics. The end result of de-fishing your image is that you get a reduced field of view. This is akin to using a rectilinear wide-angle lens, but it often yields a slightly wider field of view than a standard wide-angle lens.

Using Vibration Reduction Lenses

Nikon has an impressive list of lenses that offer Vibration Reduction (VR). This technology is used to combat image blur caused by camera shake, especially when handholding the camera at long focal lengths. The VR function works by detecting the motion of the lens and shifting the internal lens elements. This allows you to shoot at slower shutter speeds than you normally use while still getting sharp images.

Nikon has updated the VR mechanism a few times, and refers to it as VR-II and VR-III. The original VR claims that you can shoot up to 3 stops slower, while the newer VR-II boasts that you can shoot 4 stops slower. The brand new VR-III ups the claim to 5 stops of reduction.

If you're an old hand at photography, you probably know this rule of thumb: To get a reasonably sharp photo when handholding the camera, you should use a shutter speed that corresponds to the reciprocal of the lens's focal length. In simpler terms, when shooting at a 200mm zoom setting, your shutter speed should be at least 1/200 second. When shooting with a wider setting, such as 28mm, you can safely handhold at around 1/30 second. Of course, this is just a guideline; some people are naturally steadier than others and can get sharp shots at slower speeds.

Although the VR feature provides some extra latitude when shooting with low light, it's not made to replace a fast shutter speed. To get a good, sharp photo when shooting action, you need a fast shutter speed to freeze the action. No matter how good the VR is, nothing can freeze a moving subject but a fast shutter speed.

Some third-party lens manufacturers offer their own version of VR, as well. For example, Sigma has Optical Stabilization (OS) and Tamron has Vibration Control (VC). Tokina doesn't currently feature image stabilization on any of its lenses.

Two types of fisheye lenses are available: circular and full frame. Circular fisheye lenses project a complete 180-degree spherical image onto the frame, resulting in a circular image surrounded by black in the rest of the frame. A full-frame fisheye completely covers the frame with an image. The 16mm NIKKOR fisheye is a full-frame fisheye on an FX-format dSLR. Sigma also makes a few different fisheye lenses in both the circular and full frame variety. A couple of Russian companies (Zenitar and Peleng) also manufacture high-quality but affordable, manual-focus fisheye lenses. Autofocus is not truly a necessity on fisheye lenses, given their extreme depth of field and short focusing distance.

Perspective Control lenses

Perspective Control (PC-E) lenses are used to control perspective by shifting or tilting the lens elements to stop lines in the subject from converging, or to control the area of focus in a way you can't with regular optical lenses. PC-E lenses are mainly used in architecture and high-end product photography. Shifting the lens in an architectural shot allows the camera's sensor to remain parallel to the structure. This makes the lines straight and the structure doesn't look as if it's leaning back, which it would if you angled the camera back to capture the building from top to bottom.

Tilting the lens affects the depth of field. In a standard lens, the depth of field is parallel to the sensor plane because the lens elements are designed to be parallel. In a PC-E lens, the lens elements can be tilted so that the depth of field can be set at an angle. This allows you to keep areas of an image in focus from front to back, while having a shallow depth of field on the sides of the image.

Some photographers have started experimenting with these lenses to add special depth-of-field effects that draw the eye to specific parts of the image in a way that you can't do with a standard lens.

Nikon offers three PC-E lenses, including the 24mm f/3.5 wide-angle lens designed mostly for architecture (although most architecture photographers I know wish for a wider-angle lens, such as Canon's 17mm TS-E f/4.0L lens). The other two PC-E lenses are macro lenses designed more for product photography.

Image courtesy of Nikon, Inc.
4.9 The Nikon 24mm f/3.5. Notice the tilt in the lens.

Lens Accessories

A number of lens accessories are designed to work with your existing lenses to make them more useful for different applications. These accessories allow you to save room and weight in your camera bag by essentially allowing you to use one lens for numerous purposes.

Teleconverters

A *teleconverter (TC)* is a small lens element that is placed between the camera and lens. A teleconverter magnifies the incoming image to increase the effective focal length. Teleconverters are quite small, which is why some photographers prefer to use them rather than buy a longer lens. They are generally used to extend telephoto lenses rather than wide-angle or standard lenses — in fact, they aren't generally recommended for use with those types of lenses.

Teleconverters come in three standard magnifications — 1.4X, 1.7X, and 2X — which magnify your images by 40 percent, 70 percent, and 100 percent. So when using a teleconverter with a 70-200mm f/2.8G, you get effective focal lengths of 98-280mm, 199-340mm, and 140-400mm, respectively.

The upside of using a teleconverter is that you can get more reach out of the lens. This is obvious, of course, but it can get you in closer to unapproachable subjects to capture more detail. You can get more reach without a lot of extra weight (a 400mm telephoto lens is quite sizeable). You maintain the lens's minimum focus distance, which allows you to get near-macro shots. Another upside is that, when coupled to a macro lens, the teleconverter increases your magnification ratio. With a 2X converter you can increase the ratio to 2:1, or double life size.

Of course, there's no free lunch. The main drawback is that you lose light when using a teleconverter. A 1.4X TC costs you 1 stop of light, a 1.7X about 1-1/2 stops, and a 2X 2 stops. So your 200mm f/2.8 becomes a 400mm f/5.6 with a 2X extender. This may not be bad in daylight, but it can become a liability in low light. A lens with a maximum aperture of f/4.0, such as a 300mm f/4.0, would be reduced to an effective aperture of f/8.0, which is the threshold of the D600's ability to autofocus. Previous Nikon cameras only allowed AF on lenses that were f/5.6 or faster, so the D600 outshines earlier models when it comes to using teleconverters.

Another drawback to using teleconverters is that the extra glass elements have a detrimental effect on image quality. Images shot with a teleconverter often appear hazy and lack sharpness. This is why you should purchase the best teleconverters you can get. Unfortunately, the Nikon TCs are quite expensive, but they are the best. I've used third-party teleconverters that cost much less and, much to my chagrin, none of them could hold a candle to the Nikon offerings.

At the end of the day, using teleconverters is an exercise in give and take. If you need the extra length, you need to consider whether the advantages are worth the drawbacks.

4

Extension tubes

Extension tubes are often mistaken for teleconverters. The placement is the same, but their purpose is very different. Extension tubes are placed between the camera body and the lens, but there are no optical elements involved. An *extension tube* is an empty tube, and its sole purpose is to move the lens farther away from the focal plane. This allows the lens to focus closer on the subject. For example, a standard lens can focus at macro ratios of 1:1 or better.

Extension tubes are an inexpensive add-on to make any lens a macro lens. The upside to extension tubes is that there are no optical elements involved, so there is no degradation in image quality at all, aside from a shallower depth of field. As with teleconverters, there are different sizes that allow different magnifications, and increasing magnification brings a loss of light.

There are two different kinds of extension tubes: CPU and non-CPU, with the cheapest being non-CPU. Similar to Nikon's older MF lenses, these tubes have no electrical contacts to relay data to the camera. For extension tubes, you need to use lenses with manual aperture control or shoot completely stopped down. Manual focus and manual exposure are also necessary.

Stepping up a bit, you can get extension tubes with electrical contacts that allow you to autofocus and control your aperture and other settings from the camera as you normally would. Extension tubes are a great alternative to buying a dedicated macro lens and they give excellent image quality because there's no additional glass between the lens and the sensor to interfere.

Close-up filters

On the bottom tier of lens accessories are the close-up filters. These optics screw right into the filter ring on the front of your lens. Similar to extension tubes, close-up filters allow you to focus closer on your subject when getting macro shots. They essentially act as a magnifying glass for your lens. These filters come in a variety of magnifications, and can be stacked or screwed together to increase magnification exponentially.

The upside to using close-up filters is that you don't lose any light. The effectiveness of the lens aperture is not reduced at all. The downside is that close-up filters reduce image quality and can produce soft images. The image quality is further degraded as the filters are stacked.

As with teleconverters, you are better off purchasing high-quality filters. The glass in the more expensive models is manufactured more precisely and gives much sharper results than inexpensive filters with low-quality glass. Quality brands include B+W and Heliopan.

UV filters

Current DLSR cameras, such as the D600, have a UV (ultraviolet) filter installed internally in front of the sensor itself. Therefore, the purpose for which the UV filter was designed is negated, but lots of photographers (myself included) still use them to protect the front element of their lenses.

This is one of those hot-button issues that you find photographers arguing vehemently about on Internet forums. The bottom line is that there are good reasons why you should and shouldn't use UV filters.

The main pro for using a UV filter is the protection you get against scratches on the front element of the lens. Dust, dirt, and debris can get on your lens causing abrasions when you clean the glass using a lens cloth. The UV filter provides a barrier against the debris. This is especially important when shooting near the ocean, as the salty sea spray is extremely abrasive to glass. If you shoot in bad conditions as frequently as I do, you will appreciate the protection of a UV filter. Take a look at your UV filter after about 6 months of constant use and you will see the kind of damage it prevents.

However, there are also some cons to using UV filters. The first is that any extra glass you put in front of your lens is going to degrade the image quality. For this reason, I only use the best quality multi-coated filters. My personal choice is the Rodenstock HR Digital. B+W also makes some of the top-rated filters.

Another con to using a UV filter is that adding another piece of glass into the mix also gives light another surface to reflect from, which can lead to increased flare and ghosting. This is another reason I recommend using a high quality multi-coated filter — the coating helps quell this problem.

The bottom line is that it's really up to the photographer to decide whether a UV filter is a necessity. If you find yourself shooting outside in the elements a lot and you have to clean your lens frequently, you may benefit from a UV filter. If you're mainly an indoor shooter and usually work in a clean environment, such as a studio, you may never need the protection of a UV filter.

Neutral density (ND) filters

A *neutral density* or *ND* filter reduces the amount of light that enters the lens without coloring or altering it in any way. These filters are used in bright sunlight to allow slower than normal shutter speeds to be used to create special effects, such as motion blur. ND filters are also used to reduce light so that a wide aperture can be used in bright sunlight; this is used quite a bit in filmmaking.

ND filters come in different densities, called filter factors. Filter factors are measured in one stop increments and, the same as when reducing the aperture or shutter speed by one stop, the light is halved. An ND2 filter reduces the light by 1/2 or 1 stop, ND4 allows only 1/4 of the light to reach the sensor, which is 2 stops, an ND8 permits only 1/8 of the ambient light (3 stops), and so on.

There is also a type of filter called a gradual neutral density filter or GND for short. This type of filter has a gradient that goes from clear to dark. This type of filter is mostly used in landscape photography to balance the exposure from the bright sky with the darker land, although HDR photography is supplanting this technique for the most part.

Controlling Exposure

Exposure is one of the most important, if not *the* most important, concepts in photography. Getting to know what each exposure setting means and how to meld them all into a perfect exposure is the key to producing photographs exactly as you want them to appear. If you don't understand the crucial theory of exposure, you will never be able to get reproducible results of the photographs you take. Exposure is not a difficult concept to master, but it can be technically confusing, especially if you're new to using a dSLR. While it is true that the D600 has scene mode capabilities that allow you to simply set the scene and shoot, I have a feeling that you wouldn't have bought a relatively advanced camera nor would you have purchased this book if you intended to simply use it in fully automatic mode. In any case, let's start by taking a look at what goes into making an exposure.

Knowing which modes and features to use in any given situation allows you to get a good exposure, no matter what.

Defining Exposure

Strictly speaking, exposure is the amount of light that your camera collects in a single *shutter cycle.* A shutter cycle occurs when you fully depress the shutter-release but-ton, the mirror flips up, the shutter opens, the shutter curtains close, the mirror flips back down, and the shutter is reset.

Three things determine how much exposure the CMOS sensor of your D600 receives during each shutter cycle. I refer to these three elements as the *triumvirate of expo-sure.* Each of these elements must be set to a specific value in accordance with the amount of light in the scene you're photographing in order to achieve the proper expo-sure. If you change any one of these elements, one of the other elements must be changed to achieve an equivalent exposure. If you change one of these three ele-ments while leaving the others alone, you get an under- or overexposure.

The three elements of exposure are

▶ **Shutter speed.** The shutter speed simply determines the length of time the shutter is open, exposing the sensor to light.

▶ **ISO sensitivity.** The ISO setting you choose influences your camera sensor's sensitivity to light or, more correctly, how much the sensor amplifies the signals that are created when light hits the pixels.

▶ **Aperture.** The aperture, also known as the f-stop, the amount of light that reaches the sensor of your camera. Each lens has an adjustable opening. As you change the size of the aperture (the opening), you allow more or less light to reach the sensor.

If you've been around many photographers or photography forums, you may have heard the word *stop.* All three of the aforementioned elements are measured in stops. The term *stop* is relative to each of these three elements because they represent the same amount of light. Closing the aperture by 1 stop is the same as shortening your shutter speed by 1 stop or decreasing the ISO sensitivity by 1 stop.

CAUTION In current photography nomenclature, the fine adjustments that you can apply to the ISO, shutter speed, and aperture settings are referred to as *steps,* with a step representing each of the settings in between 1 stop. All Nikon dSLRs allow you to change these setting in 1/3 to 1/2 steps. For all practical purposes, you can think of a 1/3 step as 1/3 of a stop.

To clarify, a stop isn't a quantity of light. A stop is the doubling or halving of the amount of light in any given scene.

In short, each whole setting of these three elements of exposure is equivalent to 1 stop of light, and you can use these settings to double or halve the amount of light you expose your sensor to.

NOTE The D600 exposure settings are set to 1/3 stops by default.

As I cover in Chapter 2, the D600 has many exposure modes that are designed to give you a correct exposure. But keep in mind that there actually is no one correct exposure setting for any one scene. Depending on the situation, the camera can choose any number of settings that add up to a correct exposure.

Changing one aspect of the exposure requires changing one of the other elements to allow the same amount of light to reach the sensor. This is referred to as *equivalent exposure,* meaning that although some of the settings have been altered, the quantity of light reaching the sensor remains the same. This means that for any given scene, there can be seven or more correct exposures at a specific ISO setting. If you add in ISO sensitivity, you can have more than fourteen separate exposure settings that will give you the exact same exposure. And, if you consider that the D600 is set by default to work in 1/3-stop settings, that number triples.

Now, when I say there isn't any one correct exposure setting that works for any given scene, this statement comes with a caveat. There is *one* exposure setting that is correct and that is the one that *you,* the photographer, choose. You can look at the exposure meter in the camera and adjust the settings until the meter shows that you have the right settings to get the right amount of light to make a nice exposure, but that doesn't mean that the image will come out exactly as you envision it. This means that you select the appropriate settings to create an artistic image, an *expressive* exposure setting, if you will.

In the following sections, I discuss the basics of the different elements in the exposure trio and how you can use them to express yourself creatively not only to make good exposures but also to use them to create effects that add interest to your images.

ISO

The ISO sensitivity number indicates how sensitive to light the medium is — in the case of the D600, that medium is the CMOS sensor. The higher the ISO number, the more sensitive it is and the less light you need to take a photograph. For example, you might

choose an ISO setting of 100 on a bright, sunny day when you are photographing out-side because you have plenty of light. However, on a cloudy day you may want to con-sider an ISO of 400 or higher to make sure your camera captures enough available light.

ISO sensitivity settings on the D600 in 1-stop increments are 100, 200, 400, 800, 1600, 3200, and 6400. Each ISO setting is twice as sensitive to light as the previous setting. For example, at ISO 400, your camera is twice as sensitive to light as it is at ISO 200. This means it needs only half the light at ISO 400 that it needs at ISO 200 to achieve the same exposure.

The D600 allows you to adjust the ISO in 1/3-stop increments (100, 125, 160, 200, and so on), which enables you to fine-tune your ISO to reduce the noise that is inherent in higher ISO settings. Personally, when setting my ISO sensitivity, I use 1-stop settings. Keep in mind, however, that when using Auto ISO, the camera uses 1/3-step ISO set-tings at all times.

NOTE In ✏ b1, you can set the ISO sensitivity to be controlled in 1/2-stop increments.

In an artistic context, you can use the ISO to control either the aperture or the shutter speed; for example, if you need a faster shutter speed and smaller aperture to get a desired effect, then raising the ISO sensitivity setting is the way to go (or vice versa).

Shutter speed

Shutter speed is the amount of time that the shutter exposes the sensor to light. Shutter speeds are indicated in seconds, with long shutter speeds in whole seconds and short shutter speeds in fractions of a second. Common shutter speeds (from slow to fast) in 1-stop increments include 1 second, 1/2, 1/4, 1/8, 1/15, 1/30, 1/60, 1/125, 1/500, 1/1000, and so on. Increasing or decreasing shutter speed by one setting halves or doubles the exposure, respectively.

NOTE The numerator of the shutter speed isn't featured on any of the camera displays, so you end up with what seems to be a whole number; for example, 1/250 second simply appears as 250. To delineate the fractions from the whole numbers, a double hash mark is used; for example, a 2-second exposure appears as 2".

The D600 shutter speed is controlled in 1/3 steps, so it uses the numbers 1 second, 1/1.3, 1/1.6, 1/2, 1/2.5, 1/3, 1/4, 1/5, 1/6, 1/8, and so on.

So what role does shutter speed play in creating expressive exposures? Shutter speed allows the photographer to portray motion in a still photograph in a variety of ways. Although you can use various techniques to creatively portray motion, there are ultimately two types of exposures: fast (or short) exposures and slow (or long) exposures.

For general daytime photography with a still or moderately moving subject, 1/30 second or slower is considered a slow shutter speed while 1/60 second or faster is considered a fast shutter speed. That being said, there are no hard and fast rules about what a fast or slow exposure is; that depends solely on the subject. For example, for most general photography, 1/250 second is a fast exposure, but if you're photographing race cars, 1/250 second is a slow exposure. On the opposite end, if you're photographing the night sky, 1/8 second is a relatively fast exposure, whereas in the daytime, 1/8 second would be very slow. Ultimately, the speed of the shutter is relative to the speed of the subject.

5

5.1 Even at a relatively fast shutter speed of 1/400 second, you can see the motion blur of the wheels on this Shelby Cobra, which suggests movement. I also used panning to add some blur to the background while keeping the subject sharp. Exposure: ISO 320, f/13, 1/400 second using a Nikon 70-200mm f/2.8G VR.

Fast shutter speeds

Fast shutter speeds are used to freeze motion. This stops the movement of the subject and captures the moment with every minute detail intact for that tiny slice of time when the shutter is open. This allows you and your viewers to examine a moment frozen in time forever. This is one the reasons why photography is such an enduring form of art; it allows us to sit back at our leisure and examine in detail something that occurred for only a fraction of a second. An excellent example is this exciting shot of a bull attacking a professional bull rider. Fast shutter speeds portray movement by stopping the movement, as counterintuitive as that may seem.

5.2 A fast shutter speed allowed me to freeze the action of this bull attempting to maul a cowboy. As you can see, even the dirt that is being kicked up is sharp in midair. Exposure: ISO 2800, f/2.8, 1/1000 second using a Nikon 70-200mm f/2.8G VR.

5.3 I used a fast shutter speed to catch this motocross rider doing a bar-hop, which only lasts for a split second. Exposure: ISO 400, f/4, 1/640 second using a Nikon 28-70mm f/2.8D.

Slow shutter speeds

On the opposite end of the spectrum is the slow shutter speed, which portrays motion in a still photograph. Taking an image with a slow shutter speed adds another dimension to the image, almost like time travel. You capture the subject moving through time and space.

Slow shutter speeds are used to create motion blur so you can see that the subject is actually moving. You can apply this motion blur only to the background by panning along with the subject, or the subject can contain blur. When using a slow shutter speed, you often need to use a tripod to keep some elements of the image sharp. Although blur can be a great way to show motion, you usually don't want the whole image to be a blurry mess.

Long exposures are not only for portraying motion; they can also allow us to see things that are normally too dim for human eyes to perceive, as you can see in Figure 5.7, a photograph of the Milky Way.

5

5.4 Using a slow shutter speed allows these automobiles to appear to be stretched through time as they move while everything else is sharp. Exposure: ISO 1600, f/2.8, 1/15 second using a Nikon 14-24mm f/2.8G.

5.5 A slow shutter speed allowed these fast-moving horses' legs to become indistinct blurs, while panning gave the background a blur and kept the jockeys and the horses' bodies relatively sharp to portray extreme speed. Exposure: ISO 200, f/13, 1/50 second using a Nikon 70-200mm f/2.8G VR.

5.6 Even subjects unrelated to sports can benefit from using motion blur to add some interest to the image. Exposure: ISO 500, f/8, 1/125 second using a Nikon 105mm f/2.8G VR Macro lens.

5.7 A very long exposure allowed me to record the light from the Milky Way to the sensor of the D600. Exposure: ISO 800, f/2.8, 30 seconds using a Nikon 14-24mm f/2.8G.

Aperture

In my opinion, the aperture is the most important part of creative and expressive photography. With the aperture you can control how much of the image is in focus, what part is in focus, and where you lead the viewer's eye. The aperture is the size of the opening in the lens that determines the amount of light that reaches the image sensor. The aperture is controlled by a metal diaphragm that operates in a similar fashion to the iris of your eye. Aperture is expressed as f-stop numbers, such as f/1.4, f/2, f/2.8, f/4, f/5.6, f/8, f/11, f/16, and f/22. Here are a couple of important things to know about aperture:

▶ **Smaller f-numbers equal wider apertures.** A small f-number such as f/2.8 opens the lens so that more light reaches the sensor. If you have a wide aperture (opening), the amount of time the shutter needs to stay open to let light into the camera decreases.

▶ **Larger f-numbers equal narrower apertures.** A large f-number such as f/16 closes the lens so that less light reaches the sensor. If you have a narrow aperture (opening), the amount of time the shutter needs to stay open to let light into the camera increases.

One commonly asked question is why the numbers of the aperture seem counterintuitive. The answer is relatively simple: The numbers are actually derived from ratios, which translate into fractions. The f-number is defined by the focal length of the lens divided by the actual diameter of the aperture opening. The simplest way to look at it is to put a 1 on top of the f-number as the numerator. For the easiest example, take a 50mm f/2 lens (okay, Nikon doesn't actually make a 50mm f/2, but pretend for a minute). Take the aperture number, f/2. If you add the 1 as the numerator, you get 1/2. This indicates that the aperture opening is half the diameter of the focal length, which equals 25mm. So at f/4, the effective diameter of the aperture is 12.5mm. It's a pretty simple concept once you break it down.

NOTE The terms *aperture* and *f-stop* are interchangeable.

As with ISO and shutter speed, there are standard settings for aperture, each of which has a 1-stop difference from the next setting. The standard f-numbers are f/1.4, f/2, f/2.8, f/4, f/5.6, f/8, f/11, f/16, and f/22. Although these may appear to be a random assortment of numbers, they aren't. Upon closer inspection, you will notice that every

other number is a multiple of 2. Broken down even further, each stop is a multiple of 1.4. This is where the standard f-stop numbers are derived from. If you start out with f/1 and multiply by 1.4, you get f/1.4; multiply this by 1.4 again and you get 2 (rounded up from 1.96); multiply 2 by 1.4 and you get 2.8, and so on.

As it does with the ISO and shutter speed settings, the Nikon D600 allows you to set the aperture in 1/3-stop increments.

> **NOTE** In photographic vernacular, *opening up* refers to going from a smaller to a larger aperture, and *stopping down* refers to going from a larger to a smaller aperture.

Now that you know a little more about apertures, you can begin to look at why different aperture settings are used and the effect that they have on your images. The most common reason why a certain aperture is selected is to control the depth of field, or how much of the image is in focus. Quite simply, using a wider aperture (f/1.4–4) gives you a shallow depth of field that allows you to exercise selective focus, focusing on a certain subject in the image while allowing the rest to fall out of focus.

5.8 The shallow depth of field draws your eye directly to the subject. Exposure: ISO 1800, f/5, 1/50 second using a Nikon 50mm f/1.4G.

5

5.9 As you can see in this series of images, the deep depth of field (f/5.6 for 1/160 second) of the shot on the left allows the background to show and distracts from the main subject. The image on the right was shot at f/1.4 for 1/2500 second and allows the flower to become the prominent feature of the image. Taken with a Nikon 50mm f/1.4G.

Conversely, using a small aperture (f/11–32) maximizes your depth of field, allowing you to get more of the scene in focus. Using a wider aperture is generally preferable when shooting portraits because it blurs out the background and draws attention to the subject; a smaller aperture is generally used when photographing landscapes to ensure that a larger range of the scene is in focus.

Another way that the aperture setting is used, oddly enough, is to control the shutter speed. You can use a wide aperture to allow a lot of light in so that you can use a faster shutter speed to freeze action. Conversely, you can use a smaller aperture if you want to be sure that your shutter speed is slow.

5.10 Sometimes a deep depth of field allows you to capture the whole scene in great detail. This is often used for landscapes to get both the foreground and the background critically sharp. Exposure: ISO 320, f/14, 1/800 second, –1EV using a Sigma 28-70mm f/2.8-4.

Fine-Tuning Your Exposure

You can't always rely on your camera's meter to give you the most accurate reading. It is, after all, a computer and doesn't know what your intentions are for your image, and it can be tricked into under- or overexposing your images by areas of extreme brightness or darkness in the scene. A common scenario where this occurs is when you are shooting at the beach or in a snowy area. The camera meter senses all of this brightness and tries to control the highlights; however, it ends up underexposing the image, causing the sand or snow to appear a dirty gray instead of a brilliant white, as it should be. The quick fix here is to add a stop or two of exposure compensation, which I talk about in the next section.

5

Exposure compensation

Exposure compensation is a D600 feature that allows you to fine-tune the automatic exposure setting supplied by the camera's exposure meter. Although you can adjust the exposure of the image in your image-editing software (especially if you shoot RAW), it's best to get the exposure right in the camera to be sure that you have the highest image quality. If, after taking the photograph, you review it and it's too dark or too light, you can adjust the exposure compensation and retake the picture to get a better exposure.

Exposure compensation is adjusted in EV (exposure value); 1 EV is equal to 1 stop of light. You adjust exposure compensation by pressing the Exposure Compensation button (⊠), next to the shutter-release button, and rotating the Main Command dial to the left for more exposure (+EV) or to the right for less exposure (–EV). Depending on your settings, the exposure compensation is adjusted in either 1/3- or 1/2-stops of light. You can change this setting in ✎ b2.

You can adjust the exposure compensation up to +5 EV and down to –5 EV, which is a pretty large range of 10 stops. To remind you that exposure compensation has been set, the Exposure Compensation indicator is displayed on the top LCD control panel and the viewfinder display. It also appears on the rear LCD screen when the shooting info displays.

> **CAUTION** Be sure to reset the exposure compensation to 0 after you finish to avoid unwanted over- or underexposure.

Using histograms

One of the most important tools you have at your disposal is the histogram. The easiest way to determine if you need to adjust the exposure compensation is to preview your image. If it looks too dark, adjust the exposure compensation up; if it's too bright, adjust the exposure compensation down. This, however, is not the most accurate method of determining how much exposure compensation to use. To accurately determine how much exposure compensation to add or subtract, look at the histogram. The histogram is a visual representation of the tonal values in your image. Think of it as a bar graph that charts the lights, darks, and midtones in your picture.

The histogram's range is broken down into 256 brightness levels from 0 (absolute black) to 255 (absolute white), with 128 coming in at middle gray. The more pixels there are at any given brightness value, the higher the bar. If there are no bars, then the image has no pixels in that brightness range.

NOTE The histogram displayed on the LCD is based on an 8-bit image. When you're working with 12- or 14-bit files using editing software, the histogram may be displayed with 4,096 brightness levels for 12-bit or 16,384 brightness levels for 14-bit.

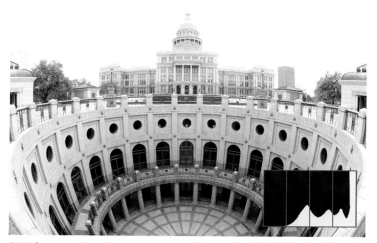

5.11 An example of an overexposed image (no highlight detail) and its histogram. Notice that the histogram information is spiking and completely touching the far-right side of the graph.

The D600 offers four histogram views: the luminance histogram, which shows the brightness levels of the entire image, and separate histograms for each color channel (Red, Green, and Blue).

The most useful histogram for determining if your exposure needs adjusting is the luminance histogram. To display the luminance histogram without the color channel histograms, simply press the multi-selector up (▲) while viewing the image on the LCD. This displays a thumbnail of the current image, the shooting information, and a small luminance histogram.

5

Theoretically, you want to expose your subject so that it falls approximately in the middle of the tonal range. If your histogram graph has most of the information on the left side, then your image is probably underexposed; if it's mostly on the right side, then your image is probably overexposed. Ideally, with most average subjects that aren't bright white or extremely dark, you want to get your histogram to have most of the tones in the middle range, tapering off as they get to the dark and light ends of the graph.

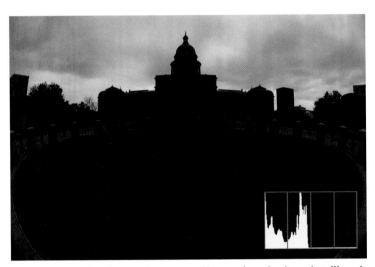

5.12 An example of an underexposed image (no shadow detail) and its histogram. Notice the spikes at the far-left side of the graph.

But this is only for most average types of images that would be not too light and not too dark, with little contrast. As with almost everything in photography, there are exceptions to the rule. If you take a photo of a dark subject on a dark background (a low-key image), then naturally your histogram will have most of the tones on the left side of the graph. Conversely, when you take a photograph of a light subject on a light background (a high-key image), the histogram will have most of the tones skewing to the right.

The most important thing to remember is that there is no such thing as a perfect histogram. A histogram is just a factual representation of the tones in the image. Also remember that although it's okay for the graph to be near one side or the other, you usually don't want your histogram to have spikes bumping up against the edge of the

graph; this indicates that your image has blown-out highlights (completely white, with no detail) or blocked-up shadow areas (completely black, with no detail).

Now that you know a little bit about histograms, you can use them to adjust exposure compensation. Here are the steps to follow when using the histogram as a tool to evaluate your photos:

1. **After taking your picture, review its histogram on the LCD.** To view the histogram in the image preview, press the Playback button (▶) to view the image. Press ▲, and the histogram appears directly to the right of the image preview.

2. **Look at the histogram.** An example of an ideal histogram appears in Figure 5.13.

3. **Adjust the exposure compensation.** To move the tones to the right to capture more highlight detail, add a little exposure compensation by pressing ⌧ and rotating the Main Command dial to the right. To move the tones to the left, press ⌧ and rotate the Main Command dial to the left.

4. **Retake the photograph if necessary.** After taking another picture, review the histogram again. If needed, adjust the exposure compensation more until you achieve the desired exposure.

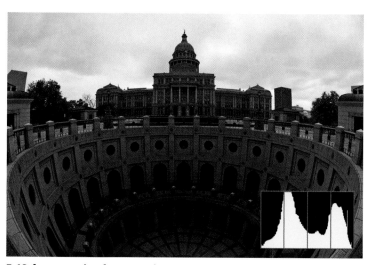

5.13 An example of a properly exposed image and its histogram. Notice that the graph does not spike against the left or right edges, but tapers off.

5

When you're photographing brightly colored subjects, it may sometimes be necessary to refer to the RGB histograms. Sometimes it's possible to overexpose an image in only one color channel, even though the rest of the image looks like it is properly exposed. To view the separate RGB histograms, you need to set the display mode in the Playback menu.

To view RGB histograms, follow these steps:

1. **Press MENU.**

2. **Use the multi-selector to select the Playback menu.** Press ▶.

3. **Use the multi-selector to highlight Playback display options.** Press ⊗ or press ▶ to view the menu options.

4. **Press ▼ to scroll down to the menu option Additional photo info RGB histogram.** Pressing ▶ sets the option to On. This is confirmed by a small check mark in a box next to the option.

5. **When the option is set, press ▲ to scroll up to the Done option and press ⊗.** If you fail to select Done and press ⊗, the setting is not saved.

It's possible for any one of the color channels to become overexposed — or blown out, as some photographers call it — although the most commonly blown-out channel is the Red channel. Digital camera sensors are more prone to overexposing the Red channel because they are generally more sensitive to red colors. When one of these color channels is overexposed, the histogram for that particular color channel looks similar to the luminance histogram of a typical overexposed image.

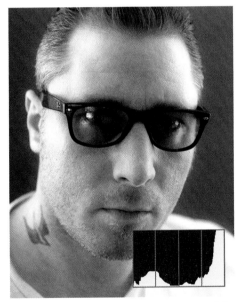

5.14 An example of a high-key image with its histogram. Although most of the tones are to the right, the histogram tapers off down to the shadow side, indicating that there is detail in the shadow area.

Typically, the best way to deal with an image that has an overexposed color channel is to reduce exposure by using exposure compensation. Although this is a quick fix, reducing the exposure can also introduce blocked-up shadows; you can deal with this by shooting RAW or, to a lesser extent when shooting JPEGs, by using Active D-Lighting, which is a proprietary Nikon camera feature that preserves shadow and highlight detail.

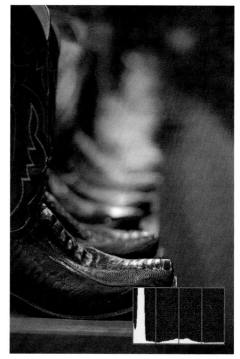

5.15 An example of a low-key image with its histogram. Notice that although most of the tones are to the left, the histogram tapers off down to the highlight side, indicating that there is detail in the highlight area.

5

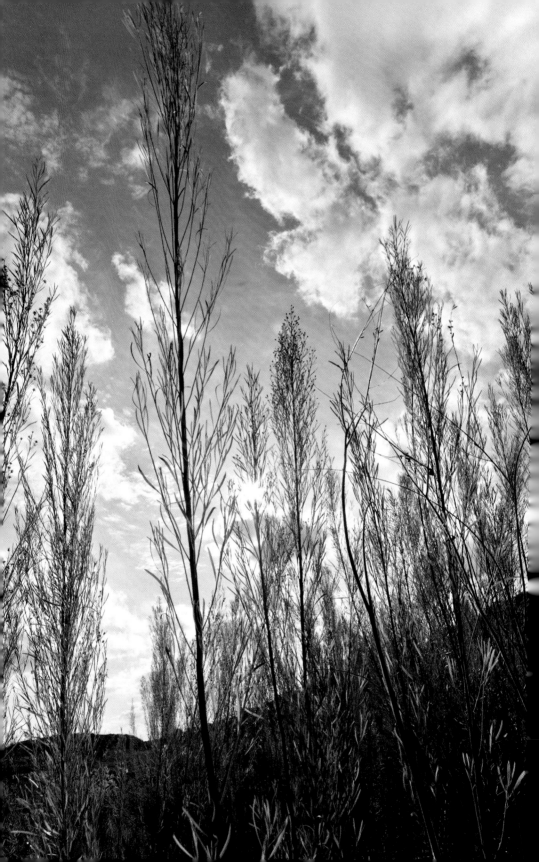

Working with Light

Light is the most important part of photography. Indeed, without light, photography wouldn't even exist. The word *photography* is derived from two Greek words: *photos* ("light") and *graphos* ("writing" or "painting"). Without light, there would be no way to physically record an image.

Not only is the availability of light a part of photography — the *quality* of light also affects your images. Light can be different colors; it can also be hard and directional, or so soft and diffused that it seems to come from everywhere and nowhere at all.

Working with and controlling light is how photographers produce images that are creative and unique.

Controlling the light is the key to setting the tone of your image.

Lighting Essentials

When light strikes a subject, it affects the way the image looks. The quality and the angle of the light, as well as the color, affect the tone or mood of the image, and the different qualities of light can cause the same subject to appear vastly different.

This section covers the two main types of lighting that are used by photographers and filmmakers today: soft and hard light.

Quality of light

Quality of light is a term photographers and filmmakers use to describe how light falls on and affects a scene. The two specific types of lighting are hard and soft. Both hard and soft light have their place in photography, and their uses span all types of photography, from portraits to landscapes and beyond.

The first thing a photographer should consider when planning the concept for an image or when assessing an existing light scene is the quality of light. For example, if you're planning to shoot a portrait, you need to decide how you want to portray the person. If you're shooting a landscape, think about what time of day the lighting is best for that particular terrain.

Soft light

Soft light is distributed evenly across the scene and also appears to wrap around the subject. It comes from a large light source, and the shadows fade gradually from dark to light, which results in a subtle shadow edge transfer. This is a very desirable type of light to use in most types of photography, especially in portraiture. You can also create soft light by placing a light source close to the subject or by diffusing the light source, thereby mimicking a larger light source.

> **NOTE** The term *shadow edge transfer* is used to describe how abruptly the shadows in images go from light to dark. This is the determining factor in whether light is soft or hard. Soft light has a smooth transition and hard light has a well-defined shadow edge transfer.

Soft light is very flattering to most subjects. It is used to soften hard edges and smooth out the features of a subject. Soft lighting can be advantageous for almost any type of photography, although in some instances it can lack the depth that you get from using a more direct light source.

To achieve soft lighting naturally, you can place the subject in an area that isn't receiving direct sunlight, such as under a porch, overhang, or tree. Cloudy, especially partly cloudy, days are also great for soft, diffused lighting.

When artificial light is the source of your subject's illumination, you usually need to modify the light in some way to make it soft. Redirecting or bouncing the light off a wall or some other reflective material softens the light; aiming the light source through diffusion material is also a good way to soften the light.

6.1 A soft-light portrait. Exposure: ISO 400, f/4, 1/200 second.

Hard light

Opposite to soft light, you have hard light. With hard light, the shadow edge transfer is more defined. It is very directional, and you can pinpoint where the light source is located very easily. Moving the light source farther from the subject results in harder light because the light source becomes smaller relative to the subject.

Hard light isn't used as extensively as soft light, but it is very effective in highlighting details and textures in almost any subject. Hard light is often used in landscape shots to bring attention to details in natural formations. Hard light is also effective for creating gritty or realistic portraits.

6

Artificial hard light is easily achieved with a bare light source. You can also use accessories, such as grids or snoots, to make the light more directional. In Figure 6.2, I used a reflector fitted with a 60-degree grid to make the monolight directional. The bright midday sun is an excellent example of a natural, hard light source.

Lighting direction

The direction from which light strikes your subject has a major impact on how your images appear. When using an artificial light source, you can easily control the direction of the lighting by moving the light source relative to the subject. When using natural lighting, moving the subject relative to the light source is the key to controlling the lighting direction.

6.2 A hard-light portrait. Exposure: ISO 100, f/3.5, 1/60 second.

There are three major types of lighting direction:

- ▶ Frontlighting
- ▶ Sidelighting
- ▶ Backlighting

Frontlight

Frontlighting comes from directly in front of the subject, following the old photographer's adage: keep the sun at your back. This is a good general rule; however, sometimes frontlighting can produce flat results lacking in depth and dimension. In Figures 6.3 and 6.4, you can see the difference that changing the direction of the light can make in a subject. When the light is aimed straight ahead, more of it reflects from the background, which brightens the background significantly as well.

Frontlighting works pretty well for portraits, and a lot of fashion photographers swear by it, especially for highlighting hair and makeup. Frontlighting flattens out the facial features and also hides blemishes and wrinkles very well. Be aware that using front-lighting with the sun as your light source can cause your subject to squint.

Sidelight

Although sidelighting comes in from the side, it doesn't necessarily have to come in from a 90-degree angle. It usually comes in from a shallower angle, such as 45 to 60 degrees.

Lighting the subject from the side increases the shadow contrast and causes the details to become more pronounced. This is what gives your two-dimensional photo-graph a three-dimensional feel. In Figure 6.3 you can see that the tuning pegs where the strings are attached almost look flat and nonexistent. In Figure 6.4 the sidelight causes the pegs to jump out from the image more.

6.3 This guitar headstock was lit from the front. Notice the flat, even lighting. Exposure: ISO 800, f/5.6, 1/60 second.

6

6.4 The light was moved to the side for this shot. Notice that the guitar headstock has more texture, depth, and form, giving it more dimensionality. Exposure: ISO 800, f/5.6, 1/60 second.

Sidelight is equally effective when using either hard or soft light, and it works great for just about every subject.

Backlight

Backlighting involves placing the light source behind the subject. Although it's not as common as front- and sidelighting, it does have its uses. Backlighting is often used in conjunction with other types of lighting to add highlights to the subject.

Backlighting has often received a bad rap in photography, but more photographers are now using it to add artistic flair to their images. Backlight introduces effects that were once perceived as undesirable in classical photography, such as lens flare and decreased contrast. Photographers today are discovering that, when used correctly, backlighting can create interesting images.

Backlighting works great for making portraits more dynamic, incorporating silhouettes into landscape photos, and making translucent subjects such as flowers seem to glow, as shown in Figure 6.5.

6.5 Backlighting can add lens flare to your image, giving it a cinematic effect. Exposure: ISO 400, f/8, 1/2000 second with an 80-200mm f/2.8D lens at 80mm.

6

Natural Light

Natural light is probably the easiest light source to find simply because it's all around you, as the sun is the source of all natural light. Some people confuse available light with natural light. To make it clear, all natural light is available light, but not all available light is natural light. Available light is light that exists in a scene and that isn't aug-mented by the photographer. For example, when you walk into a room that is solely lit with an overhead lamp, the overhead lamp provides the available light, but it is not natural light.

That being said, natural light can be the most difficult light to work with. It can be too harsh on a bright sunny day, it can be too unpredictable on a partly cloudy day, and although an overcast day can provide beautiful soft lighting, it can sometimes lack definition, which leads to flat images.

NOTE Early in the morning and late in the evening, when the sun is rising or set-ting, are the best times to take photographs. Both times are known as the golden hour.

Natural light often benefits from some sort of modification to make it softer and a little less directional.

Here are a few examples of natural lighting techniques:

▶ **Use fill flash.** As contrary as it sounds, using flash to augment natural light can really help. You can use the flash as a secondary light source (not as your main light) to fill in the shadows and reduce contrast.

▶ **Try window lighting.** Like fill flash, this technique is one of the best ways to use natural light, even though it seems contrary. Go indoors and place your model next to a window. This provides a beautiful soft light that is very flatter-ing. A lot of professional portrait and food photographers use window light. It can be used to light almost any subject softly and evenly, yet it still provides directionality. This is definitely the quickest and often the nicest light source you'll find.

▶ **Find some shade.** The shade of a tree or the overhang of an awning or porch can block the bright sunlight while still providing plenty of diffuse light with which to light your subject.

▶ **Take advantage of the clouds.** A cloudy day softens the light, allowing you to take portraits outside without worrying about harsh shadows and too much contrast. If it's only partly cloudy, you can wait for a cloud to pass over the sun before taking your shot.

▶ **Use a modifier.** Use a reflector to reduce the shadows, or a diffusion panel to block the direct sunlight from your subject.

Continuous Light

Continuous lighting is a constant light source that gives you a "what you see is what you get" effect; therefore, it's the easiest type of light to work with. You can set up the lights and see what effect they have on your subject before you even pick up your D600.

6.6 Window lighting. Exposure: ISO 250, f/1.4, 1/50 second.

Continuous lights are an affordable option for great photographic lighting, and the learning curve isn't steep at all.

As with other lighting systems, you have a lot of continuous light options. Here are a few of the more common ones:

▶ **Incandescent.** Incandescent, or tungsten, lights are the most common type of lights (a standard light bulb is a tungsten lamp). With tungsten lamps, an electrical current runs through a tungsten filament, heating it and causing it to emit light. This type of continuous lighting is the source of the name "hot lights."

6

Continuous Lights versus Flash

Incandescent lights appear to be very bright to you and your subject, but they actually produce less light than a standard flash unit. For example, a 200-watt tungsten light and a 200-watt-second strobe use the same amount of electricity per second, so they should be equally bright, right? Wrong. Because the flash discharges all 200 watts of energy in a fraction of a second, the flash is actually much, much brighter.

Why does this matter? Because when you need a fast shutter speed or a small aperture, the strobe can give you more light in a shorter time. An SB-600 Speedlight gives you about 30-watt-seconds of light at full power. To get an equivalent amount of light at the maximum sync speed of 1/250 second from a tungsten light, you would need a 7,500-watt lamp! Of course, if your subject is static, you don't need to use a fast shutter speed; in this case, you can use one 30-watt light bulb for a 1-second exposure or a 60-watt light bulb for a 1/2-second exposure.

▶ **Halogen.** Halogen lights, which are much brighter than typical tungsten lights, are another type of hot light. Considered a type of incandescent light, halogen lights employ a tungsten filament, but they also include halogen vapor in the gas inside the lamp. The color temperature of halogen lamps is higher than the color temperature of standard tungsten lamps. Halogen lights are also more expensive and the lamps burn much hotter than standard light bulbs.

▶ **Fluorescent.** Fluorescent lighting is used in most office buildings and retail stores. In a fluorescent lamp, electrical energy changes a small amount of mercury into a gas. The electrons collide with the mercury gas atoms, causing them to release photons, which in turn cause the phosphor coating inside the lamp to glow. Because this reaction doesn't create much heat, fluorescent lamps are much cooler and more energy efficient than tungsten and halogen lamps. In the past, fluorescent lighting wasn't commonly used because of the ghastly green cast the lamps caused. These days, with color-balanced fluorescent lamps and the ability to adjust white balance, fluorescent light kits for photography and video are becoming more common and are very affordable.

Here are some disadvantages of using incandescent lights:

▶ **Color temperature inconsistency.** The color temperature of the lamps changes as your household current varies and as the lamps get more and more use. The color temperature may be inconsistent from manufacturer to manufacturer and may even vary within the same types of bulbs.

▶ **Light modifiers are more expensive.** Because most continuous lights are hot, modifiers such as softboxes need to be made to withstand the heat; this makes them more expensive than the standard equipment intended to be used for strobes.

▶ **Short lamp life.** Incandescent lights tend to have a shorter life than flash tubes, so you must replace them more often.

If you're really serious about lighting with continuous lights, you may want to invest in a photographic light kit. These kits are widely available from any photography or video store. They usually come with lights, light stands, and sometimes light modifiers such as umbrellas or softboxes for diffusing the light for a softer look. The kits can be relatively inexpensive, with two lights, two stands, and two umbrellas costing around $100. Or you can buy much more elaborate setups ranging in price up to $2,000.

D600 Built-in Flash

The Nikon D600 has a built-in flash that pops up for quick use in low-light situations. Although this little flash is fine for snapshots, it's not always the best option for portraying your subject in a flattering light.

> TIP Even when you're using the pop-up flash for snapshots, I recommend using a pop-up flash diffuser. There are a number of different brands and types, but I use a LumiQuest Soft Screen. It folds up flat to fit in your pocket and costs a little over $10.

The greatest feature of the built-in flash is that it allows you to control off-camera Speedlights wirelessly. This is something that even Nikon's flagship camera, the D4, can't do because of its lack of a built-in flash. Nikon Speedlights are dedicated flash units, meaning that they are built specifically for use with the Nikon camera system and offer much more functionality than a non-dedicated flash. A *non-dedicated flash* is a flash made by a third-party manufacturer; the flashes usually don't offer fully automated flash features. There are, however, some non-Nikon flashes that use Nikon's i-TTL (intelligent Through-the-Lens) flash metering system.

6

Built-in Flash Exposure Modes

The built-in flash of the D600 has a few different exposure modes that control the way the flash calculates exposure, flash output, and brightness, and a couple of modes for using some advanced flash techniques.

i-TTL and i-TTL BL

The D600 determines the proper flash exposure automatically by using Nikon's proprietary i-TTL system. The camera gets most of the metering information from monitor preflashes emitted from the built-in flash. These preflashes are emitted almost simultaneously with the main flash so it almost looks as if the flash has fired only once. The camera also uses data from the lens, such as distance information and f-stop values, to help determine the proper flash exposure.

Additionally, two types of i-TTL flash metering are available for the D600: Standard i-TTL flash and i-TTL Balanced Fill-Flash (BL). With Standard i-TTL flash mode, the camera determines the exposure for the subject only and doesn't take the background lighting into account. With i-TTL BL mode, the camera attempts to balance the light from the flash with the ambient light to produce a more natural-looking image.

When you use the built-in flash on the D600, the default mode is i-TTL BL when using Matrix metering (▨) or Center-weighted metering (▣). To use the flash in Standard i-TTL, you must switch the camera to Spot metering (▣).

Manual

The built-in flash power is set by fractions in Manual mode, with 1/1 being full power. The output is halved for each setting (which is equal to 1 stop of light). The settings are 1/1, 1/2, 1/4, 1/8, 1/16, 1/32, 1/64, and 1/128.

The Guide Number (GN) for the built-in flash is 39 when measuring distance in feet, or 12 when using meters at full power (1/1) set to ISO 100. To determine the GN at higher ISO settings, multiply the GN by 1.4 for each stop that the ISO increases. For example, doubling the ISO setting to 200 increases the GN by a factor of 1.4, so GN $39 \times 1.4 = $ GN 54.6.

Similarly, when reducing the flash power by 1 stop, you divide the GN by a factor of 1.4, so at 1/2 power the GN is about 28 (GN $39 \div 1.4 = $ GN 27.8).

Repeating Flash

This option allows you to set the flash to fire a specified number of times while the shutter is open, producing an effect similar to that of a strobe light. This gives you an image similar to a multiple exposure. This option is useful only in low-light situations since it requires a longer shutter speed to record the flash sequence.

You must set three options when using Repeating Flash:

▶ **Output.** This is the strength of the flash. The same settings are used in Manual flash mode.

▶ **Times.** This is where you specify how many times you want the flash to go off. Note that if you don't select a long enough shutter speed, you will not get the specified number of flashes.

▶ **Frequency.** This is expressed in Hertz (Hz) and sets the number of times per second that you want the flash to go off. The frequency and the shutter speed should be matched to get the proper effect.

Commander

One of the best features of the D600 is that the built-in flash can control off-camera Speedlights. To use this feature, you need at least one compatible Speedlight to be used off-camera. Compatible Speedlights with off-camera ability are the SB-600, SB-700, SB-800, SB-900, SB-910, and SBR-200 flashes from the ring light kits. To set up the Commander mode, follow these steps:

1. **Press the Menu button (MENU) and ▶ to navigate to the Custom Settings menu (✎).**

2. **Use the multi-selector to highlight ✎ e Bracketing/flash, and then press ▶ to enter the ✎ e menu.**

3. **Use the multi-selector to highlight ✎ e3 Flash cntrl for built-in flash, and then press ▶ to view flash control options.**

4. **Press ▼ to choose Commander mode, and then press ▶ to view settings.**

5. **Press ▲ or ▼ to choose a flash mode for the built-in flash.** You can choose M, TTL, or --. The last option (--) allows the flash to control the remotes without adding additional exposure.

6. **Press ▶ to highlight the exposure compensation setting.** Use ▲ or ▼ to apply exposure compensation if desired. If the built-in flash is set to –, this option is not available.

7. **Use the multi-selector to set the mode for Group A.** You can choose TTL, AA, M, or –. Press ▶ to highlight exposure compensation. Press ▲ or ▼ to apply exposure compensation if desired. Repeat this process for Group B.

8. **Use the multi-selector to highlight the Channel setting.** You can choose from channels 1 to 4. You can change these channels if you are shooting in the same area as another photographer using the Nikon Creative Lighting System (CLS). If you are both on the same channel, you will trigger each other's Speedlights. If you use CLS alone, it doesn't matter which channel you choose.

9. **Press the OK button (⊗).** If you do not press this button, no changes are applied.

CAUTION Make sure you set all your remote Speedlights to the same channel or they will not fire.

Flash Sync Modes

Flash sync modes control how the flash operates in conjunction with your D600. These modes work with both the built-in Speedlight and accessory Speedlights, such as the SB-910, SB-700, SB-600, and so on. These modes allow you to choose when the flash fires, either at the beginning of the exposure or at the end, and they also allow you to keep the shutter open for longer periods, enabling you to capture more ambient light in low-light situations.

Before covering the sync modes, I need to talk a little about sync speed.

Sync speed

The *sync speed* is the fastest shutter speed that you can use while achieving a full flash exposure. This means that if you set your shutter speed faster than the rated sync speed of the camera, you don't get a full exposure and end up with a partially underexposed image. With the D600, you can't actually set the shutter speed above

the rated sync speed of 1/200 second when using a dedicated flash because the camera won't let you. This means you don't need to worry about having partially black images when using a Speedlight.

Limited sync speeds exist because of the way shutters work in modern cameras. All dSLR cameras have a *focal plane shutter*. This shutter is located directly in front of the focal plane, which is the surface of the sensor. The focal plane shutter has two shutter curtains that travel vertically in front of the sensor to control the time the light can enter through the lens. At slower shutter speeds, the front curtain covering the sensor moves away, exposing the sensor to light for a set amount of time. When you have made the exposure, the second curtain moves in to block the light, thus ending the exposure.

To achieve shutter speeds faster than 1/200 second, the second curtain of the shutter starts closing before the first curtain has exposed the sensor completely. This means the sensor is actually exposed by a slit that travels along the height of the sensor. This allows your camera to have extremely fast shutter speeds, but it limits the flash sync speed because the entire sensor must be exposed to the flash at once to achieve a full exposure.

Front-curtain sync

Front-curtain sync mode is the default mode for your camera when you are using the built-in flash or one of Nikon's dedicated Speedlights. With Front-curtain sync, the flash fires as soon as the shutter's front curtain fully opens. This mode works well with most general flash applications.

When you set the Shooting mode to Programmed auto (**P**) or Aperture-priority auto (**A**), the shutter speed is automatically set to between 30 seconds and 1/60 second, depending on your setting on ✐ e2. If you attach an external Speedlight and you select one of the Auto FP settings in ✐ e2 when in Manual (**M**) or Shutter-priority auto mode (**S**), you can set the shutter speed up to 1/320 second, albeit at reduced output levels.

Front-curtain sync works well when you're using relatively fast shutter speeds. However, when you're using **S** and the shutter is slowed down (also known as *dragging the shutter* in flash photography) — and especially when you're photographing moving subjects — Front-curtain sync causes your images to have an unnatural-looking blur in front of them. Ambient light reflecting off the moving subject creates this effect.

When doing flash photography, your camera is actually recording two exposures concurrently: the flash exposure and the ambient light. When you're using a faster shutter speed in lower light, the ambient light usually isn't bright enough to have an effect on the image. When you slow down the shutter speed substantially, it allows the ambient light to be recorded to the sensor, causing ghosting. *Ghosting* is a partial exposure that usually appears transparent on the image.

Ghosting causes a trail to appear in front of the subject because the flash freezes the initial movement of the subject. Because the subject is still moving, the ambient light records it as a blur that appears in front of the subject, creating the illusion that it's moving backward. To counteract this problem, you can use Rear-curtain sync mode, which I explain later.

Slow sync

When doing flash photography at night, your subject is often lit well, but the background appears completely dark. Slow sync mode helps take care of this problem. In Slow sync mode, the camera allows you to set a longer shutter speed (up to 30 seconds) to capture some of the ambient light of the background. This allows the subject and the background to be more evenly lit, and you can achieve a more natural-looking photograph.

Auto FP High-Speed Sync

Although the D600 has a top-rated sync speed of 1/200 second, Nikon has built in a convenient option in ✔ e1 that allows you to use a flash at shutter speeds faster than the rated sync speed. This is called Auto FP High-Speed Sync (the FP stands for focal plane, as in the shutter). Setting ✔ e1 to Auto FP allows you to shoot the built-in flash at 1/320 second and other compatible Speedlights (SB-910, SB-900, SB-800, SB-700, and SB-600) to a maximum of 1/4000 second. Earlier I stated that the sensor must be fully exposed to receive the full flash exposure and that's limited to 1/250 second, so how then does Auto FP flash work?

Instead of firing one single pop, the flash fires multiple times as the shutter curtain travels across the focal plane of the sensor (hence the Auto FP). The only drawback is that your flash power, or Guide Number (GN), is diminished, so you may need to take this into consideration when doing Manual flash calculations.

Auto FP is a useful feature. It's mainly used when shooting in brightly lit scenes using fill flash. An example would be shooting a portrait outdoors at high noon; of course, the light is very contrasty and you want to use fill flash, but you also require a wide aperture to blur out the background. At the sync speed of 1/250 second, ISO 100, your aperture needs to be at f/11. If you open your aperture to f/2.8, you then need a shutter speed of 1/8000 second. This is possible using Auto FP.

TIP You can use Slow sync mode in conjunction with Red-Eye Reduction mode (✦◉) for night portraits.

TIP When you use Slow sync mode, be sure the subject stays still for the whole exposure to avoid ghosting. With longer exposures you can use ghosting creatively.

Red-Eye Reduction

When using on-camera flash, such as the built-in flash, you often get the red-eye effect. This occurs because the pupils are wide open in the dark, and the light from the flash is reflected off the retina and back to the camera lens. Fortunately, the D600 offers a Red-Eye Reduction mode (✦◉). When you activate this mode, the camera either turns on the AF-assist illuminator (when using the built-in flash) or fires some preflashes (when using an accessory Speedlight), which causes the pupils of the subject's eyes to contract. This reduces the amount of light from the flash that reflects off the retina, thus reducing or eliminating the red-eye effect.

Rear-curtain sync

When using Rear-curtain sync mode, the camera fires the flash at the end of the exposure just before the rear curtain of the shutter starts moving. This is useful when you're taking flash photographs of moving subjects. Rear-curtain sync mode allows you to more accurately portray the motion of the subject by causing a motion blur trail behind the subject rather than in front of it, as is the case with Front-curtain sync mode. You can also use Rear-curtain sync mode in conjunction with Slow sync mode.

6

> **NOTE** Rear-curtain sync mode is available in all exposure modes (**P**, **S**, **A**, and **M**); Rear-curtain slow sync mode is available only in **P** or ⓐ mode.

Flash Compensation

When you photograph subjects using flash, whether you're using the built-in flash on your D600 or an external Speedlight, there may be times when the flash causes your principal subject to appear too light or too dark. This usually occurs in difficult lighting situations, especially when you use i-TTL metering. Your camera's meter can be fooled into thinking the subject needs more or less light than it actually does. This can happen when the background is very bright or very dark, or when the subject is off in the distance or very small in the frame.

Flash Compensation allows you to manually adjust the flash output while still retaining i-TTL readings so your flash exposure is at least in the ballpark. With the D600, you can vary the output of your built-in flash's TTL setting (or your own manual setting) from –3 Exposure Value (EV) to +1 EV. This means that if your flash exposure is too bright, you can adjust it down 3 full stops under the original setting. Or if the image seems underexposed or too dark, you can adjust it to be brighter by 1 full stop.

Press the Flash Compensation button (🔲) and rotate the Sub-command dial to apply Flash Compensation.

Creative Lighting System Basics

The Creative Lighting System (CLS) is what Nikon calls its proprietary system of Speedlights and the technology that goes into them. The best part of CLS is the ability to control Speedlights wirelessly, which Nikon refers to as Advanced Wireless Lighting (AWL).

AWL allows you to get your Speedlights off-camera so that you can control light placement like a professional photographer would do with studio-type strobes.

To take advantage of AWL, all you need is your D600 and at least one remote Speedlight, an SB-900, SB-800, SB-700, SB-600, or SBR-200.

You can use the built-in flash of the D600 as a commander, also referred to as a *master flash*. Communications between the commander and the remote units are accomplished by using pulse modulation. *Pulse modulation* means that the commanding Speedlight fires rapid bursts of light in a specific order. The pulses of light are used to convey information to the remote group, which interprets the bursts of light as coded information. The commander tells the other Speedlights in the system when and at what power to fire. You can also use an SB-700, SB-800, or SB-900 Speedlight or an SU-800 Commander as a master. This allows you to control three separate groups of remote flashes and gives you an extended range.

This is how CLS works in a nutshell:

1. **The commander unit sends instructions to the remote groups to fire a series of monitor preflashes to determine the exposure level.** The camera's i-TTL metering sensor reads the preflashes from all the remote groups and takes a reading of the ambient light.

2. **The camera tells the commander unit the proper exposure readings for each group of remote Speedlights.** When the shutter is released, the commander, via pulse modulation, relays the information to each group of remote Speedlights.

3. **The remote units fire at the output specified by the camera's i-TTL meter, and the shutter closes.**

All these calculations happen in a fraction of a second as soon as you press the shutter-release button. It almost appears to the naked eye as if the flash just fires once. There is little lag-time waiting for the camera and the Speedlights to do the calculations.

CAUTION The Nikon SB-400 cannot be used as a remote unit.

Given the ease of use and the portability of the Nikon CLS, I highly recommend purchasing at least one (if not two) Speedlights to add to your setup.

Light Modifiers

When you set up a photographic shot, you are building a scene using light. For some images, you may want a hard light that is very directional; for others, a soft, diffused

6

light works better. Light modifiers allow you to control the light so you can direct it where you need it, give it the quality the image calls for, and even add color or texture to the image. There are many kinds of diffusers, with the following being the most common:

▶ **Umbrella.** The photographic umbrella is used to soften the light. You can either aim the light source through the umbrella or bounce the light from the inside of the umbrella, depending on the type of umbrella you have. Umbrellas are very portable and make a great addition to any Speedlight setup.

▶ **Softbox.** These also soften the light and come in a variety of sizes, from huge 8-foot softboxes to small 6-inch versions that fit right over your Speedlight mounted on the camera.

▶ **Reflector.** These are probably the handiest modifiers you can have. You can use them to reflect natural light onto your subject or to bounce light from your Speedlight onto the subject, making it softer. Some can act as diffusion material to soften direct sunlight. They come in a variety of sizes from 2 to 6 feet and fold up into a small, portable size. I recommend that every photographer have a small reflector in his or her camera bag.

Working with Live View and Video

Live View and video are now standard features on all of Nikon's current dSLRs, and when Nikon released the D600, it had pretty much perfected them. Luckily, this technology — with features such as full 1080p HD video and HDMI output for external monitors and the ability to record uncompressed video straight to a hard drive — has trickled down to the D600, so great full-frame video is available to D600 filmmakers. No longer are you stuck with what is essentially a fully automatic point-and-shoot video camera as you were with previous models; now you can adjust the settings directly on screen without needing to access the options in the menu. The D600 is a viable, compact HD video camera that you can rely on to produce professional-quality HD video.

Many filmmakers are turning to dLSR cameras because of their portability and wide selection of lenses.

Live View Overview

Live View (⌷Lv) is simply a live feed of what is being projected through the lens onto the sensor. This live feed can also be used to produce a video. First things first: to enter ⌷Lv, you must press the Live View button (⌷Lv). Next, to shoot stills you must switch the Live View selector to Live View photography (📷), and to shoot video you must switch the selector to Live View movie (🎥).

When you use ⌷Lv, shooting stills and shooting videos is very similar. Although each feature has some options that the other doesn't, I'm first going to cover the options they *do* have in common.

Focus modes

The D600 offers two different focus modes when using Live View: still photography (📷) or video (🎥). These modes are different although similar to the ones you find when using the traditional through-the-viewfinder shooting method. You can quickly change the focus modes by pressing the focus mode button and rotating the Main Command dial. There are two modes to choose from: Single-servo AF (AF-S) or Full-time-servo AF (AF-F). The third option is simply changing the focus mode switch to Manual and focusing manually.

Single-servo AF

This mode is the same as using AF-S when shooting stills traditionally with the view-finder method. Press the multi-selector ▲, ▼, ▶, or ◀ to move the focus point to your subject, and then half-press the shutter-release button to focus. When set to 📷, the shutter doesn't release until the camera detects that the scene is in focus. Using 🎥, you half-press the shutter-release button to bring it in focus and then press the Movie record button to start recording video. Note that unlike in still photography, the scene doesn't have to be in focus to start recording video. You can start recording out of focus and then half-press the shutter-release button to focus in for effect. Once the camera has locked focus, it stays focused at that distance unless you press the shutter-release button again.

NOTE Be sure that the focus selector lock switch is in the unlocked position before attempting to move the focus point.

For still photography, I recommend using 🔲 for stationary subjects like portraits, still life, products, and landscapes.

For video, you need to be sure that your subject isn't moving backward or forward by a large margin, especially if you're using a wide aperture for shallow depth of field. Even the slightest change in distance can cause the subject to go out of focus. This setting is good for doing interviews or shooting scenes where there is not much subject movement.

Full-time-servo AF

Full-time-servo focus mode (🔲) allows the camera to focus continuously while using 🔲 mode and when using 🎥 mode (similar to Continuous-servo AF [🔲]). Even though the camera focuses continuously when using 🔲 mode, the scene must be in focus before the shutter can be released.

When using 🔲 while recording video, you should be aware that the camera often hunts for focus, especially if you are moving or panning the camera. This can cause the video to go in and out of focus during your filming, which can cause your videos to look unprofessional.

The Autofocus modes, 🔲 and 🔲, operate in conjunction with the AF-area modes, which are covered in the next section.

AF-area modes

To make the 🔲 focusing quicker and easier, Nikon gives you a few different options for AF-area modes. The AF-area modes are different from the traditional through-the-viewfinder shooting AF-area modes. You can quickly change them by pressing the focus mode button and rotating the Sub-command dial. There are four options that are outlined here.

> **NOTE** All AF-area modes are disabled when you set the camera or lens to manual focus or when you attach a manual focus lens to the D600.

▶ **Face-priority AF.** Use the Face-priority AF mode (🔲) for shooting portraits or snapshots of the family. You can choose the focus point, but the camera uses face recognition to focus on the face rather than something in the foreground or

background. This can really be an asset when shooting in a busy environment, such as when a lot of distracting elements are in the background. When the camera detects a face in the frame, a double yellow border is displayed around the AF area. If the D600 detects more than one face (the camera can read up to 35 faces), then it chooses the closest face as the focus point. You can use the multi-selector to choose a different face if you desire. When you use this mode to shoot group shots, I suggest using an aperture of f/5.6 or smaller to ensure greater depth of field to get all the faces in focus.

▶ **Wide-area AF.** The Wide-area AF mode (⬛) makes the area where the camera determines focus from about four times the size of the Normal-area AF mode (⬛). This is good when you don't need to be very critical about the point of focus in your image. For example, when shooting a far-off landscape, you really only need to focus on the horizon line. This is a good general mode for everyday use. You can move the AF area anywhere within the image frame.

When using ⬛, ⬛, or ⬛ in ⬛, press ⊛ to quickly return the AF area to the center of the frame.

▶ **Normal-area AF.** The Normal-area AF mode (⬛) has a smaller AF point, and you use it when you need to achieve focus on a very specific or precise area within the frame. This is the preferred mode to use when shooting with a tripod; when shooting macros, still life, and similar subjects; and when shooting portraits that require a more precise focus than ⬛ mode provides (generally portraits are focused on the eye closest to the camera).

▶ **Subject-tracking AF.** The Subject-tracking AF mode (⬛) is an interesting fea-ture, especially when used in conjunction with video. Use the multi-selector to position the AF area over the top of the main subject in the image. Focus on the subject, and then press ⊛ to start tracking the subject. The AF area follows the subject as it moves around within the frame. Be aware, however, that this fea-ture works best with slow to moderately paced subjects that stand out from the background. When using this mode with very fast-moving subjects, the camera tends to lose the subject and lock onto something of a similar color and bright-ness within the frame. This mode also becomes less effective as the amount of light decreases. To disable ⬛, simply press ⊛. This resets the AF area to the center. To reactivate ⬛, press ⊛ again.

Live View Still Photography

As you may already know, the image from the lens is projected to the viewfinder via a mirror that is in front of the sensor. There's a semitransparent area in the mirror that acts as a beam splitter, which the camera uses for its normal phase-detection AF. For ⟨Lv⟩ to work, the mirror must be flipped up, which makes phase-detection AF unusable, so the camera uses contrast detection directly from the sensor to determine focus. This makes focusing with ⟨Lv⟩ a bit slower than focusing normally. In addition, when you're shooting stills, the mirror must flip down and back up, which takes some extra time. This makes ⟨Lv⟩ a challenging option to use when shooting moving subjects or events such as sports, where timing is the key element in capturing an image successfully.

That being said, ⟨Lv⟩ is a great option when shooting in a controlled environment or studio setting, especially when using a tripod. You can move the focus area anywhere within the frame; you're not limited to the tightly packed 39-AF-point array. Using ⟨Lv⟩ also allows you to achieve sharper images when doing long exposures because the mirror is already raised, eliminating any chance of mirror slap, which can sometimes cause images to blur slightly when shooting exposures longer than 1/2 second.

> **TIP** Keep in mind that when using Live View handheld, holding the camera at arm's length increases the risk of blurry images due to added camera shake. Keep your elbows close to your sides for added stability.

Shooting still photographs when using ⟨Lv⟩ is very simple. Simply flip the Live View Selector switch to ⟨◻⟩ and press ⟨Lv⟩. Now you're ready to shoot. Use the multi-selector ▲, ▼, ▶, or ◀ to position the focus point. When using ⟨AF-S⟩, half-press the shutter-release button to focus; when using ⟨AF-F⟩, wait until focus is achieved, and then fully press the shutter-release button to take the picture.

> **NOTE** When using ⟨AF-F⟩, pressing the shutter-release button causes the camera to refocus before actually taking the photo.

Here are a few things to know about the display when using ⟨Lv⟩ for still photography:

▶ **Playback button (▶).** Pressing this button allows you to review your images (or videos). Pressing it again returns you to Lv.

▶ **Menu button (MENU).** Pressing this button allows you to access the menu system. Not all options are available to you. Press it again to return to Lv.

▶ **Retouch/Picture Control button (⊡/⊞).** Press this button to change or adjust the Picture Controls. Press ▲ and ▼ to select the Picture Control, and then press ⊛ to set and return to Lv. Press ▶ to adjust the Picture Control, as discussed in Chapter 2. Press ⊛ to accept any changes. Press the Delete button (🗑) to reset any changes you have made to default, or press ⊡ to cancel and return to Lv.

▶ **Help/Protect/White balance button (?⊶/WB).** Press this button and use the Main Command dial to change the WB settings, and the Sub-command dial to fine-tune as normal. Press ▲ and ▼ to brighten or dim the LCD monitor.

▶ **Zoom in button (🔍).** Press this button to zoom in on your focus point to check focus. Press the Thumbnail button ⊞ to zoom out when you're back to the standard framing; the shooting info bar reappears at the bottom of the screen.

▶ **Zoom out/Thumbnail/ISO button (⊞/ISO).** By default, pressing this button and rotating the Main Command dial allows you to manually change the ISO setting, and rotating the Sub-command dial allows you to turn the ISO-A setting on and off.

▶ **Info button (ℹ).** Pressing this button toggles you through a few different views of the Lv screen. From the default setting, press it once and the setting's icons are removed from the top of the screen (your shooting info is still displayed at the bottom). Press it a second time to display a composition grid, press it a third time to display the virtual horizon, and press the button a fourth time to bring you back to the default.

CAUTION If you change the display using the ℹ button, the changes remain in effect until you press ℹ to change it back to the default display. Exiting Lv and turning the camera on and off does not reset the display to default.

▶ **AE-L/AF-L button (⊞).** This button functions as assigned in Custom Settings menu f4 (✐ f4) when you press it. The Live View photography display is a bit different than what you would see looking through the viewfinder, although it displays some of the same information. The bottom of the frame looks a lot like

the toolbar from the viewfinder, albeit with only the essential shooting informa-
tion. Here's what you find:

- **Metering mode**

- **Shutter speed**

- **Aperture**

- **ISO setting**

- **Remaining shots**

At the top of the Live View feed are a number of different setting indicators. Although
most of these settings should be familiar to you, Live View is different from your tra-
ditional view through the viewfinder:

▶ **Focus point.** Right in the center of the frame is the square focus point. Move
this around by using the multi-selector ▲, ▼, ▶, or ◀.

▶ **Shooting mode.** Whatever shooting mode or scene mode you have selected
shows up in the top-left corner. When changing between scene modes, simply
rotate the Main Command dial.

▶ **Autofocus mode.** The two AF modes are displayed next: **AF-S** and **AF-F**. Switch
between these modes by pressing the AF mode button and rotating the Main
Command dial.

▶ **AF-area mode.** One of the four AF-area modes are displayed next: ⬚NORM, ⊞, 🎭,
or ⬚WIDE.

▶ **Active D-Lighting.** This shows your current setting for the Active D-Lighting
option, which you set in the Shooting menu (📷).

▶ **Picture Controls.** This shows your Picture Control setting: ⬚SD, ⬚NL, ⬚VI, ⬚MC,
⬚PT, or ⬚LS.

▶ **White balance setting.** This is where the current white balance setting is
displayed: AUTO, ☀, ☀, ☀, ⚡, ☁, ⬚, K, and PRE.

▶ **Image size/Quality.** This is where your file size and file formats are displayed:
RAW, JPEG, TIFF, and the size if it applies to the file format. You must change
these settings prior to entering ⬚Lv by pressing ⬚/QUAL and using the Main
Command dial to change the file format and JPEG compression, and the Sub-
command dial to change the size when shooting JPEG.

▶ **Image area.** These display your image area: ⬚FX or ⬚DX.

NOTE When you select **M** as the exposure mode, an exposure meter appears in the bottom-right corner of the image area.

NOTE A countdown timer appears near the top left (under the exposure mode display) when the Lv is set to end in order to protect the circuitry from overheating or if ✎ c4 is set to any option other than No limit.

Movie Live View

You can also use the Live View feature of the D600 to capture HD video. The Movie Live View feature operates very similarly to Live View for still photography. Simply flip the Live View Selector switch to 🎥, and press Lv. The mirror flips up and you're ready to start filming. Use the multi-selector ▲, ▼, ▶, or ◀ to position the focus point. When using AF-S, half-press the shutter-release button to focus; when using AF-F, wait until you achieve focus, and then press the Movie record button to start recording.

CAUTION Fully depressing the shutter-release button causes the D600 to shoot a still frame and ends video recording.

NOTE You can set the shutter-release button to record video in ✎ g4.

When using Lv in 🎥, the camera functions similarly to Live View except that when you press ?/ₒₙ/**WB**, the monitor brightness indicator and microphone sensitivity appear (on the right and left, respectively). At the default setting, while holding ?/ₒₙ/**WB**, press ▲ to brighten the monitor and ▼ to dim the monitor. Pressing ◀ switches to the microphone sensitivity setting adjustment (🎙). Use ▲ and ▼ to adjust the sensitivity (you can set it from 1 to 20, Auto, or Off). If headphones are attached, pressing ◀ again allows you to adjust the volume of the headphones (𝛀) You can adjust them from 1 to 30, or Off.

CAUTION It is very important to note that when you select one of the settings — monitor brightness (☼), 🎙, or 𝛀 (if applicable) — the last selected setting becomes the default. You must manually select the setting you want to change using ◀ or ▶.

Why Shoot Video with a dSLR?

Not very long ago, video in dSLRs was considered a gimmick so that more peo- ple would buy dSLRs not only to take pictures but also to shoot home videos just like a compact camera. However, as the technology has advanced, dSLR videog- raphy has become a viable form of filming, not only for family events but also for television shows and even feature-length films meant for the big screen. This is because smaller dSLR cameras have features that outweigh some advantages of a dedicated video camera. Here are some of the major advantages:

▶ **Price.** dSLR cameras are much cheaper than a mid- to pro-level HD video camera.

▶ **Image quality.** The D600's FX-sized sensor also allows the camera to record video with less noise at high sensitivities than most video cameras can.

▶ **Interchangeable lenses.** You can use almost every Nikon lens on the D600. And, while some HD video cameras take Nikon lenses, you need an expen- sive adapter, and you lose some resolution and the ability to get a very shal- low depth of field.

▶ **Depth of field.** You can get a much shallower depth of field with dSLRs than you can with standard video cameras when using a lens with a fast aperture, such as a 50mm f/1.4. Most video cameras have sensors that are much smaller than the sensor of the D600, which gives them a much deeper depth of field. A shallow depth of field gives videos a more professional, cinematic look.

The Movie Live View display is a bit different than what you see in Live View, but it contains some of the same information. For example, you still have the bottom toolbar with almost the same information:

▶ **Metering mode**

▶ **Shutter speed**

▶ **Aperture**

▶ **ISO setting**

▶ 🎥

Displayed over the 🎬 feed are a num-
ber of different setting indicators,
most of which should be familiar to
you; however, a few are a little differ-
ent from your traditional through-the-
viewfinder settings:

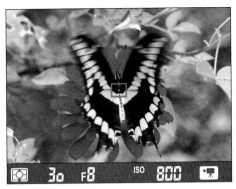

7.1 Movie Live View display

▶ **Focus point.** Right in the center
of the frame is the square focus
point. Move this around by using
the multi-selector ▲, ▼, ▶,
or ◀.

▶ **"No movie" icon (📷).** The 📷
icon only appears when a movie can't be recorded — for example, if the mem-
ory card is full.

▶ **Autofocus mode.** Just like in 📷, there are two AF modes: AF-S and AF-F. Switch
between these modes by pressing the AF mode button and rotating the Main
Command dial.

▶ **AF-area mode.** Also like in 📷, you aren't limited to the 39 AF points; you can
move the focus point anywhere within the frame. The options for the AF-area
modes are the same as for Live View (covered earlier in this chapter). Change
these modes by rotating the Sub-command dial.

NOTE AF mode and AF-area modes do not display when you switch the camera
to Manual focus or you attach a manual-focus, non-CPU lens.

▶ **Picture Controls (✏/🗑).** Press this button to change or adjust the Picture
Controls. Press ▲ and ▼ to select the Picture Control, then press 🆗 to set and
return to ⓛⓥ. Press ▶ to adjust the Picture Control as discussed in Chapter 2.
Press 🆗 to accept any changes. Press 🗑 to reset any changes you have made
to the default, or press ✏ to cancel and return to ⓛⓥ.

▶ **White balance setting.** This is where the current white balance setting is dis-
played: AUTO, ☀, ☁, ☀, 🔆, 🌤, 📷, 🅚, and PRE.

▶ **Frame size/frame rate.** This is where the movie size and frame rate are dis-
played. You can change these settings in the 📷 menu under the Movie settings
submenu.

▶ **Time Remaining.** This displays how much time you have left for the video. The time can differ, depending on the movie quality and the size or remaining space on the memory card.

▶ **Destination.** This indicates what card slot the movies are being recorded to: 1 or 2.

▶ **Guide.** The Guide is located just above the toolbar at the bottom of the screen. This gives you the information you need to adjust the ☼, 🔊, and 🎧 volume (discussed earlier); when using ⊕, it shows that you need to press ⊛ to activate it.

Frame Size and Frame Rate

The D600 offers two HD video sizes: 1920 × 1080 and 1280 × 720. These are more commonly referred to as 1080p and 720p. The *p* is a term that stands for progressive. If you're familiar with HD, you've probably heard the terms *progressive* and *interlaced*. Your D600 has an HDMI (High-Definition Multimedia Interface) output setting (found in the Setup menu [𝗬]) that lets you choose between progressive and interlaced resolutions. So, what's the difference? Interlaced video scans every other line that makes up the picture, though the picture appears as if it is being displayed all at once. Progressive scanning displays single lines of the image going from top to bottom. As with interlaced technology, all of this happens too fast for the human eye to detect the separate changes, and so everything appears to happen all at once. As with playback, when recording, the D600 records progressively down the pixel lines.

The 1080p video size has more resolution and therefore holds more detail and has less noise in low light. Most professionals prefer to shoot in 1080p and downsize later if necessary. There are, however, some reasons for shooting in 720p. For example, the file sizes are smaller and, if you're only shooting videos to post to the web, you don't really need the higher resolution. If you plan on making DVDs to show on an HDTV, then the extra resolution of 1080p is going make quite a bit of difference in quality. So it boils down to what your intended output is.

An important part of video capture is *frame rate*. This is the rate at which the still images are recorded, and it is expressed in terms of frames per second (fps). At the end of the resolution number (1080 or 720), there is another number in subscript (24, 25, 30, 50, or 60). This subscript number is the frame rate. Video capture involves recording still images, linking them together, and then playing them back one after

another in sequence. This allows the still images to appear as if they're moving. Most video cameras capture video at 30 or 60 fps. A rate of 30 fps is generally considered the best for smooth-looking video that doesn't appear jerky. Shooting at 24 fps is the minimum rate required to fool the human eye into seeing seamless motion. This is the frame rate that film-based motion pictures use, so 24 fps gives HD video a cinema-like quality.

The Nikon D600 shoots full 1080p HD video at 30, 25, or 24 fps. You can record 720p at 60, 50, 30, or 25 fps. You can set this rate in the ◘ menu under the Movie settings option. Select 24 fps for the cinematic look or 30 fps for a smoother look. The 25 and 50 fps options are for videos that will be played back on PAL devices (the analog TV encoding system used in Europe). Shooting at 60 fps allows you to slow the video to 30 fps for slow motion in editing software. This allows the slow-motion effect to blend in seamlessly when combined with other 30 fps video. Be aware that this only works seamlessly when both segments are recorded in 720p or if you downsize your 1080p 30 fps clips to 720p using software.

Video Setup

Using the video feature on the D600 is quite simple — flip the Live View Selector switch to 🎥 and press ⌷Lv⌷, focus, and press the Movie record button. However, there are some important settings to consider before you start recording:

▶ **Frame size/frame rate.** Choose the image size based on your intended output and your preferred frame rate. See the previous sidebar details on frame rate and size. You have the following choices:

- 1920 × 1080; 30 fps (1080 30)
- 1920 × 1080; 25 fps (1080 25)
- 1920 × 1080; 24 fps (1080 24)
- 1280 × 720; 60 fps (720 60)
- 1280 × 720; 50 fps (720 50)
- 1280 × 720; 30 fps (720 30)
- 1280 × 720; 25 fps (720 25)

▶ **Movie quality.** You have two choices: High and Normal. The difference all comes down to bit rate. At higher bit rates, more information is being recorded, resulting in better color rendition and dynamic range; of course, higher bit rates also mean more data and larger file sizes. Keep in mind that High quality movie clips are limited to 20 minutes and Normal quality clips can be up to 29 minutes and 59 seconds. Again, your choice comes down to your intended output. For the web, using Normal quality is fine; for viewing on HDTVs, stick with High quality.

▶ **Microphone.** The three microphone settings are Auto, Manual, and Off. Auto works for most general filming, but for a more consistent sound in a controlled environment, you can set the microphone sensitivity manually. You can monitor the levels when filming, and you can also adjust this setting on the Live View screen by pressing **?⊶/WB** (and pressing ◀ if necessary).

▶ **Picture Control.** As it does with your still images, the D600 applies Picture Control settings to your movie. You can also create and use Custom Picture Controls that fit your specific application. One of my favorites is a Custom Picture Control that I created called Raging Bull; it uses the Monochrome Picture Control (⊡MC) with added contrast and the yellow filter option (see Figure 7.2). This gives me a black-and-white scene that's reminiscent of the Martin Scorsese film of the same name. Before you start recording your video, decide which Picture Control you want to use for your movie.

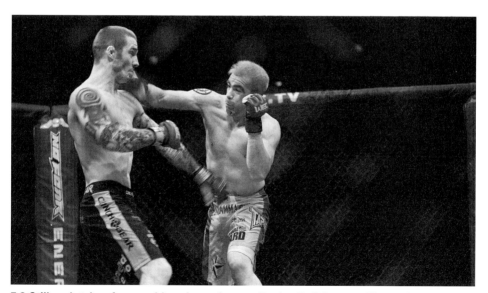

7.2 Still grab taken from a video shot using my Raging Bull Custom Picture Control.

225

Shutter Speed

In filmmaking, there's a concept called the 180-degree shutter rule. Without getting into why it has this name, the 180-degree shutter rule states that your shutter speed should be about twice your frame rate for natural-looking images. So 1080⁄₂₄ and 720⁄₂₄ should use a shutter speed of 1/50 second, 1080⁄₃₀ and 720⁄₃₀ at 1/60 second, and 720⁄₆₀ at 1/125 second. This gives the video just enough blur to make it look natural to human eyes.

Slower shutter speeds give the video a smeared appearance, although the D600 avoids this by not allowing you to set the shutter speed slower than the frame rate.

On the opposite end of the spectrum, faster shutter speeds can cause the video to appear slightly jerky. This is because just as when shooting a still image, the action is frozen (remember, videos are just stills played in succession), and as the subject moves through the frame, there is no motion blur to make it look more natural to the eyes. Of course, you can use the jerky, fast shutter speed as an effect as well. Movies such as *Saving Private Ryan* and *Gladiator* used this effect in the action scenes.

▶ **Exposure mode.** This is a *very* important setting. The exposure mode you choose determines who chooses the settings, you or the camera.

- **Programmed auto (P) and Shutter-priority auto (S).** These modes let the camera make all the exposure choices for you. When you press 🔲, the camera sets the shutter speed, aperture, and ISO sensitivity. While you're filming, if the lighting changes, the camera adjusts the exposure by adjusting the ISO sensitivity; if the scene becomes too bright, the shutter speed is raised to keep a good exposure (unless you lock the exposure using 🔒). The only control you have over the exposure is that you can adjust exposure compensation (🖾).

- **Aperture-priority auto (A).** This mode allows you a little more control. You can set the aperture to control the depth of field, but the camera automatically controls the shutter speed and the ISO sensitivity. You can also use 🖾 to brighten or darken the image.

- **Manual (M).** If you're serious about video, this is the exposure mode you should be using. This mode lets you control the exposure by adjusting the aperture, shutter speed, and ISO setting yourself. It takes a little more time to set up, but this allows you to control not only the depth of field but also the amount of noise and the shutter speed effect if you want.

Video Playback

Playing back your videos is super easy. Press ▶ and scroll through the videos and stills as normal. When the video is displayed on the LCD screen, press ⓞ to start playback. Press ▲ to stop, ▼ to pause, ◀ to rewind, and ▶ to fast-forward. Use ⊕ to raise the volume and ⊖ to lower the volume.

Connecting your camera to an HDTV or HD monitor displays what is on the LCD, and the options are exactly the same.

In-Camera Editing

You can make simple edits to your videos in-camera; for more serious edits, you need to think about using third-party software, such as iMovie for Mac or Adobe Premiere Elements for Mac or PC. These are great affordable, entry-level editing programs, but as you progress, you may need to step up to more powerful programs such as Final Cut Pro from Apple or Adobe Premiere Pro. In-camera, you have three options: choose the Start frame, choose the End frame, and grab a still image from the video. Each edit you make is saved as a new file, so there's no need to worry about making any permanent changes to your original file. To edit the video, follow these steps:

1. **Press the MENU button and use the multi-selector to select the Retouch menu (⊿).** You can also press ▶, select the video, and press ⊿.

2. **Select Edit Movie and press ⓞ or ▶ to view menu options.** (Pressing ⊿ from the playback screen automatically brings up the options.)

3. **Choose the edit you want to make and press ⓞ or ▶.** The options are Choose start point, Choose end point, or Save selected frame. A menu appears with all videos that are saved to the current card. (When the movie is selected directly from the playback screen, this option doesn't appear.)

4. **Use the multi-selector to scroll through the available videos and press ⓞ when your video is selected.** The selected video is highlighted in yellow.

5. **Press ⊛ to begin playback and press ▲ at the point where you want to make the edit.** You can use ▼ to stop playback and ◄ or ► to go back or forward in the video clip.

6. **Press ▲ to make the edit.** I prefer to pause the movie by pressing ▼ so I can be absolutely sure it is where I want the edit to be. I then make the edit. The movie is automatically saved.

NOTE When viewing a movie file on playback, you can use the Sub-command dial to jump ahead in ten-second increments. If the clip is less than ten seconds long, it jumps to the end of the clip.

Using Index Points

Using ✎ g1, g2, or g3, you can assign a button to act as an index marker. This allows you to mark specific areas of the video where you may want to make a cut (you can use up to 20 index points per video). These index points are placed as you are filming when you press the specified button.

When playing your video back on the camera, you can rotate the Main Command dial to jump to an index point and pause the video. You can then press ⊠ to make edits. Use ▲ or ▼ to choose whether you want to make the index the start/end point or save the frame. Press ⊛ to make your selection or ▣ to cancel the edit.

If you select Choose start/end point when you press ⊛, you have the option of selecting the start point or end point; use ▲ or ▼ to highlight the start or end point, and then press ⊛. Press ▣ to cancel.

Once you select a starting and ending point, press **?/⊶/WB** and then ▲ to make the cut. You now have four choices:

▶ **Save as new file.** This allows you to keep the original unedited file. I recommend using this selection.

▶ **Overwrite existing file.** This replaces your original movie with the new edited version.

▶ **Cancel.** This ends the editing session and you can start over or skip to another movie.

▶ **Preview.** This allows you to watch the newly edited clip before deciding what option to choose.

Viewing and Shooting Using the HD Output

The D600 has a new 3.2-inch 921,000-dot TFT-LCD monitor. While the monitor loses a tiny bit of resolution to the D7000's monitor, it gains nearly a quarter-inch of real estate over the D7000. Using this monitor, you can play back your images for review, and you can also use the HDMI port to connect to an HD device to shoot stills and video without having to rely solely on the camera's small monitor. This allows you to view your images and movies with much more clarity.

The D600 offers you two different ways to view your images directly from the camera: you can simply press the Playback button (▶) or you can connect the camera directly to an HDTV or monitor. Gone from the D600 is the ability to connect the camera to a standard TV, which frees up some real estate for more practical uses such as headphone and microphone jacks.

Viewing images on the camera

To play back and review your images, start by pressing ▶. This brings up the current image. You can then use the multi-selector ◄ and ► to scroll through the images on the active memory card. Pressing the multi-selector ▲ or ▼ displays the photo information. How much information it displays depends on your settings in the ▶ menu – Playback display options.

There are a few other buttons that you can use during playback:

▶ **Delete (🗑).** Pressing this button brings up a confirmation dialog box asking whether you want to delete the current image. Press 🗑 again to permanently erase the photo.

▶ **Retouch/Picture Control (☑/🖼).** Pressing this button brings up the Retouch menu. Using these options, you can retouch and edit your images and save a copy to the memory card. You can also press ⊗ for the same options.

▶ **Help/Protect/White balance (?⊶/WB).** Pressing this button marks the image as protected and prevents it from accidentally being deleted. Note that this may also lock the file, preventing you from making changes to it on some computers. Once the image is protected, simply press the button again to remove protection status.

▶ **Zoom in (⊕)**. Press this button to zoom in on the image for a closer look to check for focus, sharpness, and so on. Once you're zoomed in on the image, you can use the multi-selector to navigate to different areas of the image. If faces are detected in the image, you can use the Sub-command dial to jump from face to face. Rotating the Main Command dial allows you to scroll through the other images on the card at the same magnification ratio.

▶ **Zoom out/Thumbnail/ISO (⊖/ISO)**. In default full-frame playback, pressing this button brings up thumbnail playback, which displays numerous smaller thumb-nails of the images. One press displays 4 thumbnails, two presses displays 9 thumbnails, and three presses displays 72 thumbnails. Pressing the button a fourth time brings up a calendar where you can select to view images that were taken on a particular date. When playback is in thumbnail mode, you can use the multi-selector to highlight an image, and you can then zoom in, delete, retouch, or protect the image. To exit thumbnail view, press ⊕/QUAL until you return to full-frame playback.

Viewing images on an HDTV

Being able to view your images and videos straight from the camera on your HDTV is a really nice feature. You can set up a slide show to show all your friends the photos you shot that day, or you can edit your photos using the Retouch menu straight from the camera while being able to view the images larger than life. If your HDTV is device control compatible (HDMI-CEC), you can also use the remote control to browse the images and camera menus. Isn't technology great?

This brings me to an important issue regarding connecting you camera to an HDTV that is CEC compatible. When the camera is connected to a CEC-compatible HDTV, the camera will only function in Playback mode *unless* you go into the Setup menu (⚡), select the HDMI option, select Device control, and then set it to Off.

NOTE If your HDTV is HDMI-CEC compatible, the camera displays CEC in place of the number of remaining frames.

When the Device control option is Off and the camera is connected to an HDTV, you see exactly what normally appears on the camera's monitor. Note that the camera monitor also continues to display as well.

In order to connect your D600 to an HD device, you need to purchase a Type C mini-pin HDMI connector from Nikon or the nearest electronics store.

Attaching the camera to your HDTV is a pretty simple procedure:

1. **Turn the camera off.** This can prevent static electricity from damaging your camera.

2. **Open the connector cover.** The connector cover is on the left side of the camera when the lens is facing away from you.

3. **Plug in the Type C mini-pin HDMI connector.** This cable is available separately from almost any electronics or camera store. Plug the cable into the HDMI out jack. This is the connection just below the USB port, and is clearly labeled.

4. **Connect the HDMI cable to the input jack of your HDTV.**

5. **Set your HDTV to the HD in setting.** This may differ, depending on your TV. See the owner's manual if you are unsure.

6. **Turn on the camera, and press the Playback button (▶).** The playback functions exactly the same as if you were looking at the LCD monitor.

CAUTION When connected to an HDMI-CEC device, the camera is not able to record video or still images.

Shooting video using an external HD device

With the HDMI output of the D600, you can connect the camera not only to your HDTV but also to an HD monitor using the same connector. This option allows you to view the video feed from your camera using a much larger display. There are many different HDMI displays, from small ones that you can mount on your hot shoe or a dSLR rail or cage support rig, to large tabletop versions made primarily for use as computer monitors.

There are a number of reasons why you may want to invest in an external HD monitor for your D600:

▶ **Focus.** Whether shooting stills or video, larger is always better when checking focus. A larger screen can give you more precision when selecting your focus point or when focusing manually. This is more important when shooting, especially when using a wide aperture for shallow depth of field and when performing focus pulls (switching focus from one subject to another while filming). These techniques require a sharp eye, and the small LCD isn't the best option for this.

▶ **Articulated screen.** As you know, the D600 isn't equipped with an articulated screen, making framing shots from odd angles much more difficult. Using an external monitor, you aren't tied to using the camera LCD when shooting, so you can shoot up high, down low, at an angle, and so on with greater ease.

▶ **Composition and framing.** Having a larger monitor helps you see the frame more clearly, allowing you to pay closer attention to details that aid you in framing and composition. For example, you can survey the scene for errant cords, or other unwanted objects in the background.

▶ **Great for multiple viewers.** In the studio or during a video shoot, you may have more than one person who needs to see the monitor at any given time — for example, an art director for shooting stills, or a cinematographer and a director when shooting video.

Advanced Topics

A number of advanced topics, such as tone mapping and working with off-camera flashes, are not covered in the D600 manual but are of interest to a lot of photographers using the D600. I have included these topics here to give you basic insight into some advanced photography techniques that you can easily accomplish with the D600 so that you can begin to take your photography to the next level.

Go beyond the basics with your D600.

U1/U2 User Settings

Although the manual briefly touches on the user settings, all you really get out of it is that you can set the D600 to certain parameters and recall them simply by setting the dial. While this information is certainly important, it lacks quite a bit of detail. The user settings are located on the Mode dial along with the rest of the exposure settings. You can rotate the Mode dial to U1 or U2 to access them in an instant.

To clarify exactly what these user settings are, I liken them to the camera's built-in scene modes, but with one *huge* difference — the user settings are scene modes that *you* program into the camera. Now, you can have a landscape, portrait, or close-up scene mode with exactly the settings you want, not just the preprogrammed, fully automatic settings that the scene modes provide, leaving you with almost no options.

The great thing about the U1/U2 user settings is that once you set the camera up and save the settings, you can instantly recall them. If you adjust the settings while shooting, you can return to your original settings by simply turning the camera off and on again, or by rotating the Mode dial, and then rotating it back again.

To be clear, the user settings save *every* setting as you have it in the camera. This means that if you set U1 to Manual exposure at f/2.8 for 1/125 second, then when you set the Mode dial to U1, it not only puts the camera in Manual exposure mode, but also recalls the exact exposure settings. The user settings even recall exactly where your focus point is located. This is a pretty handy feature if you have a couple of shooting scenarios that you use often. Keep in mind that the user settings don't apply to release modes, popping up the built-in flash, and Live View modes (⬛ and 🎥). However, the menu settings, flash sync settings, exposure settings, white balance, and Picture Controls are all saved for instant recall.

Applying the user settings is a very simple process:

1. **Apply camera settings.** For this step, I recommend resetting the camera to the default settings and going through the entire menu system from top to bottom, including AF modes, AF-area modes, metering modes, and flash sync modes (see Chapters 1 and 2 for details on what every menu item does). If you start from the ground up, you can be sure that every item is *exactly* how you want it. Changing settings willy-nilly can lead to surprises when shooting, which is exactly what the user settings are meant to avoid.

2. **Press the Menu button (MENU).** Use the multi-selector to navigate to the Setup menu (🔧).

3. **Use the multi-selector to navigate to Save user settings.** Press the OK button (⊙) or the multi-selector right (▶).

4. **Choose Save to U1 or Save to U2.** Press ⊙.

5. **Select Save settings to apply the user settings or Cancel to exit.** Press ⊙ to finish.

> **TIP** To reset the camera to the factory defaults, press and hold Q⊠/ISO and ⊞ for approximately 2 seconds until the LCD flashes blank for a moment. Then press **MENU**, go to the Custom Settings menu (✐), and select Reset custom settings. Press ⊙ or ▶, select Yes, and press ⊙.
>
> **8**

Okay, so now you know what the user settings are and how to save them, but what are you supposed to program into them? Well, it's a highly personal choice, and you will probably find that your settings do not necessarily reflect the same choices that others make for the same subjects. But to start you off, Tables 8.1 to 8.7 list a few of my personal settings. If I have not listed a setting, then it is set to the factory default. Note that these settings are starting points for these types of shots; I generally end up modifying one or more of these settings to adjust to any given shooting situation.

Table 8.1 Recommended User Settings for Portraits

	Exposure mode	A	f/1.4–2.8
	Metering mode	⊡	
	Focus mode	AF-S	
	AF-area mode	[□]	
	Release mode	S	
⌖			
	Image quality	RAW	
	White balance	Set according to light source	
	Set Picture Control	⊡PT	
	Color space	Adobe RGB	
	ISO sensitivity settings	Set according to needs	
✐			
	c1-Shutter-release button AE-L	On	
	d1-Beep	On	
	d2-Viewfinder grid display	On	

Table 8.2 Recommended User Settings for Portraits with Off-Camera Speedlight

	Exposure mode	🅰	f/1.4–2.8
	Metering mode	🔲	
	Focus mode	**AF-S**	
	AF-area mode	[▫]	
	Release mode	S	
📷			
	Image quality	RAW	
	White balance	Set according to light source	
	Set Picture Control	🔲PT	
	Color space	Adobe RGB	
	ISO sensitivity settings	Set according to needs	
✎			
	c1-Shutter-release button AE-L	On	
	d1-Beep	On	
	d2-Viewfinder grid display	On	
	e1-Flash sync speed	1/250 (Auto FP) [outdoors] 1/60 second [indoors]	
	e3-Flash cntrl for built-in flash	Commander mode	

Table 8.3 Recommended User Settings for Landscapes

	Exposure mode	🅰	f/11–22
	Metering mode	🔲	
	Focus mode	**AF-S**	
	AF-area mode	[▫]	
	Release mode	S	
	Auto bracketing	ON	3 frames /2EV
📷			
	Image quality	RAW	
	White balance	Set according to light source	
	Set Picture Control	🔲LS	

	Color space	Adobe RGB	
	ISO sensitivity settings	Set according to needs	
✎			
	a7-Built-in AF-assist illuminator	Off	
	c1-Shutter-release button AE-L	On	
	d1-Beep	On	
	d2-Viewfinder grid display	On	
	d10-Exposure delay mode	On [only when using tripod]	
	e6-Auto bracketing set	AE only	
	e7-Bracketing order	Under > MTR > over	

Table 8.4 Recommended User Settings for Sports and Action

	Exposure mode	**5**	1/250 second
	Metering mode	▣	
	Focus mode	AF-C	
	AF-area mode	[⬚]	9-point
	Release mode	Cₕ	
◘			
	Image quality	RAW	
	White balance	Set according to light source	
	Set Picture Control	⊠SD	
	Color space	Adobe RGB	
	ISO sensitivity settings	Auto	Minimum shutter speed – Auto/Faster
✎			
	a3-Focus tracking with lock-on	4	
	a5-Focus point wrap-around	On	
	a7-Built-in AF-assist illuminator	Off	
	d2-Viewfinder grid display	On	
	f4-Assign AE-L/AF-L	AF-ON	

8

Table 8.5 Recommended User Settings for Events with Accessory Speedlight On-camera, Indoor with Ambient Daylight

	Exposure mode	A
	Metering mode	▪▪
	Focus mode	AF-C
	AF-area mode	[▫]
	Release mode	S
📷		
	Image quality	RAW
	White balance	Auto
	Set Picture Control	▣SD
	Color space	Adobe RGB
	ISO sensitivity settings	400
✎		
	c1-Shutter-release button AE-L	On
	d2-Viewfinder grid display	On
	e1-Flash sync speed	1/60 second
	e4-Exposure comp. for flash	Background only
	f2-Assign Fn button	FV Lock
	f3-Assign preview button	Flash off

Table 8.6 Recommended User Settings for Events with Accessory Speedlight On-camera, Indoor with Low Light

	Exposure mode	M	1/15 second at f/5.6
	Metering mode	▪▪	
	Focus mode	AF-S	
	AF-area mode	[▫]	
	Release mode	S	
📷			
	Image quality	RAW	
	White balance	Auto	
	Set Picture Control	▣SD	
	Color space	Adobe RGB	
	ISO sensitivity settings	400	

	✎			
	c1-Shutter-release button AE-L	On		
	d2-Viewfinder grid display	On		
	e2-Flash shutter speed	1/15 second		
	e4-Exposure comp. for flash	Background only		
	f2-Assign Fn button	FV Lock		
	f3-Assign preview button	Flash off		

Table 8.7 Recommended User Settings for Concerts and Live Music

	Exposure mode	**M**	1/125 second at f/2.8
	Metering mode	⊡	
	Focus mode	**AF-C**	
	AF-area mode	[⊡]	
	Release mode	C$_H$	
📷			
	Image quality	RAW	
	White balance	Auto	
	Set Picture Control	**SD**	
	Color space	Adobe RGB	
	ISO sensitivity settings	Auto	Minimum shutter speed – Auto/Faster
✎			
	a3-Focus tracking with lock-on	4	
	a5-Focus point wrap-around	On	
	a7-Built-in AF-assist illuminator	Off	
	c1-Shutter-release button AE-L	On	
	d2-Viewfinder grid display	On	
	f4-Assign AE-L/AF-L	AF-ON	

Working with Off-camera Flashes

One advanced technique that has gained popularity in the past few years is off-camera flash photography. Often you will hear people use the new buzzword for this technique, "strobist," but make no mistake: professional photographers have been using off-camera flash almost since the day that flash powder was invented.

In pre-digital days, most amateur photographers shied away from off-camera flash photography, assuming that it was based on arcane knowledge passed down from professional photographers and that it was difficult to figure out the complex calculations required to get the perfect exposure. Amateur photographers didn't want to waste time and money processing film that may have badly exposed images.

When digital photography became affordable for most people in the early 2000s, ideas about using flash changed. They didn't have to worry about wasting film anymore and they could check their images instantly to see whether their flash exposures were good. This led to a steep increase in the use of off-camera flash. Right about this time, Nikon also came out with the Creative Lighting System (CLS), which for the first time allowed off-camera flash to be done wirelessly with automatic TTL metering.

Now off-camera flash has hit an all-time high, and many photographers are applying this technique to create more professional images, as well as push the envelope to produce more creative and innovative images than ever before. This has all come about, in my opinion, because photographers, not being constrained by the cost of buying and developing film, have been more willing to experiment with light and to create innovative results.

I'm not going to cover setting up the Nikon Creative Lighting system, because there are whole books on that subject (such as *Nikon Creative Lighting System Digital Field Guide* from Wiley), but I'm going to cover the basics of putting together a portable kit that will work for just about any subject.

Gear

You don't need a lot of gear to achieve great lighting using off-camera flash. You already have the expensive part of the kit, the D600 and a lens. You can build a small off-camera lighting kit for about $100 to $200 if you want to go the inexpensive route, or you can spend hundreds or even thousands of dollars depending on how far you

want to take it. To get started, let's go with a bare-bones kit, although make no mis-
take, a simple one-light setup is all you need to make some pretty amazing images.

**8.1 This is my portable lighting kit complete with Speedlights, light stands, and
umbrellas in a military rifle bag. I can sling the bag right over my shoulder for on-the-go
photo shoots.**

Speedlights or flashes

So, you have the camera and the lens; now you need a flash. If you're looking into
wireless shooting, you've already got a step up, as the D600 built-in flash acts as a
commander and can trigger up to two separate groups of off-camera Nikon Speedlights
wirelessly. You can add as many Speedlights per group as you can afford, but gener-
ally, one to three Speedlights per group is more than enough light. At this point for
fully automated TTL wireless flash, all you need is a dedicated Nikon Speedlight, such
as an SB-600, SB-700, SB-800, SB-900, or SB-910. You can program any one of these
flashes to work as a remote flash with the built-in flash of the D600. Nikon has discon-
tinued the SB-600, SB-800, and SB-900, but they are still widely available on the used
market and work perfectly with the D600. The main reason to go with the Nikon CLS
flashes is that you can completely control them from a central location (your camera).
You can place the flash in a hard-to-reach area and adjust the output without leaving
your shooting location.

CAUTION There are now a number of third-party flashes that are made to work
within the Nikon CLS, but I can't attest to their compatibility, as I've never
used them.

If you want to use your flashes wire-lessly, but you don't want or need the fully automated features of the Nikon CLS, there's another route that's quite a bit cheaper than buying the latest Nikon Speedlights. You can use your built-in flash in manual mode to fire an off-camera flash if the flash has an optical sensor. The Nikon SB-26 and smaller SB-50DX are both great Speedlights that have sensors that you can trigger by firing another flash. You can use both of these Speedlights with your D600 in certain modes. The SB-50DX also has a cool added bonus: it ships with an infrared filter that fits over the flash head so you can use it to trigger off-camera flashes optically without adding to the exposure when using it on-camera (this isn't always included when you but it secondhand). The most compact and affordable Nikon Speedlight with an optical trig-ger is the SB-30. This little flash

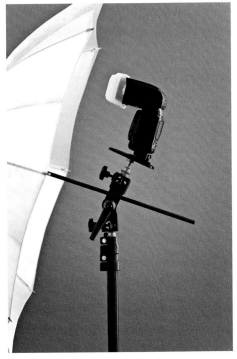

8.2 The SB-900 Speedlight with bracket and umbrella

doesn't have the output of the SB-26 or the SB-50, but it is a great compact off-camera flash that will literally fit in your pocket.

To avoid having your built-in flash add exposure to your images when using it to trigger your off-camera flash, you can buy a cheap Nikon SG-3IR flash-blocking panel.

NOTE The SB-700, SB-800, SB-900, and SB-910 Speedlights have optical trig-gering capability. Nikon also makes an optical trigger called the SU-4 that you can use with just about any flash.

If you're even more budget-conscious and don't mind using a cord to trigger the flashes, you can go with a nondedicated flash. The Vivitar 283 is one of the most rec-ommended and inexpensive nondedicated flashes out there. (Vivitar also offers the 285 and the 285HV, but these aren't recommended for use with dSLRs because the triggering voltage can fry the circuitry of your camera, so double and triple-check

the flash model number before attaching to your camera's hot shoe.) You can also go with the older Nikon Speedlights; the best ones for this job are the SB-24, SB-26, and SB-28 (these also work on-camera in certain modes as well) because they all have PC sync ports. The only other things you need to buy are a PC sync cord and a hot-shoe adaptor such as the Nikon AS-15 or a Wein Safe-sync. I recommend the Wein Safe-sync if you're using older flashes such as the Vivitar 283, as it protects your camera from damage if the flash has a high-voltage trigger.

> **TIP** As you advance into off-camera flash photography, you may want to invest in radio triggers, which don't require the off-camera flash to see the commander flash.

Light stands and brackets

The next thing you're going to need is a light stand. Light stands come in at many different price points, depending on the features, but for starting out you can get a nice budget stand for about $25. As you progress, you may want to look into more versatile options such as boom stands. I recommend getting a stand that extends to at least 6 feet, but is preferably taller. An 8- or 10-foot light stand is ideal for portrait lighting and can also be used effectively for tabletop photography.

Along with a stand you will need a bracket. You use a bracket to mount your flash, as well as to adjust the flash angle and attach a light modifier. There are many different manufacturers of these accessories, and they usually cost anywhere from $20 to $50. Do an Internet search for *umbrella bracket* and you'll have no problems finding something that will work for you. Some brackets accommodate two or more flashes for more light output.

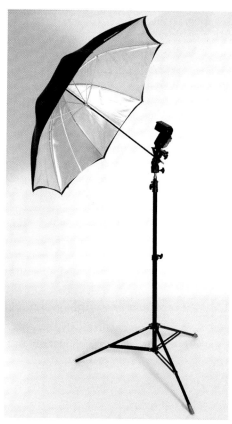

8.3 This is what a typical lighting setup looks like when it's ready to shoot. The wireless setup and small flash make it easy to move to adjust or modify lighting on the fly.

Umbrellas

Although there are many different types of light modifiers for off-camera flash, I find that for the money, you simply cannot beat the quality of a good umbrella. Umbrellas are cheap, extremely portable, and provide a superb light source. You can shoot through an umbrella with a bit of distance and get a defined but soft effect, or you can move the light closer to the subject and bounce it from the umbrella for a very soft, flattering light. Umbrellas are very versatile lighting tools.

Umbrellas come in many sizes. Of course, smaller umbrellas give you a more directional light, while a larger umbrella gives you a more diffused light. I recommend starting out with an umbrella about 36 to 45 inches in diameter. These are affordable, portable, and are large enough to light almost any general subject.

There are a few different types of umbrellas:

▶ **Shoot-through umbrella.** This is a simple umbrella made out of a reflective, translucent nylon. You can aim it directly at the subject and shoot right through, giving you more directional light with little light loss so you can shoot at a lower output or smaller aperture setting. You can also turn these umbrellas around and bounce the light from them, although you lose a significant amount of light.

▶ **Reflective umbrella.** This type of umbrella has a black outside with a reflective coating on the inside, usually a highly reflective silver or gold to warm up the image. The light is bounced from the umbrella to the subject and is generally quite soft.

▶ **Convertible umbrella.** This type of umbrella is made of reflective nylon like the shoot-through umbrella, but also has a removable black cover that allows you to stop the loss of light when bouncing flash from the umbrella.

▶ **Reflector.** Although it isn't completely necessary for your initial kit, a reflector comes in handy in many situations. Sometimes I'll use the reflector as a source for bouncing the flash. On more occasions than one, I've used the reflector to simply add some natural light into the scene and not use the flash at all.

Manual flash exposures

To determine the proper settings for your camera and flash to achieve a good exposure, you must know a simple equation: GN / D = A. This equation contains the three most important parts of flash exposure: Guide Number, Distance, and Aperture.

Guide Number

The Guide Number (GN) is simply a numeric value that represents the amount of light that your Speedlight emits at specific settings. The GN of the Speedlight isn't a fixed number, as it changes with the ISO setting and the zoom head position. Furthermore, each model of Speedlight has a different GN. The GN for your particular flash at any given output setting can be found in the user manual.

To figure out the GN at ISO settings other than ISO 100, you must multiply the GN by an ISO sensitivity factor. Doubling the ISO setting halves the exposure the same way that opening the aperture one stop does. As a result, you can calculate the ISO sensitivity factor by multiplying some numbers that may be familiar to you, which should make the process a bit easier to remember.

8

To calculate the adjusted GN, multiply the GN at ISO 100 by

▶ 1.4 for ISO 200

▶ 2 for ISO 400

▶ 2.8 for ISO 800

▶ 4 for ISO 1600

▶ 5.6 for ISO 3200

▶ 8 for ISO 6400

Why do these numbers look so familiar? They are the same as the 1-stop intervals for aperture settings.

> **TIP** If you plan to do a lot of manual flash exposures, I suggest making a copy of the GN table from the owner's manual and keeping it in your camera bag with the flash.

Distance

The second component in the flash exposure equation is the distance from the light source to the subject. The closer the light is to your subject, the higher the intensity of the light that falls on it is. Conversely, the farther away the light source is, the less illumination your subject receives. This is important because if you set your Speedlight to a certain output, you can still achieve a proper exposure by moving the Speedlight closer or farther away as needed.

One thing to consider when taking distance into account is the *inverse square law*. For our purposes, this law of physics states that for a point source of light (in this case a Speedlight), the intensity of the light is inversely proportional to the square of the distance between the subject and the light source. While this may sound a bit confusing at first, it simply means that doubling the distance between the subject and the light source results in one quarter the amount of illumination.

For example, if you have your Speedlight set up 4 feet from your subject and you move it so that it's 8 feet away, you will need 4 times the amount of light to get the same exposure. Quadrupling the light is easily accomplished by opening the aperture 2 stops or by increasing the flash illumination manually.

Aperture

The third component in the flash exposure equation is the aperture setting. As you already know, the wider the aperture, the more light that falls on the sensor. Using a wider aperture allows you to use a lower power setting (such as 1/4 when in Manual mode) on your flash, or if you're using the automatic i-TTL mode, the camera fires the flash using less power. Using a wider aperture can also help you conserve battery power because the flash is firing at a reduced level.

GN / D = A

Here's where the GN, distance, and aperture all come together. The basic formula allows you to take the GN and divide it by the distance to determine the aperture at which you need to shoot. You can change this equation to find out what you want to know specifically:

▶ **GN / D = A.** If you know the GN of the flash and the distance of the flash from the subject, you can determine the aperture to use to achieve the proper exposure.

▶ **A / GN = D.** If you know the aperture you want to use and the GN of the flash, you can determine the distance to place your flash from the subject.

▶ **A × D = GN.** If you already have the right exposure, you can take your aperture setting and multiply it by the distance of the flash from the subject to determine the approximate GN of the flash.

Technique

Once you get your off-camera lighting setup together, it's time to get out there and shoot. As I mentioned before, professional photographers have been using off-camera

flash for many years, and so there are definitely some building blocks to work from so that you're not just flying blind. Getting your flash off of your camera allows you to move the light around so that you can create depth and drama in your images that just isn't possible with an on-camera flash.

Portraits

When shooting portraits, you use off-camera flash to create light that is flattering to your subject. You achieve these results by controlling where the shadows fall on your subject's face. Photographers use light placement to create different lighting patterns. In addition to these lighting patterns, there are two main types of lighting — broad lighting and short lighting. Broad lighting occurs when your main light is illuminating the side of the subject that is facing you. Short lighting occurs when your main light is illuminating the side of the subject that is facing away from you. In portrait lighting, there are five main types of lighting patterns.

8

▶ **Butterfly or Hollywood glamour.** This type of lighting is mostly used in glamour photography. The name is derived from the butterfly shape of the shadow that the nose casts on the upper lip. You achieve this type of lighting by positioning the main light directly above and in front of your model.

▶ **Loop or Paramount.** This is the most commonly used lighting technique for portraits. Paramount Studios used this pattern so extensively in Hollywood's golden age that this lighting pattern became synonymous with the studio's name. You achieve this lighting pattern by placing the main light at a 10° to 15° angle to the face, making sure to keep the light high enough that the shadow cast by the nose is at a downward angle and not horizontal.

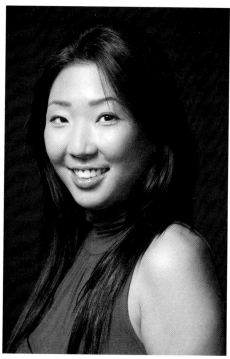

8.4 Butterfly portrait. Exposure: ISO 200, f/4, 1/250 second.

▶ **Rembrandt.** The famous painter Rembrandt van Rijn used this dramatic lighting pattern extensively. It's a moody pattern usually typified by using less fill light. You place the light at a 45° angle and aim it a little bit down at the subject. This pattern is epitomized by a small triangle of light under one of the subject's eyes.

▶ **Split.** This is another dramatic pattern that benefits from little or no fill light. You can create it by simply placing the main light at a 90° angle to the model. The face is divided by the shadow and highlight areas.

▶ **Shadowless.** This lighting pattern requires two lights; you set up a Speedlight at 45° on both sides of your model. You can also achieve this light by using a ring flash. This type of light can be very flattering, although it can lack moodiness and drama. It is also referred to as *frontlighting*. When using a two light setup, be aware that shadows behind the subject can be tricky, so position the model at a distance from the background, or light the background with an additional Speedlight.

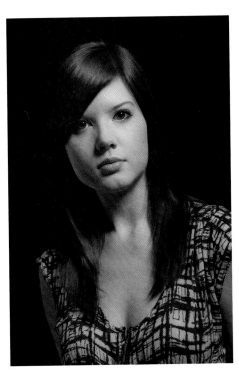

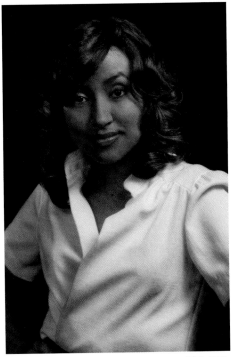

8.5 Paramount portrait. Exposure: ISO 100, f/8, 1/200 second.

8.6 Rembrandt portrait. Exposure: ISO 200, f/5.6, 1/125 second.

One great technique for making your portraits more interesting when using off-camera flash is to underexpose the background to give it more depth and saturation and to accentuate the lighting on the subject. This is pretty simple to do and allows you to create very dramatic portraits.

First, you use your camera's light meter to take a reading of the ambient background light. Take a note of the recommended settings and reduce the exposure by a stop. For example, if the ambient light reading is 1/125 second at f/5.6, ISO 200, then stopping down to f/8 or reducing the ISO to 100 will underexpose the background. You then use the A / GN = D manual flash calculation to determine how far to set up your flashes.

Another technique is to use your Speedlight in iTTL and set ✦ e4 to Background only and use ⊠ −1EV to −2EV. This setting allows the camera to retain the proper flash exposure while the exposure compensation adjusts the ambient exposure. Although I find it doesn't work quite as well as setting your flashes manually, if you're in a rush (say you're shooting a quick headshot for the local paper), then it works quite well in a pinch.

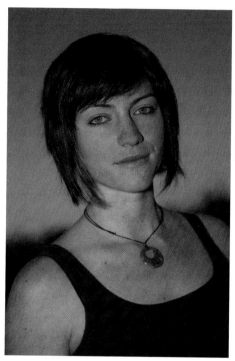

8.7 Underexposed background portrait. Exposure: ISO 100, f/2.8, 1800 second.

Small product and still-life

Lighting small objects using a small off-camera flash kit is pretty much a snap. In general, the key to getting a good shot is to make the light look natural. This usually means soft, even lighting, which is where your umbrella comes in.

There are a number of ways to light a small- to medium-sized object. If you're going for flat lighting, simply place the light source directly above the object and bounce the light from the umbrella straight down at it. This is a good way to create no-nonsense lighting that's good for online auction photos and similar subjects. It's simple and easy.

Personally, I like to use my off-camera flash to add a little depth to my subjects, especially if I'm going for an artistic approach rather than a utilitarian product shot. Coming in at an angle allows you to create shadow areas so that you can add dimension to your subject. In this case, it helps to use lighting that is a bit harder. Shooting through the umbrella directly toward your subject gives you a little more definition while still retaining a soft-edged shadow. If I'm looking for a more dramatic lighting effect, I'll often forgo the umbrella entirely and instead I'll bounce the flash using a nearby wall or a reflector.

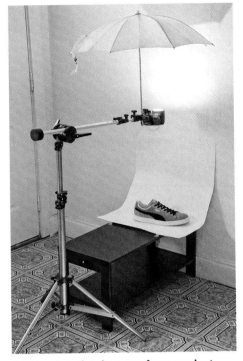

8.8 Here's a simple setup for a product shot that can be done almost anywhere with minimal time and effort.

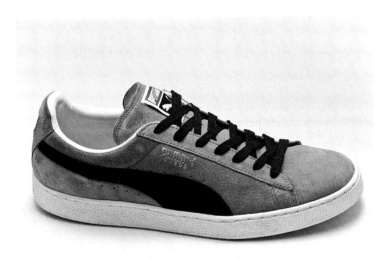

8.9 Final product. Exposure: ISO 400, f/8, 1/200 second.

HDR and Tone Mapping

High Dynamic Range, or HDR as it's most commonly referred to, is a technique that allows you to represent a wide dynamic range on a medium that can only reproduce or display a minimal amount of dynamic range, such as photographic paper or a computer screen. But, let's back up for a minute. What exactly is dynamic range? In photography, dynamic range is the latitude between the darkest and brightest parts (also referred to as the luminance) of a scene. Pretty simple. Photographers measure the difference of brightness in EV or stops (1 EV = 1 stop). So it stands to reason that they also measure dynamic range in stops.

8

8.10 A good HDR image should have clean shadow detail and good highlight detail. Metered exposure: ISO 100, f/8, 1/40 second. Three exposures bracketed 3 stops apart.

In theory, at the base ISO 100 setting, the D600 can capture 14 stops of latitude of dynamic range. This is quite impressive, although I'd venture to say that in truth, it's probably closer to 12 stops in ideal conditions. The problem is that in any given scene, you can have a much wider range of tonality. For instance, a typical outdoor scene at high noon may have a dynamic range of 18 stops or more!

So this brings up the question, "If my camera sensor can only capture 12 to 14 stops of dynamic range, how can I capture the full tonal range of a scene?" The simple answer is *bracketing*.

Bracketing

HDR exposure bracketing is a technique where you take a series of photographs using different settings. Exposure bracketing involves taking three or more shots of the same scene with different exposures; most commonly you take an image as it is metered, and at least two more, one underexposed and one overexposed. You then take these images, which have a wide range of tonality, and combine them either manually using layers in Photoshop or using dedicated HDR imaging software. This results in an image that contains more brightness values than your camera sensor can record in one exposure.

Most HDR enthusiasts recommend using at least five bracketed exposures at 2 stops apart (one metered, two underexposed, and two overexposed). This allows you to capture more than enough dynamic range to cover the full gamut of luminosity in any scene. Personally, I find that shooting three exposures two stops apart is plenty. You can experiment with different exposure intervals and find out what works best for you and your workflow.

8.11 A series of images bracketed using the Nikon D600 auto-bracketing feature at 3EV intervals. The images were combined using Adobe Photoshop CS6 Merge to HDR Pro, resulting in the image shown in Figure 8.10.

Here are a few tips for HDR bracketing:

▶ **Use a tripod.** Because you need to line up your images, using a tripod is highly recommended. Handheld images rarely line up perfectly and often lead to ghosting and other artifacts.

▶ **Use a constant aperture.** In order to maintain a consistent depth of field throughout the bracketed images, it's best to adjust the exposure by varying the shutter speed.

▶ **Use the D600 auto-bracketing feature.** The D600 has a feature that allows you to shoot a series of three bracketed images without doing any manual adjustments to the exposure. Simply press the Bracket button (**BKT**) and rotate the Main Command dial to the right to select 3 (three frames), and then rotate the Sub-command dial to choose the bracketing increments (0.3, 0.7, 1.0, 2.0, or 3.0). The D600 uses a combination of shutter speed and ISO adjustments to maintain a constant aperture.

In-camera HDR

If you want an easy way to create subtle HDR images, the D600 has an effortless solution with the built-in HDR feature. Using this feature, the camera automatically records two exposures (one underexposure and one overexposure) with one press of the shutter-release button, and combines them to make an almost instant HDR image. The HDR images produced by the camera are very realistic, so don't expect any radical-looking results, but in my opinion this is a pretty good option and an easy way to get an HDR image without any software.

To use this feature, go to the Shooting menu (⬛) and select the HDR (high dynamic range) option. There are three settings:

▶ **HDR mode.** This is where you turn the HDR option on and off. The On setting has two options: On (series) and On (single photo). Series allows you to shoot HDR images continuously until the feature is turned off. The single photo option shoots one HDR image and returns to the default of shooting non-HDR images.

▶ **Exposure differential.** This option allows you to choose how far apart the exposures are in order to maximize dynamic range. There are four choices: Auto, 1EV, 2EV, and 3EV. I generally recommend the Auto setting. For normal shooting environments, Auto or 1EV works best. For outdoor shooting on a sunny day,

2EV is a good choice. Indoors where you have a relatively dark room with a bright window in the scene or in an extremely high-contrast scene, you may want to step it up to 3EV.

▶ **Smoothing.** This option controls how the two composited images are blended. There are three options: High, Normal, and Low. The High setting blends the two images with less contrast in the edges of areas where different elements of the subject converge, such as a building façade against the sky. The Low setting can sometimes produce a halo effect, especially when using a higher exposure differential.

There are a couple of caveats about the in-camera HDR feature. First of all, if you set the image quality to RAW or RAW + JPEG, you cannot select the HDR feature. You can *only* use the HDR feature in the JPEG setting. Second, when you enable the HDR feature, you cannot change the image quality to RAW or RAW + JPEG. You must set HDR to Off before you can change the image quality. You can change the compression and size of the JPEG.

Tone mapping

Here's where I get into breaking down the myth of what an HDR image is. When most people think of HDR, they think of brightly colored images full of ultra-sharp details that seem to leap right out at them. In truth, an HDR image is the complete opposite of that.

After combining all of these images, you end up with a file that has a vast amount of information and a wide dynamic range. This is actually a problem. While this may sound contrary to what you think, the media that we use to view the images have a low dynamic range. Your computer monitor, your printer paper, and the pages of this book don't have the ability to reproduce the amount of dynamic range in an HDR image. To compress the dynamic range so that it's reproducible on a low-dynamic-range device, the tones must be compressed, which leaves you with a flat, low-contrast image.

This is where tone mapping comes in. The brightly colored ultra-detailed images that most people have come to know as HDR are actually *tone mapped*. Because the dynamic range of the whole image cannot be reproduced and displayed on a low-dynamic-range medium, the tone mapping software makes local adjustments to different areas of the image to create the illusion of high dynamic range.

8.12 This image was heavily tone mapped, resulting in a more surreal-looking HDR image. It was processed using Photomatix Pro.

There are many software options for producing HDR images. HDR imaging is a whole subject in itself, and if you're interested in delving deeper into it, there are whole books devoted to HDR capture and output. Here's a list of a few of the more popular software options:

▶ **Photomatix.** This is probably the most popular HDR imaging software on the market, and most photographers use it. It's very powerful and has a lot of different features. It's also available as a plug-in. Photomatix offers a fully functional, unlimited trial version that places a watermark on the finished image.

▶ **Adobe Photoshop.** Photoshop is probably the best-known image-editing software. It has offered a Merge-to-HDR option since the CS2 version, but it wasn't very good until CS5 was released, which added tone mapping options. If you already use Photoshop CS5 or CS6, you have a great HDR imaging software option already.

▶ **Luminance HDR.** This isn't the most user-friendly software, *but* it's free. It's fully functional and works best for creating more stylized HDR images. If you have time, sit down for a while and figure out how to work with it, as you can get some decent images from it. Did I mention it's free?

General Composition Tips

Photography, like painting, drawing, or just about any visual arts medium, has general rules of composition. These guidelines have been developed through the ages because, to put it simply, they work. That isn't to say that every time you put your eye up to the viewfinder, you should strictly adhere to all or even any of the so-called rules of composition; sometimes the subject calls for a different approach. But when starting out, it's good to pay attention to these tips because they will definitely help your images stand out from the general snapshots that a lot of people capture with their phone cameras.

Eventually, you will become accustomed to following the guidelines, and they will be second nature to you. At that point you will no longer need to consult the rules of composition; you will just inherently follow them.

One piece of advice that I was given while attending school was that it's important to know the rules of photography because when you know them, it is easier to recognize when to break them.

Keep It Simple

One of the easiest ways to create an interesting composition is to *keep it simple*. Having a strong subject that is easy to pick out and focus on holds the viewer's attention. Having a slew of competing elements in a composition causes it to be messy and distracting, which often leaves the viewer confused.

An easy technique for achieving simplicity in a photograph is to use a wide aperture and a shallow depth of field to isolate the subject from a busy background. By causing the background to go out of focus, you help the subject to stand out better.

Another easy way to isolate your subject is by changing your perspective. Shooting from up high or down low can completely change the background of the same subject; for example, instead of shooting down on a subject, try shooting upward to use a plain blue sky as the background.

A

Simplicity in an image can speak volumes. Try to concentrate on removing unnecessary elements to achieve simple photos.

Rule of Thirds

Beginning photographers tend to place the subject in the middle of the composition. Although this approach seems to make sense, placing the subject off-center can make your images much more interesting.

A.1 A simple, uncluttered image makes for a strong composition. Exposure: ISO 180, f/2.8, 1/50 second with a Nikon 50mm f/1.4G.

A.2 Placing the subject in accordance with the Rule of Thirds makes for a visually more interesting composition. I also used a shallow depth of field to isolate the flower from the busy background. Exposure: ISO 100, f/1.4, 1/1000 second with a Nikon 50mm f/1.4G.

That is where the Rule of Thirds comes in.

The Rule of Thirds is one of the best compositional guides in art, and it has been used by artists throughout history. It involves dividing the image into nine equal parts using two equally spaced horizontal and vertical lines, kind of like a tic-tac-toe pattern. You want to place the main subject of the image at or near the intersection of one of these lines. The D600 has on option that allows you to overlay guidelines in the viewfinder. You can activate guidelines in ✦ d2 to help you.

When using the Rule of Thirds with a moving subject, you want to keep most of the frame in front of the subject to create the illusion that the subject has someplace to go within the frame.

Leading Lines and S-Curves

Another very helpful technique is to use natural lines that occur in the scene to help draw the eye through the image. Sometimes these lines may be very distinct, such as the lines of railroad tracks leading to a vanishing point, or the lines can be subtler, like a gentle S-curve in a country road.

The key is to actively look for leading lines and to incorporate them either as the main subject or as a way to bring attention to the main subject.

A.3 Here I used the curving lines of a vase as a leading line. The image has a single, simple subject. Exposure: ISO 320, f/1.4, 1/50 second with a Nikon 50mm f/1.4G.

Helpful Hints

There are a lot of different compositional tips and guidelines that can help you make your photography more interesting than a standard snapshot. Here are a few:

▶ **Frame the subject.** Use elements in the foreground to make a frame around the subject; this keeps the viewer's eye on the subject.

▶ **Avoid having the subject look directly out of the side of the frame he or she is closest to.** Having the subject look out of the photograph can be distracting to the viewer. For example, if your subject is on the left side of the composition, having him or her face right is better, and vice versa.

▶ **Avoid mergers.** A *merger* occurs when an element from the background appears to be a part of the subject, like the snapshot of granny at the park that looks like she has a tree growing out of the top of her head.

▶ **Try not to cut through the joint of a limb.** When composing or cropping your picture, it's best not to end the frame on a joint, such as an elbow or a knee, and if the hands are included in the photo, you should keep all the fingers in the frame.

▶ **Avoid having bright spots or unnecessary details near the edge.** Anything bright or detailed near the edge of the frame draws the viewer's eye away from the subject and out of the image.

▶ **Fill the frame.** Try to make the subject the dominant part of the image. Avoid a lot of empty space around the subject unless it's essential to make the photograph work.

▶ **Use odd numbers.** When photographing multiple subjects, using odd numbers works best to help the image flow and achieve balance.

Accessories

You can use a wide variety of accessories for the D600 that serve many different purposes. Nikon has released a few new accessories, and there are also older accessories that work with the D600, such as Speedlights. Third-party manufacturers also make accessories that work with the D600. Here's a short list of some of the accessories that Nikon offers for the D600 to help enhance your shooting experience.

Nikon MB-D14 Battery Grip

While some people don't view a battery grip as a necessary tool, others swear by it. I'm in the latter camp. Not only does a battery grip allow you to add an extra battery for extended shooting time, but it also provides you with a full set of controls for handling the camera vertically.

The vertical controls allow you to hold the camera at a normal, comfortable angle, so that you don't have to shoot with your elbow up in the air. The grip also provides you with all of the controls that you have while shooting normally, including a shutter-release button (which can be switched off to prevent accidental shutter releases), both Main and Sub-command dials, a multi-selector, and a programmable AF-ON button (**AF-ON**). In addition, the MB-D14 (see Figure AB.1) is made from magnesium alloy and polycarbonate, and is weather sealed, just like the D600 camera body.

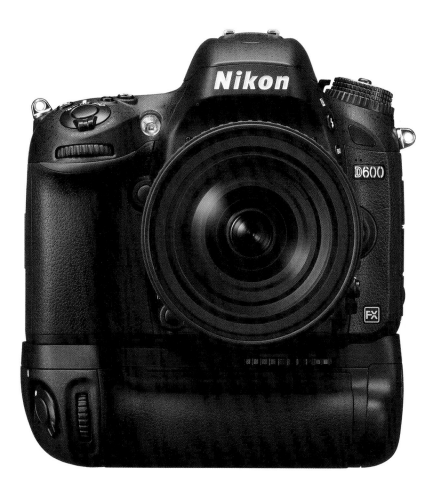

Image courtesy of Nikon, Inc.

AB.1 The D600 with the attached MB-D14 battery grip

Speedlights

A Nikon Speedlight is, in my opinion, one of the most important accessories you can buy for your D600. Speedlights are used on-camera for shooting in low light, and they give you the power and flexibility of professional lighting at an affordable price. They're also compact and can be controlled wirelessly from the D600 straight out of the box.

Nikon Speedlights operate as part of the Nikon Advanced Wireless Lighting (AWL) system and are part of what is known as the Nikon Creative Lighting System (CLS). AWL allows you to wirelessly control multiple Speedlights and groups of Speedlights while using the Nikon proprietary i-TTL flash metering system. This allows you to achieve professional lighting results with a much smaller budget and a much smaller gear bag.

The D600 allows you to control up to two groups of additional Speedlights using the built-in flash, and up to three groups of flashes when using an external commander such as an SU-800, SB-800, SB-900, or SB-910. The SB-700 is also limited to controlling two groups of Speedlights. The SB-600, SB-700, SB-800, SB-900, and SB-910 can all be used as remote flashes.

> **NOTE** The SB-600, SB-800, and SB-900 are discontinued, but still work perfectly with the D600.

Image courtesy of Nikon, Inc.
AB.2 The Nikon SB-910 Speedlight

You can find the SB-600, SB-800, and SB-900 units used (and sometimes new), so don't hesitate to buy one if you find it at a good price. They provide full functionality with all current Nikon dSLRs and will likely continue to work with future models.

Nikon's current lineup of available Speedlights includes the SB-910 flagship model, the SB-700, and the SB-400, as well as the SU-800 Commander, and the R1 and R1C1 Wireless Close-Up Speedlight System.

Nikon GP-1 GPS Unit

For traveling photographers, the Nikon GP-1 GPS unit automatically geotags images with latitude, longitude, and specific time information acquired from GPS satellites. This is one of my newest gadgets and I have to say that it works pretty well. Having geotags automatically applied to your images is a great feature, especially for nature and wildlife photographs.

The GP-1 can be attached via the hot shoe or to the strap with an included adapter. You can also use Nikon's free ViewNX2 software to correlate the images with a map.

Nikon ME-1 Stereo Microphone

If you're serious about video, an external microphone is an essential accessory. The Nikon ME-1 is a small stereo microphone that fits into the D600's hot shoe.

This external microphone allows you to record sound much more clearly than the internal microphone. And because it is located farther away from the lens, it also helps minimize the noise created by the autofocusing mechanism.

The ME-1 comes with a windscreen to reduce wind noise when shooting outdoors and also features a low-cut filter to reduce other unwanted low-frequency noises.

Image courtesy of Nikon, Inc.
AB.3 The Nikon ME-1 stereo microphone on the D600

WU-1b Wireless Mobile Adapter

This is Nikon's latest accessory that allows you to sync the D600 with your smartphone or other smart device, such as an iPad. You can use the WU-1b to transmit images automatically to your device so you can share or save them quickly. This relatively

inexpensive wireless adapter also allows you to use your smartphone as a remote release using the camera's Live View feed, which is visible on your smart device using a free app.

The only downside to this accessory is that, so far, you cannot adjust exposure settings using the app — you must make any changes to your settings on the camera body. Hopefully, Nikon will add this capability in the near future because this could revolutionize remote shooting in the studio.

Image courtesy of Nikon, Inc.

AB.4 The Nikon WU-1b Wireless Mobile Adapter

ML-L3 Wireless Remote Control

Unlike its bigger sibling the D800, the Nikon D600 has two infrared receivers, front and back, which allow you to remotely trigger the camera using the ML-L3 infrared remote. This great little accessory is perfect for shooting long exposures, taking self-portraits, or including yourself in a group portrait. The best part about this accessory is that it is very inexpensive. The ML-L3 can usually be purchased for less than $20. However, the infrared remote for higher-end Nikon cameras is over $200.

Image courtesy of Nikon, Inc.

AB.5 The Nikon ML-L3 Wireless Remote

C APPENDIX

How to Use the Gray Card and Color Checker

Have you ever wondered how some photographers are able to consistently produce photos with such accurate color and exposure? It's often because they use gray cards and color checkers. Knowing how to use these tools helps you take some of the guesswork out of capturing photos with great color and correct exposures every time.

The Gray Card

Because the color of light changes depending on the light source, what you might decide is neutral in your photograph, isn't neutral at all. This is where a gray card comes in very handy. A gray card is designed to reflect the color spectrum neutrally in all sorts of lighting conditions, providing a standard from which to measure for later color corrections or to set a custom white balance.

By taking a test shot that includes the gray card, you guarantee that you have a neutral item to adjust colors against later if you need to. Make sure that the card is placed in the same light that the subject is for the first photo, and then remove the gray card and continue shooting.

> TIP When taking a photo of a gray card, de-focus your lens a little; this ensures that you capture a more even color.

Because many software programs enable you to address color correction issues by choosing something that should be white or neutral in an image, having the gray card in the first of a series of photos allows you to select the gray card as the neutral point. Your software resets red, green, and blue to be the same value, creating a neutral midtone. Depending on the capabilities of your software, you might be able to save the adjustment you've made and apply it to all other photos shot in the same series.

If you'd prefer to made adjustments on the spot, for example, and if the lighting conditions will remain mostly consistent while you shoot a large number of images, it is

advisable to use the gray card to set a custom white balance in your camera. You can do this by taking a photo of the gray card filling as much of the frame as possible. Then, use that photo to set the custom white balance.

The Color Checker

A color checker contains 24 swatches which represent colors found in everyday scenes, including skin tones, sky, foliage, etc. It also contains red, green, blue, cyan, magenta, and yellow, which are used in all printing devices. Finally, and perhaps most importantly, it has six shades of gray.

Using a color checker is a very similar process to using a gray card. You place it in the scene so that it is illuminated in the same way as the subject. Photograph the scene once with the reference in place, then remove it and continue shooting. You should create a reference photo each time you shoot in a new lighting environment.

Later on in software, open the image containing the color checker. Measure the values of the gray, black, and white swatches. The red, green, and blue values in the gray swatch should each measure around 128, in the black swatch around 10, and in the white swatch around 245. If your camera's white balance was set correctly for the scene, your measurements should fall into the range (and deviate by no more than 7 either way) and you can rest easy knowing your colors are true.

If your readings are more than 7 points out of range either way, use software to correct it. But now you also have black and white reference points to help. Use the levels adjustment tool to bring the known values back to where they should be measuring (gray around 128, black around 10, and white around 245).

If your camera offers any kind of custom styles, you can also use the color checker to set or adjust any of the custom styles by taking a sample photo and evaluating it using the on-screen histogram, preferably the RGB histogram if your camera offers one. You can then choose that custom style for your shoot, perhaps even adjusting that custom style to better match your expectations for color.

267

Glossary

Active D-Lighting A camera setting that preserves highlight and shadow details in a high-contrast scene with a wide dynamic range.

AE See *Autoexposure.*

AF See *Autofocus.*

AF-assist illuminator An LED light that's emitted in low-light or low-contrast situations. The AF-assist illuminator provides enough light for the camera's autofocus to work in low light.

ambient lighting Lighting that naturally exists in a scene.

angle of view The area of a scene that a lens can capture, which is determined by the focal length of the lens. Lenses with a shorter focal length have a wider angle of view than lenses with a longer focal length.

aperture The opening of a lens, similar to the iris of an eye. The designation for each step in the aperture is called the f-stop. The smaller the f-stop (or f-number) is, the larger the opening of the aperture. Higher f-numbers designate smaller apertures and let in less light. The f-number is the ratio of the focal length to the aperture diameter.

Aperture-priority auto An exposure mode in which you choose the aperture and the camera automatically adjusts the shutter speed according to the camera's metered readings. Aperture-priority auto is often used to control depth of field.

aspect ratio The ratio of the long edge of an image to the short edge as printed, displayed on a monitor, or captured by a digital camera.

Autoexposure (AE) A camera mode that selects the aperture and/or shutter speed according to the camera's built-in light meter. See also *Aperture-priority auto, Programmed auto,* and *Shutter-priority auto.*

Autoexposure/Autofocus (AE/AF) Lock A camera control that lets you lock the current metered exposure and/or autofocus setting prior to taking a photo. This allows you to meter an off-center subject, and then recompose the shot while retaining the proper exposure for the subject. The function of this button can be altered in the Setup menu under the Buttons heading.

Autofocus (AF) A camera mode that determines the proper focus of the subject automatically.

backlighting A lighting effect produced when the main light source is located behind the subject. Backlighting can be used to create a silhouette effect or to illuminate translucent objects. See also *frontlighting* and *sidelighting.*

barrel distortion A lens aberration in which the lines at the horizontal and vertical edges of the image are bowed outward. This distortion is usually found in shorter focal-length (wide-angle) lenses.

bokeh A term that refers to the out-of-focus areas of an image. It's derived from the Japanese word *boke,* which is loosely translated as "fuzziness."

bounce flash A technique in which the flash head is pointed upward or toward a wall so that it bounces off another surface before reaching the subject. Bounce flash softens the light reaching the subject, and often eliminates shadows and provides smoother light for portraits.

bracketing A photographic technique in which you vary the exposure over two or more frames. This ensures a proper exposure in difficult lighting situations in which your camera's meter can be fooled.

broad lighting A lighting technique in which the main light illuminates the side of the subject that is facing you.

camera shake Camera movement (usually at slower shutter speeds) that produces a blurred image.

center-weighted metering A light-measuring algorithm that emphasizes the area in the middle of the frame when you're calculating the correct exposure for an image.

chromatic aberration A flaw in the design of a lens in which the lens doesn't focus all wavelengths of light on the same plane. This is typified by color fringing at the edges of high-contrast areas of the image.

colored gel filter A translucent material that is placed over a flash head or light to change the color of the light emitted. Gels are often used to match the flash output with the ambient light. They are also used to change the color of the background when shooting a portrait or still life by placing the gel over the flash head, and then firing the flash at the background.

compression A technique that reduces the size of a file by digital encoding, which uses fewer bits of information to represent the original subject. Some compression types, such as JPEG, actually discard some image information, while others, such as Lossless compressed RAW (NEF) files, preserve all of the details in the original.

Continuous-servo Autofocus (AF-C) A camera setting that allows the camera to continually focus on a moving subject.

contrast The range between the lightest and darkest tones in an image. In a high-contrast image, the tones extend through the entire range between white and black. In a low-contrast image, the tones are compressed into a smaller range.

curvilinear A term used to describe a lens that does not adjust for the curvature of the lens elements, resulting in an image that appears curved, especially at the edges. Fish-eye lenses are curvilinear.

dedicated flash An electronic flash unit — such as the Nikon SB-910, SB-900, SB-800, SB-700, SB-600, or SB-400 — designed to work with the autoexposure features of a specific camera.

depth of field (DOF) The portion of a scene from foreground to background that appears sharp in the image.

diffuse lighting A soft, low-contrast lighting.

D-Lighting A camera function that can correct the underexposure that often happens to images that are backlit or in deep shadow. D-Lighting works by adjusting the levels of the image after the image has been captured. Not to be confused with Active D-Lighting.

DX The Nikon designation for digital single-lens reflex cameras (dSLRs) that use an APS-C–sized (23.6mm × 15.8mm) sensor.

dynamic range The range of brightness or luminosity in any given scene from shadow areas to highlights.

equivalent focal length A DX-format digital camera's focal length, which is translated into the corresponding values for 35mm film or the FX format.

exposure The amount of light allowed to reach a camera's sensor, which is determined by the ISO setting, the light admitted by the aperture of the lens, and the length of time determined by the shutter speed.

exposure compensation A technique for adjusting the exposure indicated by a photographic exposure meter, in consideration of factors that may cause the indicated exposure to result in a less-than-optimal image.

exposure mode Camera settings that control how the exposure settings are determined. See also *Aperture-priority auto, Programmed auto,* and *Shutter-priority auto.*

fill flash A lighting technique in which a flash provides enough light to illuminate the subject in order to eliminate shadows. Using a flash for outdoor portraits often brightens the subject in conditions where the camera meters light from a broader scene.

fill lighting The lighting used to illuminate shadows. Reflectors, additional incandescent lighting, or an electronic flash can be used to brighten shadows. One common outdoor technique is to use the camera's flash as a fill.

flash An external light source that produces an almost instant flash of light to illuminate a scene. Also known as electronic flash.

Flash Compensation A feature that adjusts the flash output. If images are too dark (underexposed), Flash compensation can be used to increase the flash output. If images are too bright (overexposed), it can be used to reduce the flash output.

flash modes Modes that enable you to control the output of the flash by using different parameters. Some of these modes include Red-Eye Reduction and Slow Sync.

flash output level The output level of the flash as determined by one of the flash modes used.

focal plane The point at which the lens focuses the image. In a dSLR, the focal plane is where the sensor lies.

frames per second (fps) A term that describes how many images are recorded per second.

Front-curtain sync A camera setting that causes the flash to fire at the beginning of the period when the shutter is completely open in the instant that the first curtain of the focal plane shutter finishes its movement across the film or sensor plane. This is the default setting. See also *Rear-curtain sync*.

frontlighting The illumination coming from the direction of the camera. See also *backlighting* and *sidelighting*.

f-stop See *aperture*.

FX The Nikon designation for digital single-lens reflex cameras (dSLRs) that use a 35mm-sized (36mm × 24mm) sensor.

High Dynamic Range (HDR) Imaging that allows you to portray a photograph with more tonal range than is possible to capture in a single image, by combining images with two or more exposures. HDR is also a feature on the D600 that automatically combines two exposures and blends them together.

histogram A graphic representation of the range of tones in an image.

hot shoe The slot located on the top of the camera where the flash connects. The hot shoe is considered hot because it has electronic contacts that allow communication between the flash and the camera.

ISO sensitivity A setting that indicates the light sensitivity of a camera's sensor. In digital cameras, a lower ISO setting provides better-quality images with less image noise; however, a lower ISO setting also requires more exposure time. ISO stands for International Organization for Standardization.

JPEG (Joint Photographic Experts Group) An image format that compresses the image data from the camera to achieve a smaller file size. The compression algorithm discards some of the detail when saving the image. The degree of compression can be adjusted, allowing a selectable trade-off between storage

size and image quality. JPEG is the most common image format used by digital cameras and other photographic image-capture devices.

kelvin (K) A unit of measurement of color temperature based on a theoretical black body that glows a specific color when heated to a certain temperature. The sun is approximately 5500K.

lag time The length of time between when the shutter-release button is pressed and the shutter is actually released; the lag time on the D600 is so short that it's almost imperceptible. Compact digital cameras are notorious for having long lag times, which can cause you to miss important shots.

leading line An element in a composition that leads a viewer's eye toward the subject.

lens flare An effect caused by stray light reflecting off the many glass elements of a lens. Lens shades typically prevent lens flare, but sometimes you can choose to use it creatively by purposely introducing flare into your image.

macro lens A lens with the capability to focus at a very close range, enabling extreme close-up photographs. Nikon terminology calls these "micro" lenses.

manual exposure An exposure mode in which the aperture and shutter speed are controlled by the photographer, not the camera.

Matrix metering A Nikon-exclusive meter that reads the brightness and contrast throughout the entire frame, and then matches those readings against a database of images (over 30,000 in most Nikon cameras) to determine the best metering pattern to use to calculate the exposure value.

metering A technique for measuring the amount of light in the scene by using a light meter.

Nikon Electronic File (NEF) The Nikon RAW file format.

noise The appearance of pixels with randomly distributed color values in a digital image. Noise in digital photographs tends to be more pronounced in shadow areas with low-light conditions and long exposures, particularly when you set your camera to a higher ISO setting.

Noise Reduction (NR) A technology used to decrease the amount of random information in a digital image, often caused by long exposures and/or high ISO settings.

pincushion distortion A lens aberration in which the lines at the horizontal and vertical edges of the image are bowed inward. It is usually found in longer focal-length (telephoto) lenses.

Programmed auto A camera setting in which shutter speed and aperture are set automatically.

RAW An image file format that contains the unprocessed camera data as it was captured. Using this format allows you to change image parameters, such as white balance, saturation, and sharpening. Although you can process RAW files in-camera, the preferred method requires special software, such as Adobe Camera Raw (available in Photoshop), Adobe Lightroom, or Nikon Capture NX2 or View NX 2. See also *NEF*.

Rear-curtain sync A setting that causes the flash to fire at the end of the exposure an instant before the second (or rear) curtain of the focal plane shutter begins to move. With slow shutter speeds, this feature can create a blur effect from the ambient light that appears as a pattern following a moving subject, with the subject shown sharply frozen by the flash at the end of the blur trail. This setting is often used in conjunction with longer shutter speeds. See also *Front-curtain sync*.

rectilinear A term used to describe a design feature that corrects for the curvature distortion found in wide-angle lenses. Most wide-angle lenses are rectilinear, whereas a fish-eye lens is not and retains the field curvature.

red-eye An effect from flash photography that appears to make a person's eyes glow red or an animal's eyes glow yellow or green. This effect is caused by light bouncing from the retina of the eye. It is most noticeable in dimly lit situations (when the irises are wide open), as well as when the electronic flash is close to the lens and, therefore, prone to reflect the light directly back.

Red-Eye Reduction A flash mode that's used to prevent the subject's eyes from appearing red in color. Multiple flashes are fired just before the shutter is opened in order to cause the subject's irises to contract, therefore reflecting less light from the retina to the camera.

selective focus A camera setting that uses shallow depth of field to isolate the subject and make it more prominent by blurring out the rest of the image.

self-timer A mechanism that delays the opening of the shutter for several seconds after the shutter-release button has been pressed.

short lighting A lighting technique in which the main light illuminates the side of the subject that is facing away from the photographer.

shutter A mechanism that allows light to pass to the sensor for a specified amount of time.

Shutter-priority auto A camera mode in which you set the desired shutter speed and the camera automatically sets the aperture for you. It's best used when you're shooting action shots to freeze the subject's motion by using fast shutter speeds.

shutter speed The length of time the shutter is open to allow light to fall onto the imaging sensor. The shutter speed is measured in seconds or, more commonly, fractions of a second.

sidelighting Lighting that comes directly from the left or right of the subject. See also *frontlighting* and *backlighting*.

Single-servo Autofocus (AF-S) A setting that locks the focus on the subject when the shutter-release button is pressed halfway. This allows you to focus on the subject, and then recompose the image without losing focus.

Slow Sync A flash mode that allows the camera's shutter to stay open for a longer time to allow the ambient light to be recorded. The background receives more exposure, which gives the image a more natural appearance.

Speedlight A term for Nikon accessory flashes.

spherical aberration A problem with lens design that causes the light coming through the lens not to converge at a single point, resulting in soft or unfocused images. Most lenses on the market today include an aspherical lens element that corrects this problem.

spot meter A metering system in which the exposure is based on a small area of the image. On the D600 the spot is linked to the AF point.

Through-the-Lens (TTL) A metering system in which the light is measured directly through the lens.

vanishing point The point at which parallel lines converge and seem to disappear.

Vibration Reduction (VR) A function in which the lens elements are shifted by a mechanism in the lens to reduce the effects of camera shake. Note that VR is a Nikon proprietary term, and third-party lenses have other designations that mean the same thing, such as Optical Stabilization (OS – Sigma) and Vibration Compensation (VC – Tamron).

white balance A setting used to compensate for the differences in color temperature from different light sources. For example, a typical tungsten light bulb is very yellow-orange, so the camera adds blue to the image to ensure that the light looks like standard white light.

Index

B

D

ISO (International Organization for Standardization), 54, 271
ISO sensitivity. *See also* noise reduction (NR)
 aperture controlled by, 176
 Auto ISO, 55–56
 defined, 54, 175–176, 271
 Easy option for, 111
 exposure controlled by, 174, 175–176
 H (high speed) settings, 55
 increments for setting, 176
 indicator (Info display), 24, 28
 indicators (control panel), 19, 21, 23
 indicators (viewfinder), 15, 17, 18
 ISO button for setting, 54
 L (low speed) settings, 55
 Maximum sensitivity option, 56
 Minimum shutter speed option, 56
 noise reduction for high ISO, 29, 57, 100
 range available, 54–55
 Shooting menu option, 56, 100
 showing in control panel, 111
 shutter speed controlled by, 176
 step value option, 107
i-TTL and i-TTL BL flash modes, 204

J

JPEG files
 compression options for, 89
 compression process for, 71–72
 generation loss with, 72
 image quality options for, 73, 87
 image size options for, 72–73, 87–88
 memory card options for, 86
 printing, 72–73
 RAW files compared to, 68–69, 74
JPEG image size indicator (control panel), 19, 20
JPEG (Joint Photographic Experts Group), 71, 270–271

K

Kelvin color temperature indicator
 control panel, 18, 19
 Info display, 24, 25
Kelvin (K), 58, 272. *See also* color temperature; white balance

L

L0.3, L0.7, and L1.0 ISO settings, 55
lag time, 272
Landscape mode, 38
Landscape Picture Controls, 62

landscapes
 Scene modes for, 38, 40, 41
 silhouettes in, 199
 still photography in Live View, 214, 217–220
 U1/U2 settings for, 236–237
 Wide-area AF mode for, 216
Language option, 126
LCD illumination option, 113
LCD monitor. *See also* Information (Info) display; Live View
 brightness setting for, 123
 delay before shutoff, 110
 described, 6
 location of, 8
 resolution of, 229
leading lines for composition, 258
leading time, 272
left side of the camera, 14
lens accessories
 close-up filters, 170
 extension tubes, 169–170
 neutral density (ND) filters, 171–172
 teleconverters, 168–169
 UV filters, 170–171
lens flare, 272
lens mounting mark, 12, 13
lens release button, 12, 13
lenses. *See also* non-CPU lenses; Vibration Reduction (VR); *specific kinds*
 Autofocus switch, 13, 14
 buying secondhand, 151
 compatibility with D600, 148
 Defocus Control (DC), 164
 with dSLRs versus video cameras, 221
 DX, using with the D600, 156
 fine-tuning AF for, 129–131
 fisheye, 165–167
 focal length indicators, 4, 5
 focus distance scale, 4
 focus ring, 4
 impact of, 147
 macro, 162–164, 169, 272
 Manual lens number indicator, 19, 23, 24, 27
 Nikon codes for, 148–150
 Perspective Control (PC-E), 150, 167–168
 protecting with UV filters, 170–171
 standard or midrange zoom, 158–159
 super-zoom, 161
 telephoto, 159–161
 third-party, 150–152
 wide-angle, 152–157
 zoom ring, 4, 5
 zoom versus prime, 154

Guides to go.

Digital Field Guides are packed with essential information about your camera, plus great techniques for everyday shooting. Colorful and easily portable, they go where you go.

Free Gray/Color Checker Card Inside! Alan Hess

Nikon®
D3200
Digital **Field Guide**

978-1-118-43822-0

Free Gray/Color Checker Card Inside! J. Dennis Thom

Nikon®
D800 & D800E
Digital **Field Guide**

978-1-118-16914-8

Benjamin Edwards

Free Gray/Color Checker Card Inside!

Nikon®
Creative Lighting System
Digital **Field Guide**
THIRD EDITION

978-1-118-02223-8

Free Gray/Color Checker Card Inside! Rosh Sillars

Canon® EOS
Rebel T4i/650D
Digital **Field Guide**

978-1-118-16913-1

Free Gray/Color Checker Card Inside! Michael Corsentino

Canon®
Speedlite System
Digital **Field Guide**
THIRD EDITION

978-1-118-11289-2

Free Gray/Color Checker Card Inside! Charlotte K. Lowrie

Canon® EOS
5D Mark III
Digital **Field Guide**

978-1-118-16911-7

e Available in print and e-book formats.

WILEY

Wiley is a registered trademark of John Wiley & Sons, Inc.